# antennae

## spaces and species

2021

# antennae

**THE JOURNAL OF NATURE IN VISUAL CULTURE**
**edited by Giovanni Aloi**

*Antennae* (founded in 2006) is an independent, hybrid, peer reviewed journal. We are free to the public, non-funded by institutions, and not supported by grants or philanthropists. The Journal's format and contents are informed by the concepts of 'knowledge transfer' and 'widening participation'. Independent publications share histories of originality, irreverence, and innovation and *Antennae* has certainly been an important contributor to what will be remembered as the non-human turn in the humanities. The first issue of *Antennae* coincided with the rise of human-animal studies; a field of academic inquiry now become mainstream. Our independent status has allowed us to give a voice to scholars and artists who were initially not taken seriously by mainstream presses. Through our creative approach, we have supported the careers of experimental practitioners and researchers across the world providing a unique space in which new academic fields like the environmental humanities and critical plant studies could also flourish. In January 2009, the establishment of *Antennae*'s Senior Academic Board, Advisory Board, and Network of Global Contributors has affirmed the journal as an indispensable research tool for the subject of environmental studies and visual culture. Still today, no other journal provides artists and scholars with an opportunity to publish full color portfolios of their work or richly illustrated essays at no cost to them or to readers. A markedly transdisciplinary publication, *Antennae* encourages communication and crossover of knowledge among artists, scientists, scholars, activists, curators, and students. Contact Giovanni Aloi, the Editor in Chief at: antennaeproject@gmail.com Visit our website for more info and past issues: www.antennae.org.uk

Front cover: *Moss*, 2020 © David Fox© Raksha Patel
Back cover: Pierre Deffontaines, Mariel Jean-Brunhes Delamarre, *Atlas Aérien*, Gallimard, 1955-1964 © Gallimard

*Antennae: The Journal of Nature in Visual Culture* (ISSN 1756-9575) is published triannually by AntennaeProject, Chicago. Contents copyright © 2020 by the respective authors, artists, and other rights holders. All rights in *Antennae: The Journal of Nature in Visual Culture* and its contents reserved by their respective owners. Except as permitted by the Copyright Act, including section 107 (fair use), or other applicable law, no part of the contents of *Antennae: The Journal of Nature in Visual Culture* may be reproduced without the written permission of the author(s) and/or other rights holders.

# contents

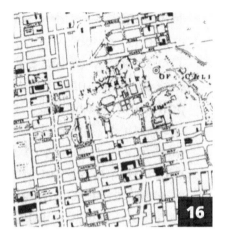

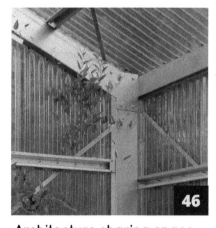

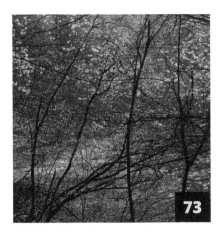

**73**

## Observing-intervening

text: **Dermot Foley**

Observing as-found conditions of ground and substrate can fine-tune our appreciation of secondary-raw-materials, as they interact with ecological processes. Foley's work is a response to the EU Waste Framework Directive (2008) and the EU Construction and Demolition Waste Protocol and Guidelines (2018).

**92**

## One True Time

text: **Louise Wright**

The 'weed' has in some settings adapted more quickly than it might have to a new kind of ecological niche – the urbanized environment of the Anthropocene – to complicate notions of place and endemism.

**96**

## Common ground

interviewee **Monica Gagliano**
interviewer **Mauro Baracco + Louise Wright**

Monica Gagliano is a pioneer in the research of plant cognition. Some of this work has focused on the ecological processes by which organisms are able to gather information on the variable conditions of their surrounding environment in order to thrive.

**102**

## Architecture as proto-ethic entanglement

text and images: **Christoph Solstreif-Pirker**

This artist portfolio builds on a performative investigation of Gruinard Island, Scotland, taken place in 2018. Having served as a testing site for biological agents during World War II, the island's soil and atmosphere remain a lethal environment for humans and non-humans.

**110**

## Architectures of becoming-animal

text: **Ron Broglio**

From childhood games to ancient cave paintings, animal representations across time and space offer us an affective crack in rational consciousness by which to slip into a larger-than-human earth and share affinity with a range of animal life.

**113**

## Westbrook Artists' Site

text: **Kevin Lair**

The mission of Westbrook Artists' Site (WAS) is to seek the creative potential in the rural post-industrial condition. It is an exploration of the tension between control and that which escapes or eludes our control, and it suggests how we may reconnect to the rural environment.

# contents

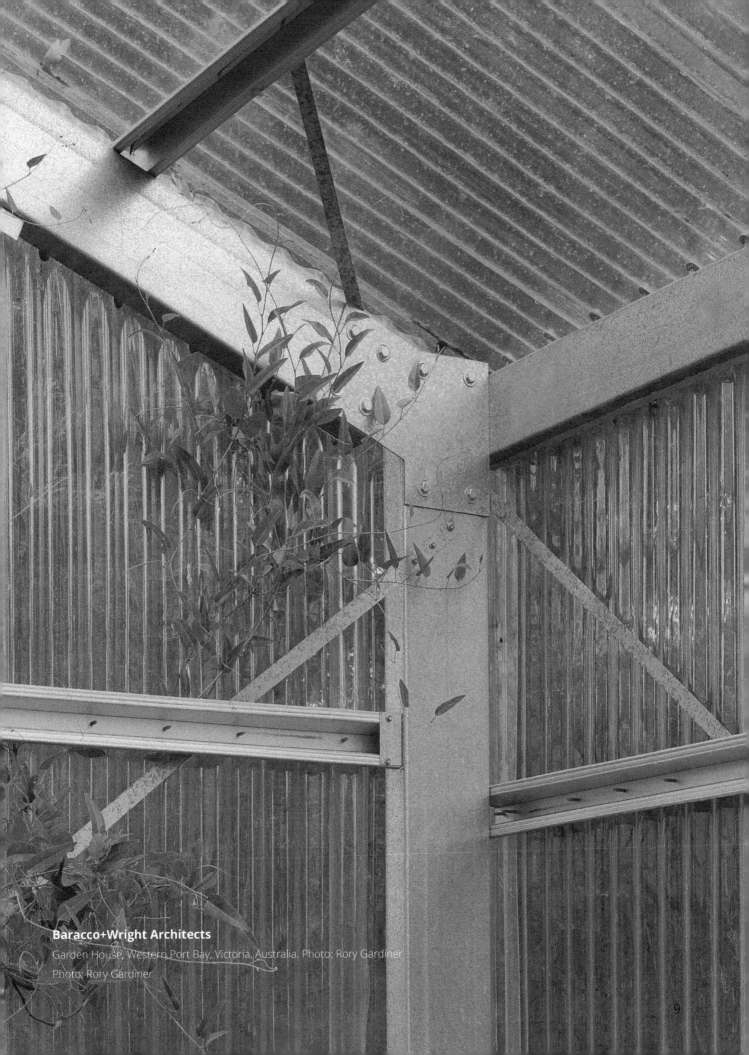

**Baracco+Wright Architects**
Garden House, Western Port Bay, Victoria, Australia. Photo: Rory Gardiner
Photo: Rory Gardiner

9

# editorial

**Giovanni Aloi**

As a child, any kind of urban animal encounter would make my day. In the 1980s, Milan was a gray city choked by factory smoke, and traffic. Its parks were too manicured for wildlife—lawns and pebbles shrunk biodiversity to pigeons, sparrows, rats, and dandelions. When you love nature but not much of it is at hand, any animal or plant will do. It's a survival mechanism. You learn to appreciate what others find irrelevant or don't see. You learn to look harder to appreciate the species that share spaces with us.

My family lived in a small apartment on the second floor of a modern block—concrete and rooftops as far as the eye could see. There was no garden. The courtyard was paved. We had a small balcony on which my mom grew some potted plants. This little oasis was packed with oleander, some echeverias, snapdragons, and jasmine; reminders of her youth in the South of Italy and the people she left behind.

On summer days, these plants would become my private wilderness. So much lurked among them: a line of ants, a caterpillar, a tiny moth, aphids, the occasional bee... and on what would become an unforgettable day, the fleeting visit of a cabbage white. Nature brought magic to a concrete jungle. I was never bored.

Luckily we lived on the Naviglio Grande, then a run-down, old-Milan neighborhood—today a trendy foodie and nightlife destination. Milan's canal network is one of the lesser-known historic jewels of the city. Built between 1179 (Naviglio Grande) and 1805 (Naviglio Paves), the canals supported commerce and made transportation of the marble of Candoglia (Piedmont), sed to build the Duomo in the city center. At the end of the 15th century, Leonardo da Vinci designed a system of dams that's still in use today. Architecture and engineering have defined the history of this city and its ecosystems. I quickly discovered that this ancient waterway was brimming with life of all kinds—one just had to look to see it. The locals kept saying there was nothing in the water because of pollution, but that wasn't true. I could often see sunfish and carp. On a good, sunny day I sometimes saw a pike. I guess back then I could not know that I was fish-watching—pretty cutting edge!

But the most exciting urban/wildlife was to be discovered in even shallower waters. Branching off the main canal was the Vicolo dei Lavandai (the alley of the laundresses) a disused and picturesque shallow canal—*a lavoir*— where up until the 1950s washerwomen scrubbed laundry on the stone stalls. During its heyday, the water would have been densely filled with soda and fats from the soap. I doubt any life could have thrived then. But what about now?

I began to spend warm spring afternoons sitting on those stones, observing. At first, small shoals of bleaks were all I could see. They would often shelter there, away from predators. The old terracotta roof cover protected them from birds. But undeterred, I kept returning at different times of the day— I stationed in different spots. By mid-summer, I would sit towards the rear stretch of the alley, where unkept vegetation framed the bricked banks. There, I saw a curious, lizard-like creature emerging to grab a gulp of air only to wiggle quickly back to the muddy bottom and disappear in a little cloud of silt. I leaned over the water to see more clearly. My reflection was in the way. It appeared again. Four legs and a long tail. A brownish olive color. I thought, can this be... a newt? Consultation of some manuals revealed it to be *Lissotriton vulgaris,* (tritone punteggiato), a species of newt that technically should not be found in Milan simply because the urban environment lacks the environmental character-

istics this animal needs to thrive. But there it was. And it was not alone. I soon noticed more. It was a colony. At any given time, during that summer, up to twenty or thirty newts could be seen searching the narrow canal bed for food, zipping up to the surface for a gulp of air, and rushing down to safety over and over. Then they began to mate. I could see the males wriggling their tales to attract females. A couple of weeks later, minute tadpole-like creatures began to populate the canal's stagnant waters.

And the newts weren't alone. The fifteen-yard-long "cul-de-sac canal" was a true micro-ecosystem in its own right. A few frogs also lived there. Cabbage whites would regularly visit the dandelions that grew by the banks and the white blooms of *Cymbalaria muralis* that filled the gaps between the bricks. Spiders wove their webs there too. A jasmine wrapped around a nearby house filled the air with its intoxicatedly-sweet scent. The water and the flowers attracted all sorts of flying insects, from flies to bees, and wasps. Moths would come by at dusk.

By mid-summer, mosquito larvae could be seen wriggling on the water surface. It was the banquet newts had been waiting for. But the heat also brought dragonfly larvae that would feast on newts and tadpoles. So much life and death unfolded, daily, away from the eyes of unsuspecting passers-by. The near-stagnant, shallow waters of the *lavoir* provided the perfect environment for a multitude of creatures that could have not lived elsewhere in the city. For a few years, I spent most summer afternoons there. Time would fly by. I studied for my final exams there, sitting on the laundresses' stone slab, often taking a break to smoke a cigarette and look into the water some more. To this day, I don't know anyone who's aware of the micro-ecosystem in the Vicolo dei Lavandai. There is no mention of it online. But the newts are still there and the last time I had the chance to sit on the stone slab for a while, I also saw frogs and dragonflies.

Milan has changed a great deal since I left in 1997. The grey city I knew is much more ecologically minded. A showy sign of its newly found will to embrace nature is manifested in the internationally acclaimed *Bosco Verticale* (Vertical Forest) towers designed in 2009 by Boeri Studio. Inspired by Italo Calvino's novel *The Baron in the Trees* (1957), in which the protagonist abandons his life on the ground to move up into the trees, *Bosco Verticale* is part of a redevelopment project for a once run-down northern area of the city.

The two towers of 18 and 26 floors house 800 trees, 5,000 shrubs, and 15,000 perennial plants, which help mitigate smog and produce oxygen. The buildings are powered by solar energy and wastewaters are redirected to support plant life. As Boeri says, "It's very important to completely change how these new cities are developing. Urban forestation is one of the biggest issues for me in that context. That means parks, it means gardens, but it also means having buildings with trees".

The preliminary studies involved collaborations with ecologists and botanists. Boeri was not only concerned with aesthetics but with establishing urban ecosystems for insects and birds. While it has been reported that the buildings teem with animal life, it is also worth acknowledging that residents, mostly hyper-rich footballers and celebrities who spend their time elsewhere and have no direct interaction with the plants. The buildings are not designed to educate the residents about the ecosystems that wrap around their homes. So, the green is maintained by a team of gardeners who care for the plants 24x7. While energetically self-sustaining, *Bosco Verticale* is far from being sustainable or inclusive in economic terms—at €15,000 per square meter, it is one of the most expensive and exclusive urban realities in the city.

While Boeri's project is a powerful statement about the ways in which architects today think about the relationship between nature and the built environment, *Bosco Verticale* also poses pressing questions about the costs of rewilding our cities in creative ways. It ultimately reproposes a contemporary conception of nature as luxury. The selection of plants complies with a capitalist-iconography we are already familiar with; an iconography that reassesses the separation between nature and culture. We might want to call this a bosco, but the vegetal reality that wraps the two towers designed by Boeri is, ecologically speaking, very far from being one since its reliance on constant maintenance and manicuring prevents a true exosystemic

balance from developing. Perhpas *Giardino Verticale* would have been a truer name?

*Bosco Verticale* and the Vicolo dei Lavandai propose two very different examples of urban ecosystems. One is architecturally designed and engineered to invite non-human life, the other incidentally invites non-human life by providing an ecosystemic niche; one requires expensive maintenance while the other thrives on our neglect; one is a celebrated example of architectural futurity, the other a nearly ignored ruin of the past.

It seems to me that the challenge involved in truly re-thinking our urban ecologies might lie somewhere in between these two extremes. It is in this spirit that this issue of *Antennae* titled 'Spaces and Species', aims, in the words of co-editors Linda Tegg, Mauro Baracco and Louise Wright, to "ask architecture to reframe what it does best – to make careful relationships between things – this time with other species. The observation this requires – reflected in this issue – is aligned to practices of listening over processes of objectification as a precursor to acting *with*. We seek more diplomatic ways to conduct ourselves in the shared environment to find the gestures and patterns of living that enable us to follow those we live amongst". Architecture has for thousands of years mediated our relationship with the nonhuman and the land. Delimiting, separating, excluding, and isolating—at times architectural structures have implicitly reinforced the nature/culture dichotomy that has not only defined our daily activities but that has shaped our anthropocentric conception. This issue of *Antennae* features the contributions of artists, architects, and scholars whose practices help us to re-envision our relationship with the spaces and species that make up the interconnected world we live in.

As always, I am particularly grateful to the co-editors, the contributors, the academic board, proofreaders, and all others who have helped in making this issue come to life.

**Giovanni Aloi**
Editor in Chief of AntennaeProject

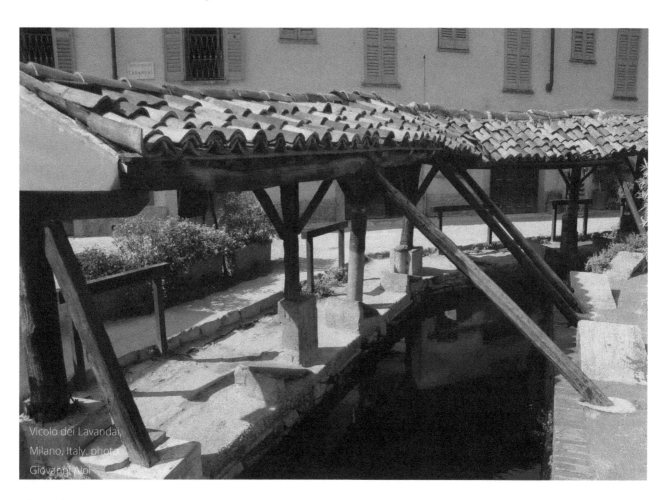
Vicolo dei Lavandai, Milano, Italy, photo Giovanni Aloi

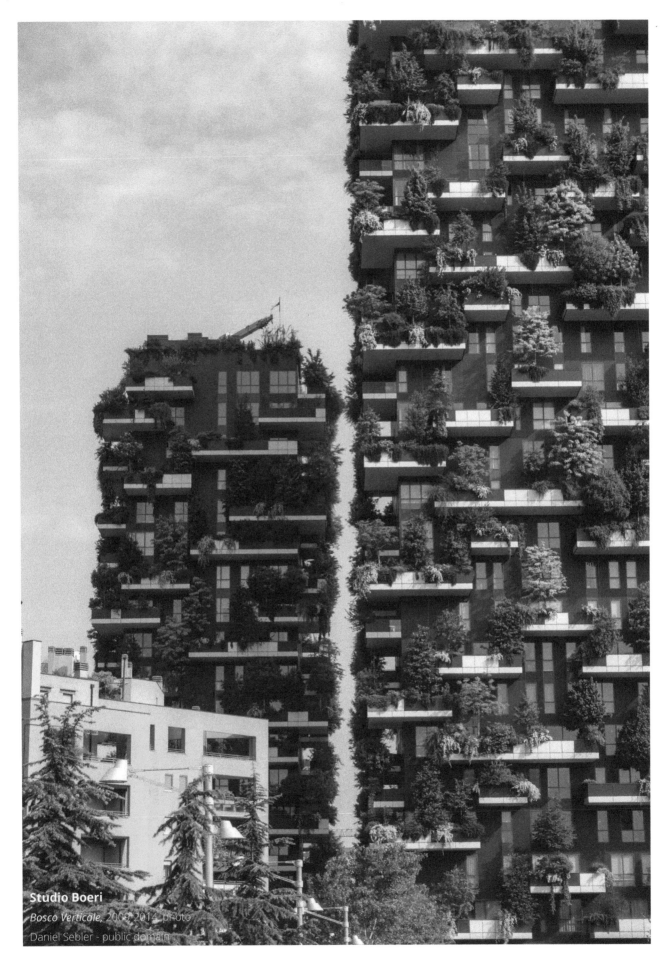

**Studio Boeri**
*Bosco Verticale*, 2009-2014, photo
Daniel Sebler - public domain

# introduction

**Louise Wright, Mauro Baracco and Linda Tegg**

*Spaces and Species* moves in small shifts of perception around the coexistence of the biotic and abiotic. It accepts and observes the spaces of urbanisation and the life they support; wonders about a reframing of architecture through these same life sustaining qualities and the ontological shift this requires towards spaces *for* species.

Primarily a coexistence occurs at the site of the ground, or at the creation by architecture of a terrain, sometimes vertical, where we find a promise of architecture in its ability to create more ground than it displaces. In this promise the surface is a consistent agent – both the site of symbiotic existence and of the separation at the question of architecture's ontology.  And, once removed from its first act of displacement, coexistence occurs side by side where the two modes of biotic and abiotic are in a dependant relationship of shade, light, sediment, moisture.

Perec's 1974 *Espèces d'espaces*,  *Species of Spaces* (*and Other Pieces*) sets out phenomenological observations of the spaces *we/he* live in and move through with their own qualities and dimensions in order to bring them into being as *spaces* at all.

Perec might have been writing for this issue of *Antennae* when he wrote "there's nothing, for example, to stop us from imagining things that are neither towns nor countryside (nor suburbs), or Métro corridors that are at the same time public parks".[1]

The focus on space itself is shared, this time reframed from types defined by human use and experience to *knowing,* or in architecture's case, an *unknowing* – that positions architecture at the centre of a destabilising of what might be inside or outside, nature or culture. This ontological opening asks architecture to reframe what it does best – to make careful relationships between things – this time with other species. The observation this requires – reflected in this issue – is aligned to practices of listening over processes of objectification as a precursor to acting *with*. We seek more diplomatic ways to conduct ourselves in the shared environment to find the gestures and patterns of living that enable us to follow those we live amongst.

We are grateful to *Antennae* and its academic board which, outside of the usual frames of architectural discourse, have provided a platform for a diversity of voices and perspectives to wonder about architecture's relationships with the living world. And, many thanks to all the contributors and collaborators.

### Endnote

[1] Georges Perec, *Species of Spaces and Other Pieces*, Editions Galilée, 1974, Penguin Books, 1997, p. 5.

Mauro Baracco, Linda Tegg,
and Louise Wright  photographed
by Rory Gardiner, 2018

# Natural History of Vacant Lots

Matthew F. Vessel and
Herbert H. Wong

# Vacant lots

*In 1987, Vessel and Wong showed us that vacant lots aren't really vacant: a surprising number of plants and animals live in the left-over spaces in our cities. This work could be considered the beginning of an understanding of how novel ecosystems are facili-tated by the urban environment. We see again how terms such as vacant, empty, left over and void characterize our overlooking of nature. As we begin to redefine the urban form of the post-industrial city these sites could come into consideration as spaces for species.In this book a map documented the extensive vacant sites around the Berkeley, California, area in 1977. We have remade this map 44 years later.*

text by **Louise Wright**

Before Gilles Clemént *Manifesto on the Third Landscape* (2004) or Lois Wein-berger *Das über die Planzen/ist eins mit Ihnen* (1990-97), Vessel and Wong asked us to look anew at the ecosystems of vacant lots. Displace-ment and reclamation were revealed where we otherwise saw an urban void.

"A town or a city is a disturbed natural area modified drastically by hu-mans to accommodate their own needs... the number of vacant lots is surpris-ingly large in most communities".[1]

In this ground-breaking book, careful observation records the habitats and lives lived on vacant lots without comment as to their *correctness*. The spe-cies that form an ecosystem are considered endemic to the lot and cardboard boxes, cans, tires, and jars are all places of *habitat* worth. With rigour, plant species, invertebrates, seasons, insects, food webs, predators and plant adaptation are all documented. Over 270 species, most unable to live where a building is, are record-ed including multiple species of nightshades, thistles, fungi, ferns, grasses, roses, peas, mallows, dragonflies, cockroaches, termites, grasshopers, crickets, butterflies, flies, moths, beetles, ants, wasps, hornets, bees, snails, slugs, spiders, toads, sala-manders, lizards, snakes, birds, and mammals such as rats, mice, moles, gophers, squirrels, racoons and coyote. We can *see* them.

In a reversal of the architectural figure ground drawing, in 1977 the vacant lots in the Berkley area were recorded. We have updated this map to 2021.

### Endnote
Matthew F. Vessel and Herbert H. Wong, *Natural History of Vacant Lots*, University of California press, 1987, p.ix

**Matthew F. Vessel** (1912- 2007) was a Professor Emeritus of Natural Science at San Jose State University.  He gave biweekly Science Radio Broadcasts for the San Mateo Schools (1946-1952) and was dedicated to teaching science to elementary teachers.

**Herbert H. Wong** (1931-2019) was a Professor of Environmental Education at Western Washington State University and Lecturer at the University of California, Berkeley. He created an award-winning environmental education site by moving the asphalt from the schoolyard and letting the children turn it into a garden.

Together they co-authored numerous children's books on science, including two environmental series that were adopted by the State Department of Education.

# N

Vacan
numb
over s
guide
tenac
and o
the li
the u
our d
natu

ence
intro
lots.
parki
turbe
ters
and
areas
by h
sects
adap
esta
food
tions
ing
settl

and
tify
sugg
tion
teac
obs
guic
ifor

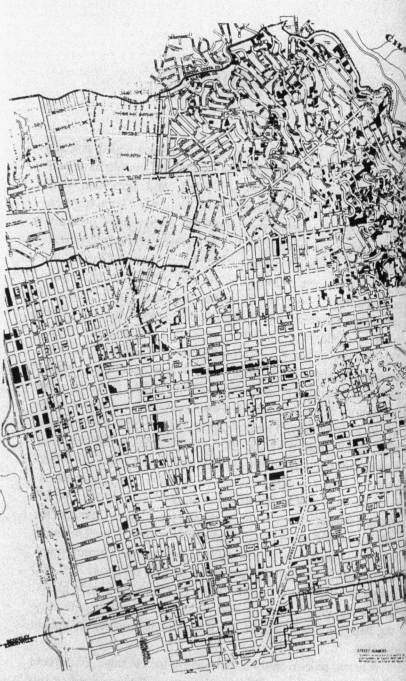

FIG. 1 Vacant lots in a built-up city area—indicated by black rectangles. (Berkeley, California, 1977)

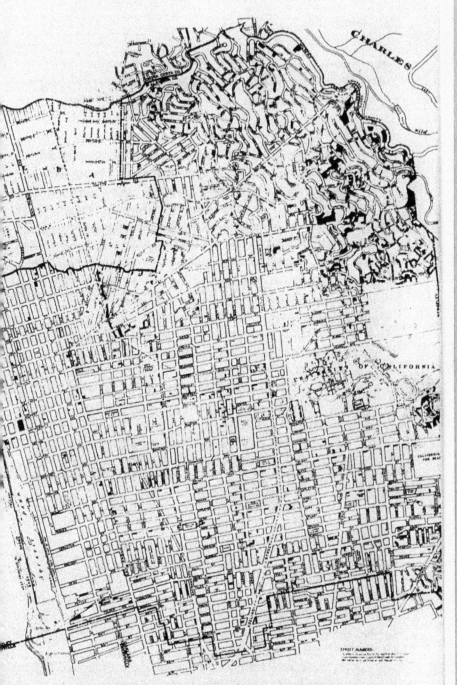

FIG. 1  Vacant lots in a built-up city area—indicated by black rectangles. (Berkeley, California, 2021)

**Matthew F. Vessel
and Herbert H. Wong**

Left, map, 1977, indicating with black dots vacant lots in the Berekely, California area from Vessel, Matthew F. and Wong, Herbert H. Natural history of vacant lots. Berkeley : University of California Press, 1987,  with illustrations by Pamela Vesterby, p. x., and right, map of same area and vacant lots, 2021, prepared by Baracco+Wright Architects.

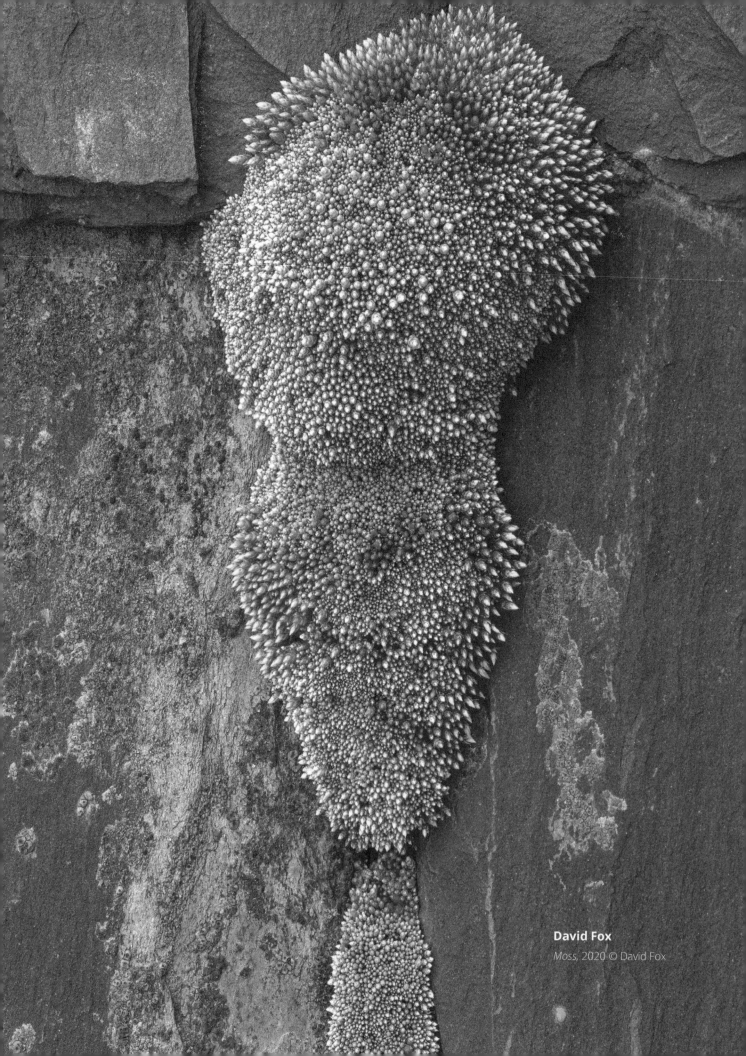

David Fox

*Moss,* 2020 © David Fox

# Moss

*As the city of Melbourne, Australia, attempted to suppress Covid-19 with a lockdown, David Fox found an abundance of life close to home. With forensic clarity, Fox's photographs present moss thriving within the mineral fabric of the city.*

text and images by **David Fox**

My only real process for photographing spontaneous plants is to look. The plants are not unique or special in any way. They are simply there. And I am simply looking, taking the time to stop and focus on what is usually ignored.

There is an intense beauty to the resilience of such plants. Despite all we do to assert ourselves over them, to control or destroy them, they persist, finding the cracks and spaces where they can grow and assert themselves.

Previous expeditions have been defined by an expansive wandering. I have spent days traipsing over the city, searching for the locations where the plants I seek may have found a space to grow. With moss, it was the opposite. My range, already reduced by the lockdown of Covid, shrank even further as I learned to focus on the minute and began to peer into the tiny divots on the surfaces of brick, stone, and concrete. More time was spent crouching in the gutters around my home, than out searching the streets and vacant lots of the city. And like all our lives in the last year, my world become smaller.

Perhaps the most surprising example for me was the low stone wall I have walked past hundreds of times and never noticed. After a day of heavy rain, it was luminous with green, and I was shocked that I could have missed such a stunning display. A few days later, walking back past the same site again, it was gone. And it was only then that I looked closer, to realise that it was still there, dull, and dormant, but still alive, waiting for the next rains to bloom again.

**David Fox** works between art and design. His open approach has seen his work connect into a wide range of creative fields including fashion and architecture. David's work is marked by a dedication to craft across an impressive range of media, technologies and systems. Recent collaborative works have been showcased at the Venice Architecture Biennale, 2018 (with Linda Tegg and Baracco+Wright Architects); Milan Design Week, and Barneys New York City, 2019 (with Jil Sander).

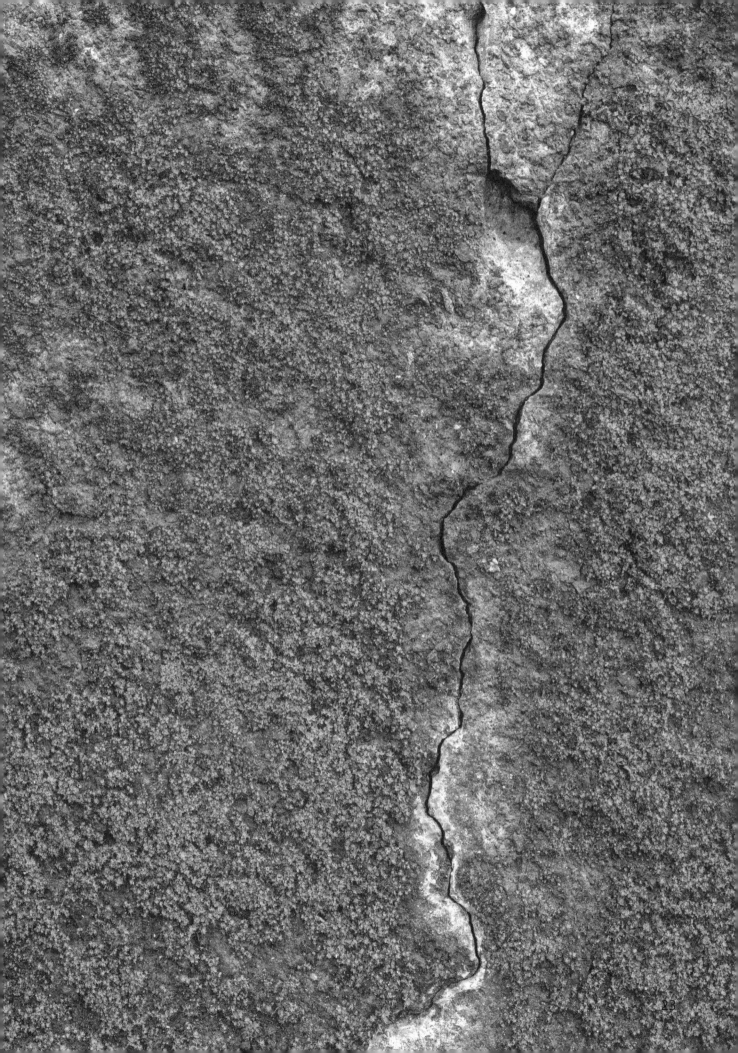

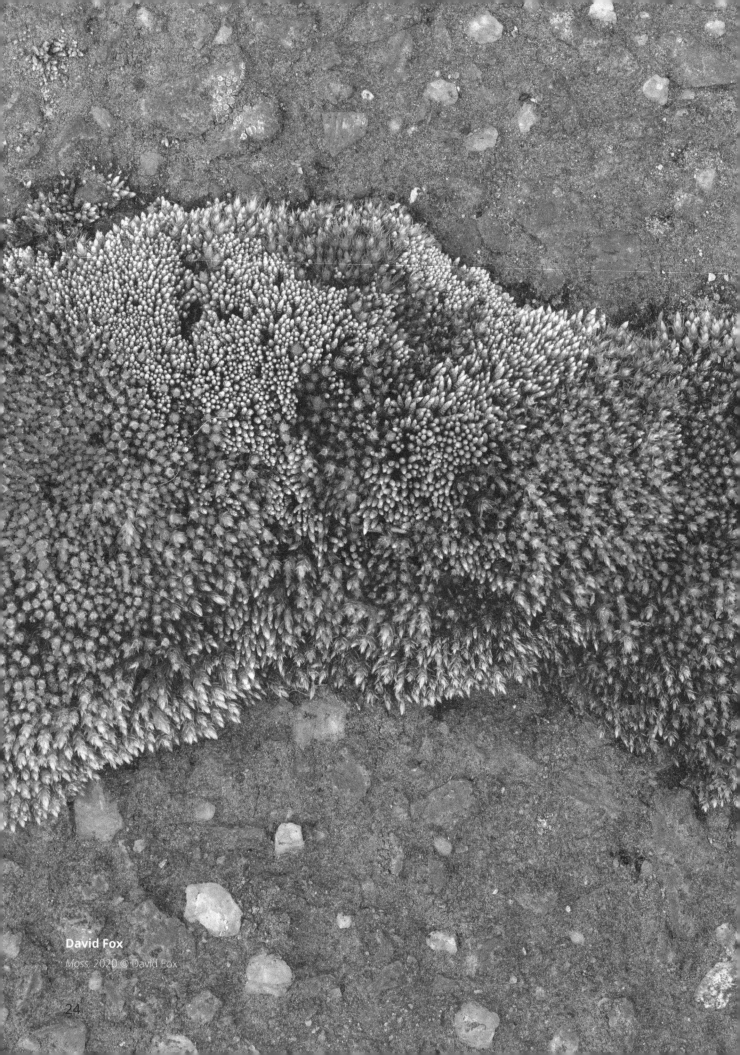

David Fox

*Moss, 2020* © David Fox

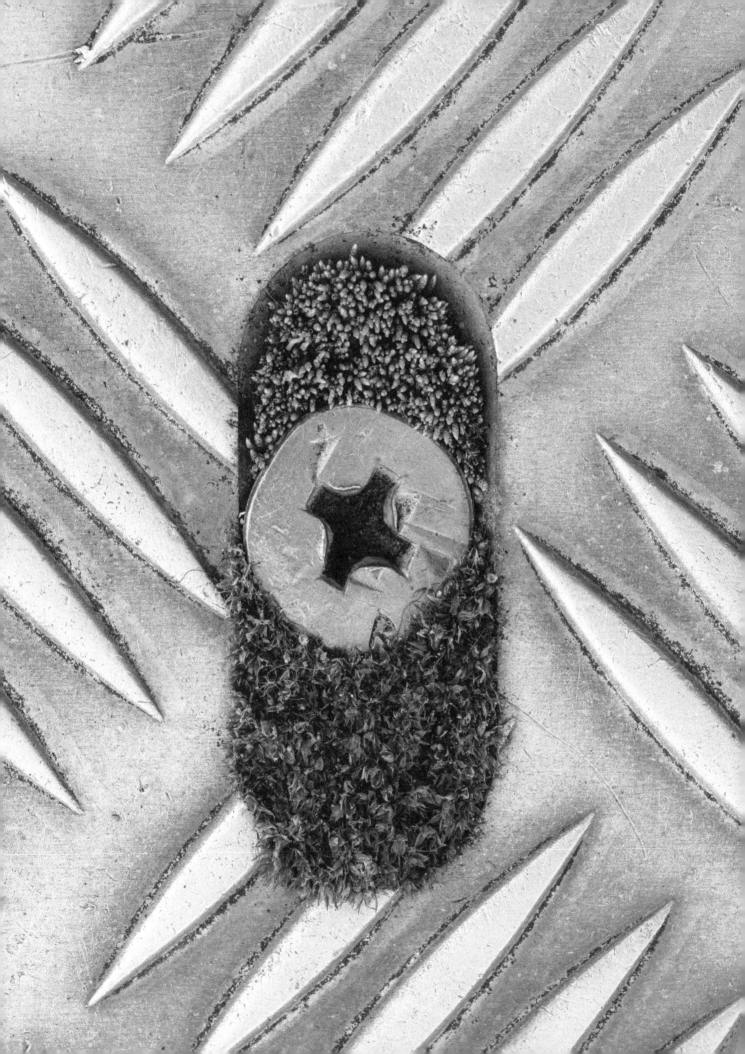

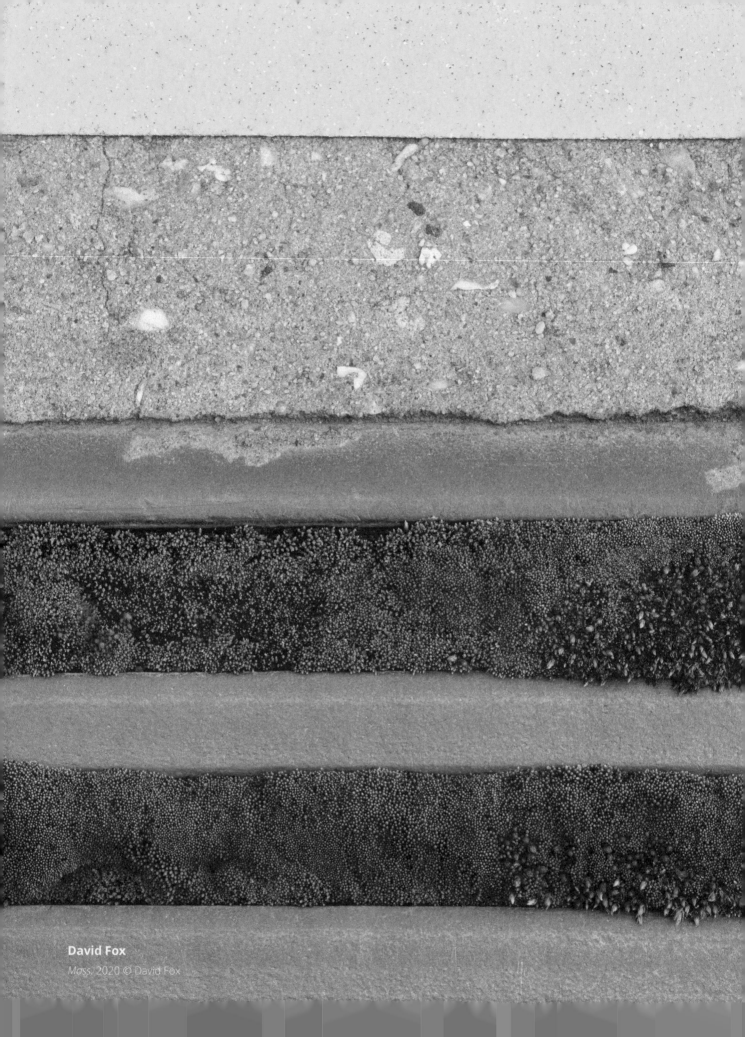

**David Fox**

*Moss*, 2020 © David Fox

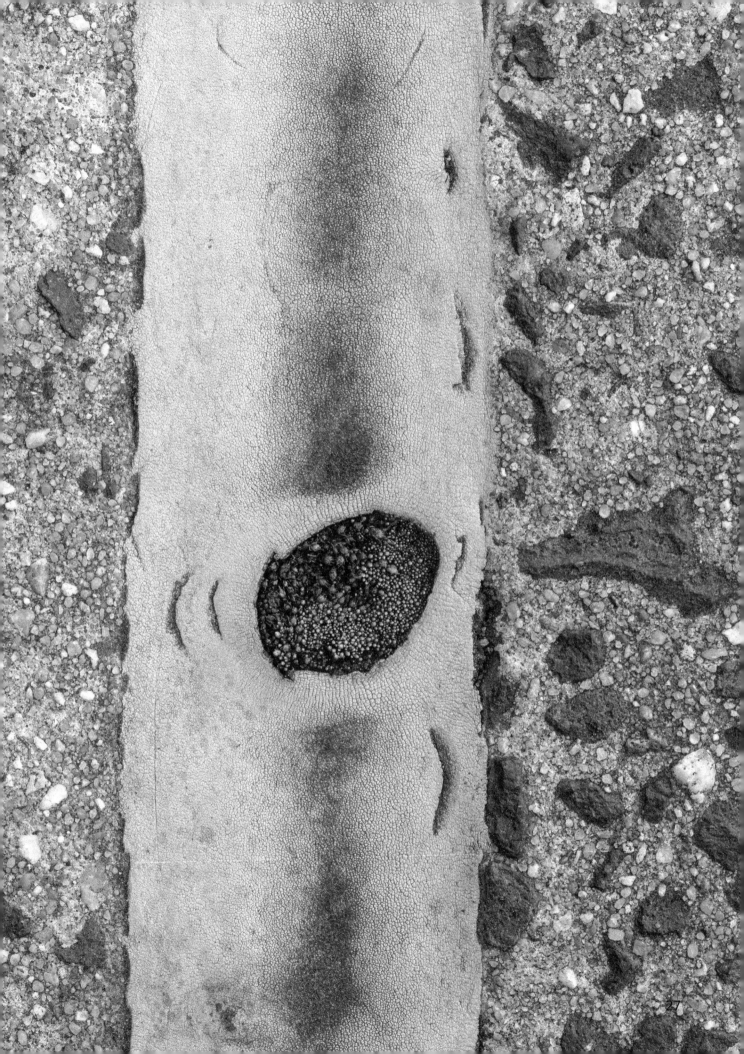

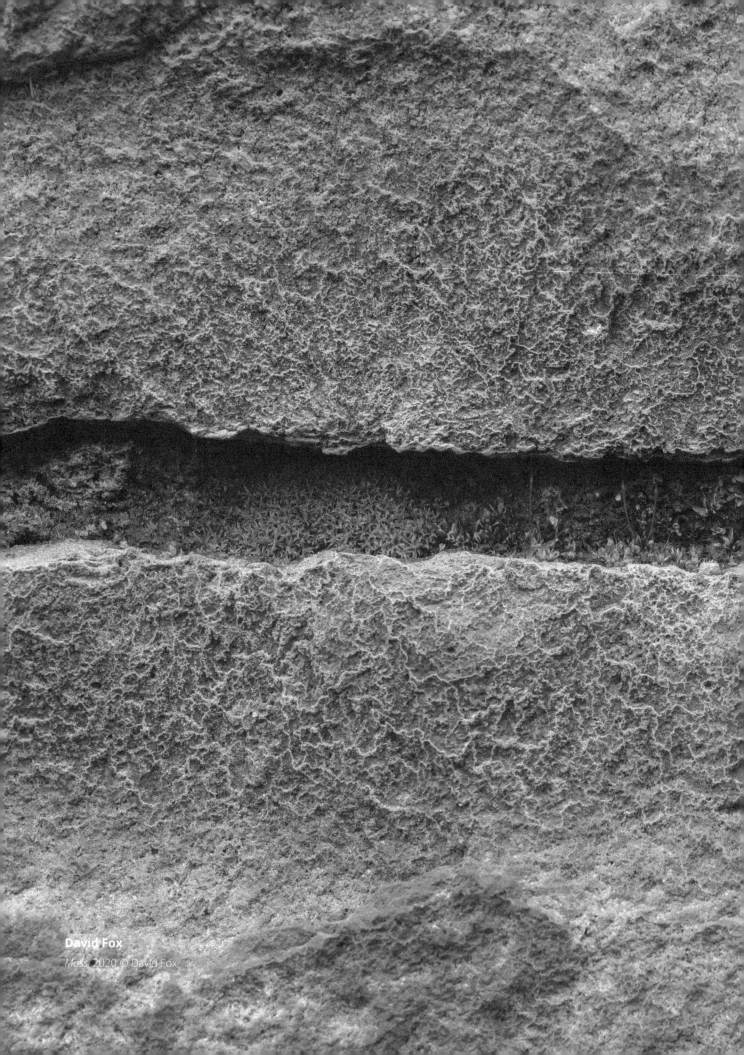

David Fox

*Moss, 2020 © David Fox*

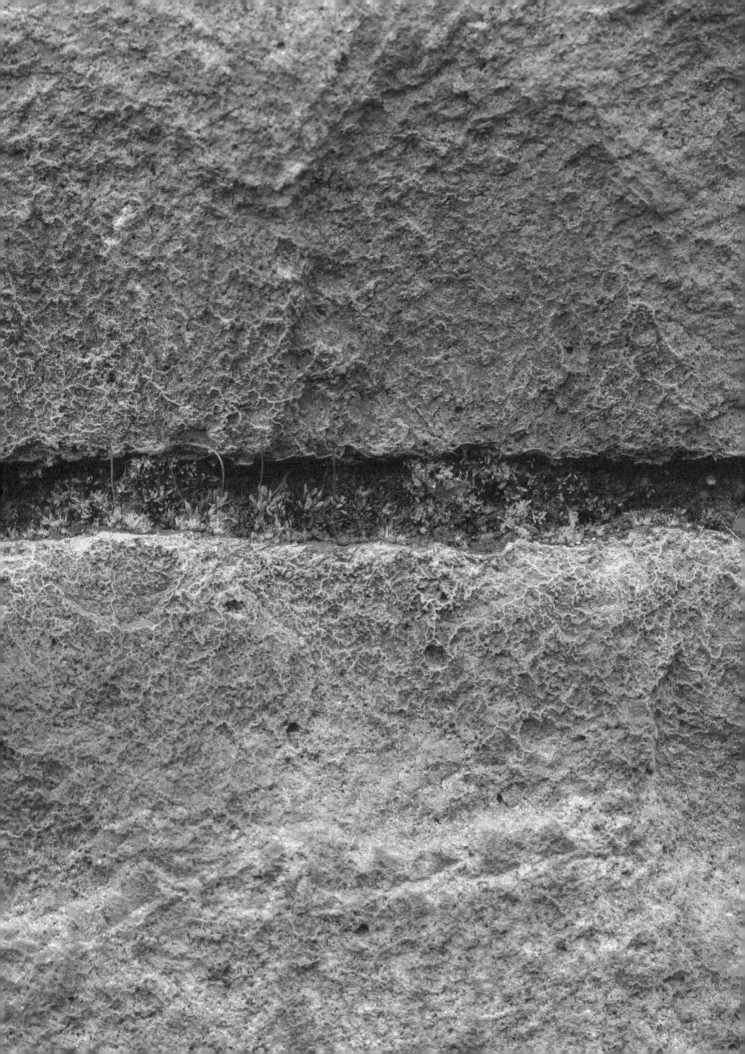

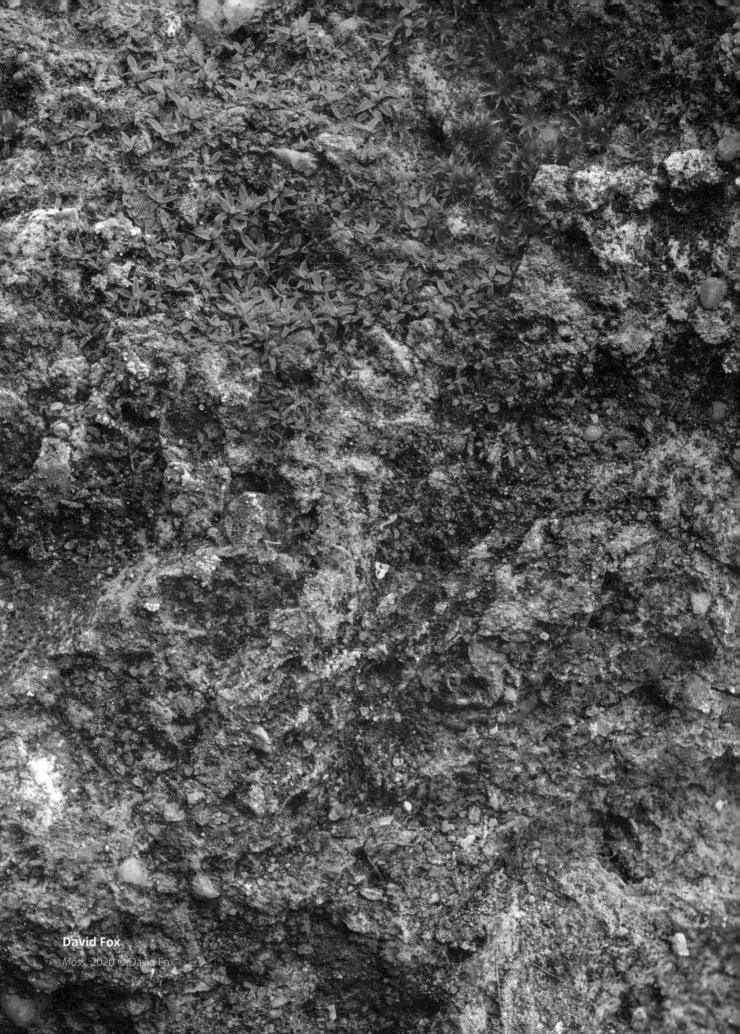

David Fox

*Moss, 2020 © David Fox*

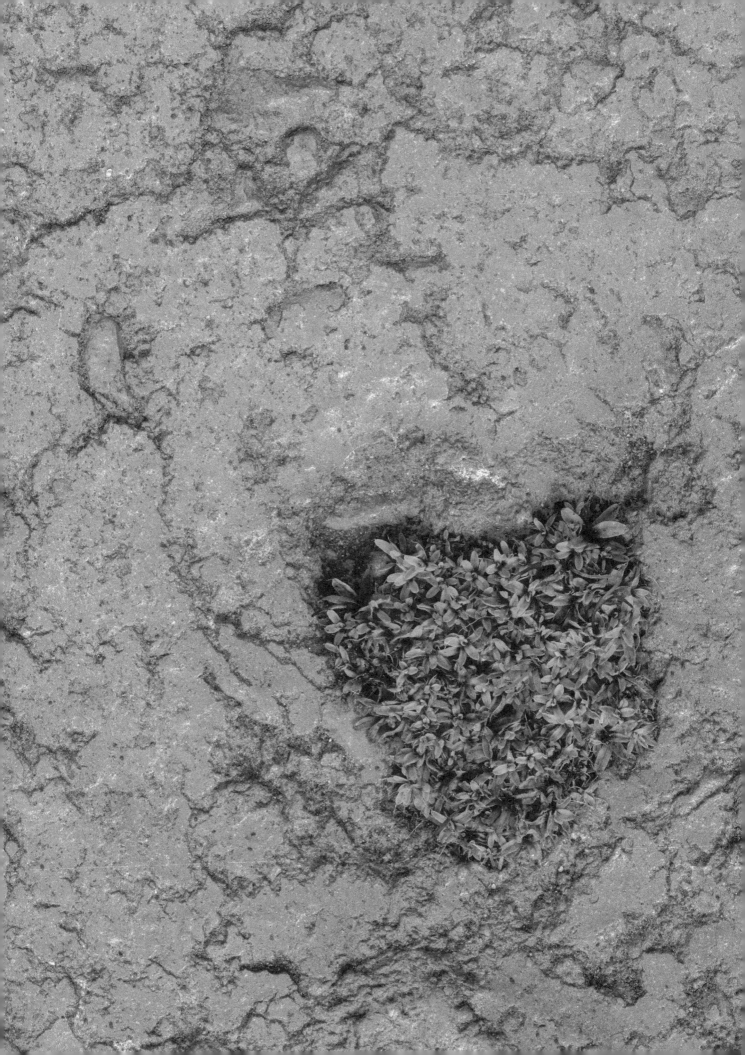

# Up here from high is Nura [Country]

*Budawang woman of the Yuin nation, Danièle Hromek, lives in a 'birdhouse' where she can see the forms and shapes of our Mother Earth, otherwise unavailable on the ground in urban spaces where the flows and shapes of Country have been smoothed off by colonial processes that flattened surfaces, removed landmarks and put concrete, asphalt and glass on top that weigh it down.*

text by **Dr Danièle Hromek (Budawang/Yuin)**

It can be hard on the ground in urban spaces to read the flows and shapes of Country – the landscape has been smoothed off by colonial processes that flattened surfaces, removed landmarks and put concrete, asphalt and glass on top that weigh it down. But I live in a 'birdhouse'. I live on the top of a hill on the almost-top floor of an apartment building in central Sydney. From here looking out from above, underneath the layers of urbanisation, you can almost see the Country Sydney lies within is composed of sandstone coastal outcrops, ridges and coves, mangrove swamps, creeks, marshes and tidal lagoons.

I am a Budawang woman of the Yuin nation. We believe the earth is our mother, that Mother Earth birthed us and continues to nourish us. From my 'birdhouse' you can see the forms and shapes of our Mother Earth, even if her nourishment for us now comes in different ways in than it used to in this place. From here you can see Father Sky giving us a different sky painting every moment as the winds move the clouds across the blue skies, becoming all shades of grey, pink, yellow, orange and purple and occasionally letting their precious rains fall. From here you can see Grandfather Sun rising every morning bringing warmth and light, giving us the gift of starting every day anew. And from my 'birdhouse' you can see beautiful Grandmother Moon, as she moves the waters in the harbour, but also in the female body, reminding how intrinsically connected we are to the lands, the waters and the skies of Country, as this is also how we recreate.

Up here on high, I am also reminded this Country is still cared for. First Peoples still carry out cultural practices that ensure care of this Country – as do more-than-humans. Birds, bats, possums, lizards, skinks, spiders, caterpillars, ants all still take seriously the actions of responsibility given to them through the Laws written during the Dreaming, the Laws of the land, the Laws that humans cannot change. The movements of those more-than-humans for whom the air is their domain are particularly evident from my 'birdhouse'. The garraway [sulphur-crested cockatoos] tear down piece by piece the building in front of mine, I like to think of it as their slow but persistent resistance to colonisation, though I am sure the so-called owners of the building do not see it that way. At my eyelevel the wirambi [bats] silently glide on mass from their places of rest during the day to their feeding places at night as they have always done forever. Warin [rainbow lorikeets] screech through the air in gangs between and over and around buildings, alerting all to their presence.

Sometimes these more-than-humans visit my 'birdhouse'. The marrayagong [spiders] and I have agreements about where they can live in the apartment and most-

ly that agreement is kept, only occasionally do we have words about incursions in each other's spaces. Some birds visit my balcony too, attracted by the insects that live in the balcony plants. They sometimes sit for long periods looking out at the Country below with their backs towards me. I wonder what they see through their ancient cultural memories? Do they see the missing old grandparent Turpentine-Ironbark trees – now a threatened species – that used to inhabit this ridgeline? Do they mourn that Country, like I do? Do their songs and sounds still carry the stories of that Country perpetually in memory and voice, as it is held in the core of First Peoples?

I like to think so.

*Please note that anything I write is part of my Indigenous Cultural Intellectual Property, and as such it is not ownable by anyone other than me and my family, and even we are simply temporary custodians.*

*All language words used above are Dharug. I give my thanks to Uncle Greg Simms, who has been teaching me languages from the Sydney area and beyond, as well as those who work to recover Dharug language (also called the Sydney Language and Gadigal Language) including Jakelin Troy, Aunty Jacinta Tobin, and the recently late Uncle Richard Green.*

# A yarn between two spatial practitioners

*A yarn between Louise Wright and Danièle Hromek, held remotely and temporally over several months during the winter and spring of 2020 – or how Danièle's Elders from the South Coast in the Dhurga language call it, dhagarwara (winter) and gambambara (spring) – of the continent now known as Australia. Yarning is a recognised research method that is a culturally appropriate way of conversing with Aboriginal people. Yarning allows meanings to come through in culturally safe conversation, and is a means of sharing knowledge and creating connections. Yarning is informal and unstructured and allows the story to flow and the participants to travel together through narrative and time to places. This yarn, among other things, wonders about the coming together of two worlds of Country and architecture. The tone gradation represents linear time, the lighter being most recent. Tracing this process Linda Tegg rendered the coming together of the yarn into various forms. A simple line drawing provided the logic for how the yarn was assembled on the page.*

conversation between **Danièle Hromek  (Budawang/Yuin) and Louise Wright**

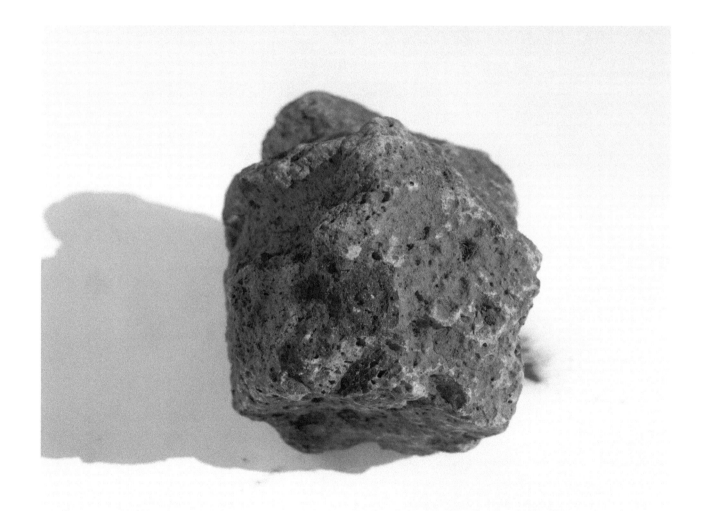

**Louise Wright**
*Basalt Floater,* remnant boulder buried under ground of the volcanic flows of Melbourne Australia.

**27 August 2020**

**LW:** I respectfully acknowledge the Wurundjeri peoples of the Kulin Nation, the Traditional Owners of the land I live on also called Melbourne, and pay respect to their Elders, past and present and commit to care for this land.

**DH:** It is always an honour to stop for a moment and think about the land and those First Peoples who have been forever connected to that place. Taking that moment is part of my personal contract between me and Nura [Country] that I will act with care and humility, and walk – and work – lightly with Nura. I give my thanks to Elders and Knowledge Holders who work tirelessly to keep stories and knowledges alive, in particular to the Gadi people on whose lands I live, work and love. I also give my heartfelt thanks to my own Elders who did whatever it took in order I could be here now. I stand on their shoulders.

*To be clear, when I talk about Country, I am not describing the areas outside urban centres, nor am I meaning the countryside. Country incorporates land, ground, space, site, environment and includes the land, waters and sky. Country is more than a place on a map, it is alive and sentient and, for First Peoples, it is our lived experience and a relationship. Country binds us to our place of origin through our ancestral, genetic, physical and narrative heritages. Country holds all our Laws, knowledges, languages safe for future generations and is also therefore our potentiality and capacity to change and create. Country is geology and geography, it is landscape and terrain – none of which is empty or wilderness as for First Peoples – it is all interconnected, it is all important, and it is all full of story. Likewise Country in urban centres is just as important as the countryside, and for First Peoples regardless of whether cities, towns, roads, fences or other constructions are built on top we can achieve healing through our connections to Country. Of course, like all relationships, our relationship with Country can be affected, and certainly colonial forces (including the colonial force of architecture) have impacted our capacity to access Country and maintain connections. However, rather than being earned or owned, Country is inherent, gifted through our heritage as Indigenous peoples. Therefore, like all relationships, our relationship with Country can be recovered and strengthened.*

**DH:** I have been thinking about the tradition of Acknowledgements of Country lately. I know they have become the 'done thing' – and it is really important they are done things. However when my Elders have talked about where they originated – that being they are based on an ancient tradition which situates us in a living reciprocal action between people, narrative and Nura [Country] that in effect ensures the care of Country and safe journeys of people. Knowing that origin has made me wonder if they need to be done better, in which they contain real commitments to take actions to care for Country. Does this commitment need to be the starting point of all projects in the built environment? As if they start from the first sentence with this commitment of care, maybe there is more of a chance Country will be part of the project from beginning to end – and beyond the life of the project.

**LW:** In his introduction to *Architecture in the Anthropocene*, Etienne Turpin proposes the outcome of the geological reformation as an erasure of a division between nature and culture. This division does not exist in Indigenous culture, resulting in a co-belonging.

> In this edition of *Antennae*, Mauro, Linda and I are wondering about how architecture can be more inclusive and less damaging, and have chosen to use the lens spaces for species, to centre around architecture's physicality in the world.

Architecture often separates us from nature (the ground, sun, wind, water, insects and so on). But if we focus on architecture as experiential, it may be able to connect, or co belong to a sort of flat ontology of 'space' and objects, a oneness. This relies on architecture being conceptualised as defining space, rather than being an object, and therefore co-belonging with 'space'.

> I speculate that this spatial knowing is one way to change how to think architecture, because it inherently requires including Country rather than something to be separated from.

**DH:** Indeed, understanding ourselves, humans, as one part of the system of Country, no more or less important than a blade of grass or a faraway star in which we are responsible to the blade of grass and the faraway star as much as we are to our own needs places us in a different space. That connection and placement within this understanding of Country also challenges ego and greed, so often the drivers for decisions being made not only in our professions but also more broadly. In this way co-being or oneness can be part of the process.

**LW:** Birdhouse brings together the two worlds you live in, one recent, urban and Western, one of Country and deep time. Your description of how you experience Country from your 'birdhouse' suggests that the building has perhaps been an enabler in connecting you with these aspects of Country, including time.

> **DH:** It has, though only needed because colonial processes meant this Country has been changed so dramatically that in many ways from above is the only way I can access Country – but what a gift to have that access still! Sky Country is such a special way of relating, it is so vast, so complete, so giving; every day Father Sky showing a new character, every night Grandmother Moon reminding me I have the capacity to create within myself.

**LW:** Architecture is part of Country, at least in its physical presence. It is a reality of Indigenous living culture. If I understand that the 'natural' material world is a mediation of ancestors, objects and features in the landscape that are intrinsic to identity. Both subject and object. A oneness. As opposed to Western Cartesian dualism. In which case to build on top of the land, flatten it, seal over it with concrete or scrape it away has posed no cultural problem for say Australians of European descent and let's say, the architecture its culture has created. Is there a way for architecture to shift closer to being a meaningful part of Country?

**DH:** I think we – those working in the built environment – have to strive to become a meaningful part of Country rather than demolishers of the landscape. Architecture has not substantially changed its processes or practices since it arrived in now-Australia, at least not in relation to Country. We talk about sustainability and yet we still create in excess of 20m tonnes of construction waste each year in now-Australia alone. We need to become more light-footed in our responses, push ourselves and our clients to seek out processes and materials that are less impactful. We need to find ways that Country and culture are embedded in our designs from the first moment, not just a Welcome to Country at the opening. Materials come from Country, they are removed from Country and often dispossessed long distances away from their homelands, how is this sustainable over the long term to keep moving parts of Country around the nation, or even globe? We – architects, planners, designers, builders – have to build our own personal relationships with Country in order we can design responsively. Until then, we are not truly going to have a so-called "Australian" architectural vernacular; we are just building replicas of distant places.

**DH:** I spent time with one of my gorgeous and wise Elders recently, Uncle Greg Simms, and he was talking about conservation. It occurred to me that our profession has a really really long way to go to truly be sustainable. To a certain degree we are asking the wrong questions. The first question we need to be asking is, how can we live here in this place forever? I think Country and Indigenous peoples answered this question and had been living that outcome for countless generations of people before colonisers came along and forcibly replaced their ways of being, laws, land practices and spatial paradigms with British versions of these, and we have been living with those since. So what do we need to learn to be sustainable in the built environment professions? This is what my Elder says he was taught by the Old People about conservation: Always show respect, acknowledge, never be greedy and always share, don't take too much too much from the water or the bush, and always listen. If these principles became practices of sustainability could they change our profession from being one of the most wasteful? Globally construction is believed to be responsible for up to 50% landfill waste, 50% of climate change, and 40% of energy usage,[1] without mentioning the destruction of biodiversity and habitats as well as air, water, and noise pollution. The world is forecast to build 230 billion square meters of new construction over the next 40 years – the equivalent of adding Paris to the globe every single week.[2] That immediately indicates we are completely missing the first principle Uncle Greg mentions of showing respect, let alone the challenge western civilisation has of greed and ego – playing out for all to see through the lens of the built environment.

**Danièle Hromek**
*Sandstone detail, Gadigal Lands, 2018*

**LW:** It's clear that care of the land through all processes of architecture is central to dragging it towards a better relationship The only way I can see this changing is through in fact building our own personal relationships with Country, otherwise any process will always be in the colonial system, as it is now, and remain institutionalised. I think this is what I mean when I use the word 'know'. Similarly, without this way of knowing, typically only larger, institutional or public works access the processes of 'engagement'. One is coming to Country once or twice removed.

**DH:** It is insufficient to have external consultants doing the consultation with community and Country, it has to also include a very personal reflective engagement with Country by each person working on the project – one that includes a commitment of care, walking lightly, doing no harm.

**LW:** As well as a more careful approach, I wonder what conceptualising architecture through Country could mean? While I feel it is about care, I'm also returning to a cultural understanding of space because this is the chasm to be bridged, central to reasons of why one would care and therefore take care. It is my hope that this understanding of 'space' in terms of Country could change how we think through architecture. You can see how I am struggling to put my finger on this.

**DH:** Aboriginal people talk about caring for Country and I know some industry and government have adopted this as an idea also, i.e. if we care for Country it will care for us. However I wonder if this way of being has been truly examined by non-Indigenous people? Because if so, they need to accept that the systems they have imported to the land now called Australia are inappropriate for this continent – including the systems architecture uses to create, materialise, define space. If caring for Country were truly part of the architectural process, culture (as expressions of Country) and the people (who come from Country – to be clear, Aboriginal and Torres Strait Islander peoples) would not be separate from architecture and there would not be any gap that needed to be bridged or closed; they would be understood as inherent to the process. Attempting to add Aboriginal people and culture into the architectural process as it currently stands neglects to understand that process as a colonial, patriarchal, capitalistic, system, which does not reflect nor include values of community and collaboration. We, as a discipline, need to "dream up" a new process that includes culture and First Peoples, or else it is only ever a patch on a system that never can have Country at its core.

**LW:** The possibilities or ways to (re)define space through Indigenous spatial knowing is what I am hovering around, not for architecture's own vanity but as a tool at the site of materialisation to change the imported nature of architecture. Inherent in this I'm suggesting that a more careful architecture would be unavoidable. But I hear what you are saying, that this possibility needs to be arrived at through process, otherwise it is yet another imported application with a predetermined destination. At the same time I feel a discussion around ontologies could be part of a new process so that, as you point

out, the systems used to define and think space can be rethought outside the current ones. I can't help feeling that to be meaningful any process needs to be embedded, without time limitations, and maybe even not defined as a process but an unfolding. It's difficult to reconcile with the contemporary Western world.

> **DH:** It is! This is why I so often talk about worldviews and perspectives in my discussions around space, architecture or design. Understandings of time and space are inherently distinct for differing worldviews and perspectives. Rethinking time as relational to space (as experienced in an Indigenous worldview or perspective), and integral to the Dreaming – that which is everpresent and always, and holds all potential, and so holds the capacity to always be creating and created. The Dreaming is where Aboriginal people gain their capacity to adapt as we have done over more time than can be counted – imagine if we considered the built environment this way how our perceptions of projects would shift also. This perhaps is how we can start to live in a place *forever*.

**LW:** To try to keep hopeful, if we accept that architecture can define space, or materialise it, and create relationships between material space and inhabitation, and even place*, then it's possibility to be meaningful within Country seems exciting.Is this something you were thinking about with your work around the spatial qualities of Peter Eisenman?

> **DH:** These drawings were speculative design drawings that I drew some years ago now. I sometimes use design as a tool to contemplate questions, deliberate over ideas, and to speculate about possible futures. The 'what if' questions I pose are often intended to open up discussion and debate about what sort of future we want to "Dream Up" as a society. For instance, 'what if climate change became unbearable, what sort of space would we need to exist?' or 'what if Aboriginal peoples' spatial values were considered in the design of spaces?' In these drawings I was exploring darkness and void in the architecture. I have in the past related voids to the non-Indigenous expression of terra nullius, which we of course know was never the truth, whatever was perceived to be a void was in fact full of Country.

> **LW:** That seems a very helpful approach. Could you share any thoughts that have come out of this? .

**DH:** It has primarily meant that the way I consider projects is through a much deeper filter of not only time, but space and culture. It has meant that, as D'harawal Elder from the Sydney area Uncle Gavin Andrews advises when I am working on a project, a site needs to be considered to be *as far as the eye can see* and not limited to the perceived boundaries drawn on maps by our profession. Country does not stop at the edge of a map, it is interconnected and boundless. This requires a complete rethink about how we in the built environment work with "site" as if our site is as far as the eye can see, indeed, our responsibility towards that site extends substantially further than we currently consider, including further in time.

**LW:** Could you speak more to Aboriginal (or your) peoples' spatial values? Does the concept of void exist in your Indigenous thinking? (sorry if these questions are too ridiculously huge…)

**DH:** Of course. Space is *held* by Country. Let's think about this some more. If Country holds space, then space, by its very nature, is full of Country. Country is not only the land, water and sky and the tangible elements we can see or touch, it is also the intangible, the relationships, knowledges, values, etc. More than this, it is the potential for everything. Country, holding space, is potentiality, or the opposite of what is often understood to be a void. Spaces also hold values. So this might be, for instance, values understood through cultural practices, however the values might also be gendered or intergenerational or narrational. In fact, without the story, it is pretty hard to make sense. Of anything.

**LW:** Your description makes me think that architecture, or the built environment, is not only damaging physically, but must be disruptive to the stories embedded in Country, and returns me to the Birdhouse, where Country is now mostly available to you through a larger abstract birds eye view.

**DH:** Architecture is after all a colonial tool, used to restrict and restrain Indigenous people globally and appropriate their lands. Once we come to terms with that truth we can reflect on the damage it has and still does cause. But truth telling is difficult at times, and it should not be up to the Indigenous peoples to always have to tell the truth. Once architecture takes responsibility for its colonial past, it is my hope new ways of doing our profession can come forward. In my world, that starts with Country and our relationships with Country.

**LW:** Interestingly, thinking still of your drawings of interiors, that is spaces that are 'defined'. Can the object of architecture create meaning in the same way? If the ontology is flat, then perhaps there is no difference between inside and outside? It's difficult not to slip into this dualism of inside and outside even though what I am saying would suggest there is no inside or outside. And, what you have said to me about space might mean it is precisely this way of thinking that must be let go.

**DH:** As a spatial designer my work lies between architecture, interior design, urban design, performative design and even fine arts, so I guess you could say I am already looking at the interstitial spaces between disciplines. I am also very interested in the spatial conditions and experiences of spaces, and often enough the interior/exterior experience and/or condition is nebulous. For instance, I'm sitting here in my high-up home and the breeze flows in through the balcony doors as does the sounds from the streets below. I am inside, but the breeze and noises imply I also have outside conditions in my experience of this space today.

**LW:** Ah yes, I forgot the non-visual or material in my intangible conception of architectural space. This is perhaps just the type of thinking required. In the way you have described your spatial experience you are in your house, and simultaneously on the street. I keep coming back to question the material implications of this way of thinking, or being, as a relevant way for architecture to change. Would you agree or can I not get past my own ontological understanding that there is always *object?*

**DH:** Perhaps it depends on how architecture is defined, for instance one definition is 'the complex or carefully designed structure of something' – which makes me think of the closest language word I've found in the language of my ancestors, Dhurga, relating to building something: djinjama, a word (that needs a suffix to make it complete) that means to make, complete, produce or build something. *Something* does not always imply *object*, neither does *structure*, nor *building*, nor *design*. This does not necessarily mean objects, somethings, designs, structures, etc are 'wrong' or 'bad', but what if they came from a perspective of care of Country, would they always be the end result?

**LW:** In more recent years the definition of architecture as object has taken on an implication that it is discreetly to that end, and therefore neglects the user, the place and so on, understood exclusively from the exterior (or photograph) rather than through its inhabitation or relationships. But of course this does not have to be the case. To me, architecture has always been closer to your description. The definition you provide is so hopeful and generous and an insight into how we can rethink it all together.

And, of course, to be a part of Country in this way, architecture needs to shift its destructive practices, especially in regards to the ground.

*I note that when I asked Wurundjeri elder Aunty Gail Smith to translate into Woi wurrung 'Free Space' for the 2018 Venice Architecture Biennale, which is 'Tendebik Tyrille', she told us that there was no direct translation for free, or space. Interestingly, space was translated more as what in English would be 'place' (and 'free', in the context of Freespace, as a place where you could go without permission).

**DH:** Oh aren't First Languages wonderful! I am a language learner and my Elders are teaching me multiple languages at the same time – as probably we always have done. I am yet to find a language word for 'space' but in the language of my Ancestors, Dhurga, ngarn means 'place' and nura means 'Country'.

**LW:** The generous sharing of language by Aunty Gail's translation was a revelation to me. It threw this notion of space, so central to architecture, into question. What can architecture be in a thought process where space is not even able to defined.

**DH:** I think space is defined, but not necessarily linguistically, it is defined by Country.

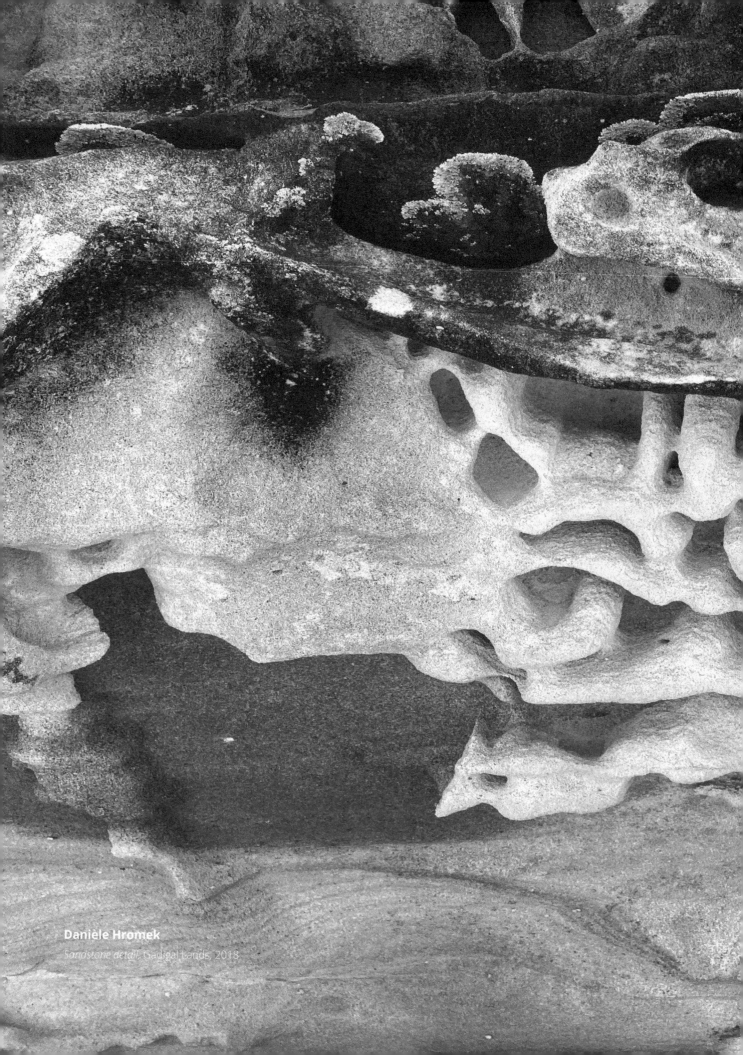

**Daniele Hromek**
*Sandstone detail, Gadigal Lands, 2018*

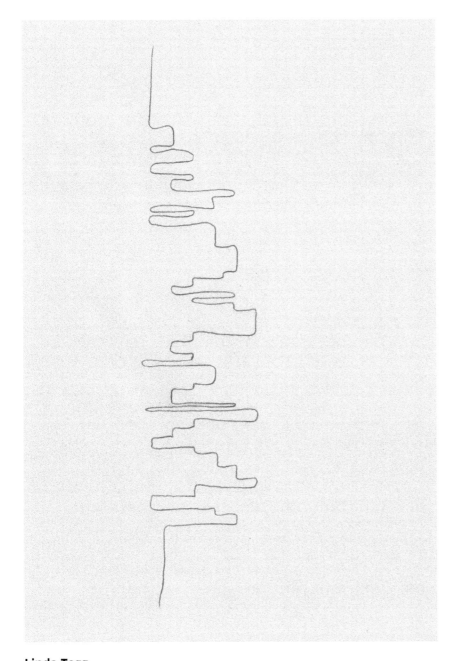

**Linda Tegg**

For 'Species and Spaces', Linda Tegg rendered the yarn between Hromek and Wright into various forms. This simple line drawing traces the coming together of their yarn across time, and provides a logic for how this yarn is assembled across pages.

### *Endnote*

[1] Liang, C.-C., & Lee, J.-P. (2018). Carbon footprint model for reverse logistics of waste disposal in interior design industry. *Asia Pacific Journal of Marketing and Logistics,* 30(4), 889-906.
[2] Abergel, T., Dean, B., & D'ulac, J., Sharon. (2017). Towards a zero-emission, efficient, and resilient buildings and construction sector: Global Status Report 2017.

**Dr Danièle Hromek** is a Budawang woman of the Yuin nation. She works as a spatial designer, cultural designer and researcher considering how to Indigenise the built environment. Her work contributes an understanding of the Indigenous experience and comprehension of space, investigating how Aboriginal people occupy, use, narrate, sense, dream and contest their spaces. Danièle's research rethinks the values that inform Aboriginal understandings of space through Indigenous spatial knowledge and cultural practice, in doing so considers the sustainability of Indigenous cultures from a spatial design perspective. Danièle is director of Djinjama, whose clients include state and local government, museums and galleries, as well as industry including architects, planners, designers, heritage and engineering firms.

# Architecture sharing space

*Architecture's physicality is at once its problem and possibility in its relationship with its site and the species supported there. It's physical size, shape, footprint and material allow it to make, share, or release ground. Possibilities include admitting light, being a life supporting substrate or structure and creating ground through verticality reducing the need to take up land and displace life elsewhere. Seemingly simple, by reframing how we know these approaches as one of sharing, an ontological shift occurs.*

text by **Louise Wright**

Before and aside from the promise of technology to neatly resolve architecture's relationship with nature there is the question of its physicality. It's physical size, shape, footprint and material allow it to *make,* share, or release ground. Less directly, there are questions of material extraction, once commonly of the place and now rarely the case.

Architecture has long been made by moving around what is on a site, or Country, to form a new arrangement that suits the need at hand: for example, the rearranging of stone and soil in the Maritime Alps on the Italian French border between the Valley Roya and Valley Vermenagna. Built in the 19th century, but once finished hardly used, a chain of six fortes span altitudes from 1850 to 2250 m above sea level: Forte Colle Alto , Margheria, Taborda, Pernante, Giaura (the highest) and Pepino. Forte Giaura is the most embedded of the fortes with a pentagonal plan it remakes a hilltop: an architecture made by removing (to create the mote like threshold) and relocating soil and to the 'roof' so that it is grassed and completes the hill. In the moat, a microclimate forms, protected from the high-altitude winds, and now site of a new ecosystem. This roof is a functioning *ground* with soil depth.

We remember Paul Virilio's *Bunker Archeology* and the revelation that architecture can be found in unlikely combinations of mass and bulk in geological forms and 'allowed' to sink into their sites.

The undeniable mass yet lightness at the same time – being there yet not there – is the architectural reality of trying to look like a mountain – of being the mountain – and an ontological opening.

In a contemporary application of using material at hand, the 21st century project of architecture might well be the reuse of what we have already made (with the 22nd being the removal), we can reimagine architecture's relationships. By reusing a toilet block into a community centre (Weave Youth and Community Services, Collins and Turner, Sydney, 2013), the simple act of less waste, less extraction and less land used is made.  At the same time this building brings a shared space for species above itself in the tree canopy like structure that supports multiple plant species and forms habitat. Taking up the ground displaces the systems that act in and through the surface and just above and just below it. In this architecture the space 5 metres above the ground is still somewhat connected.

For architecture to share these few metres above and below the surface of the ground is difficult and requires compromise on both parts in a play of light, shade, wind, water, noise, access and importantly flux. An experiment in sharing  (Garden House, Baracco+Wright Architects, Westernport,

*In the moat, a microclimate forms, protected from the high-altitude winds, and now site of a new ecosystem. This roof is a functioning ground with soil and depth.*

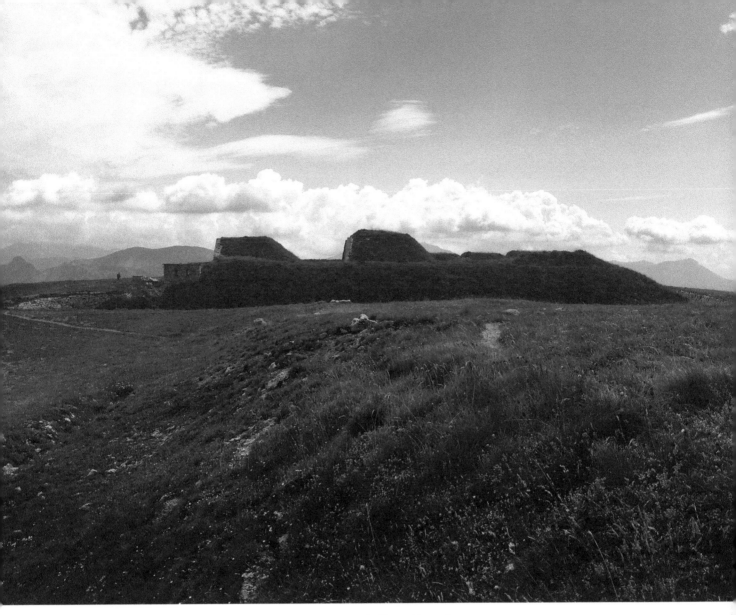

Forte Giaura, Maritime Alps, Limone Piemonte (Cuneo), Italy. Photo: Mauro Baracco

Victoria, 2013 ongoing,) uses a thin physical boundary (polycarbonate sheet) to maintain transparency otherwise displaced by a building for the sustaining of life – shifting architecture's material theory of transparency that has always been wholly in architecture's own interests to that of the species of this site where the house is conceived in parallel with the rehabilitation of the vegetation.[1] The form, or anti-form, required to share the space open a way of rethinking architecture's terms - spatial boundaries are not achieved in the usual ways (walls, windows, and rooms, ceiling and floor) but made by the vegetation on either side of the polycarbonate layer, not quite a wall – but together with the vegetation an ill-defined wall is made that starts on the inside with the moat-like horizontal threshold achieved through the way the raised floor stops short of the polycarbonate. The raised deck is another expanded threshold – this time with the ground – allowing the unsealed ground and its floodwaters that occur periodically to flow through. The window that frames an interior's relationship with nature is absent. The ontology is almost flat: *nature* is neither confined to containers or brought 'inside'.

Reframing our point of view, the high-rise apartment tower, is the most unlikely yet powerful gift of architecture and its capacity to make its own ground in the simple fact that it does not otherwise take up land con-

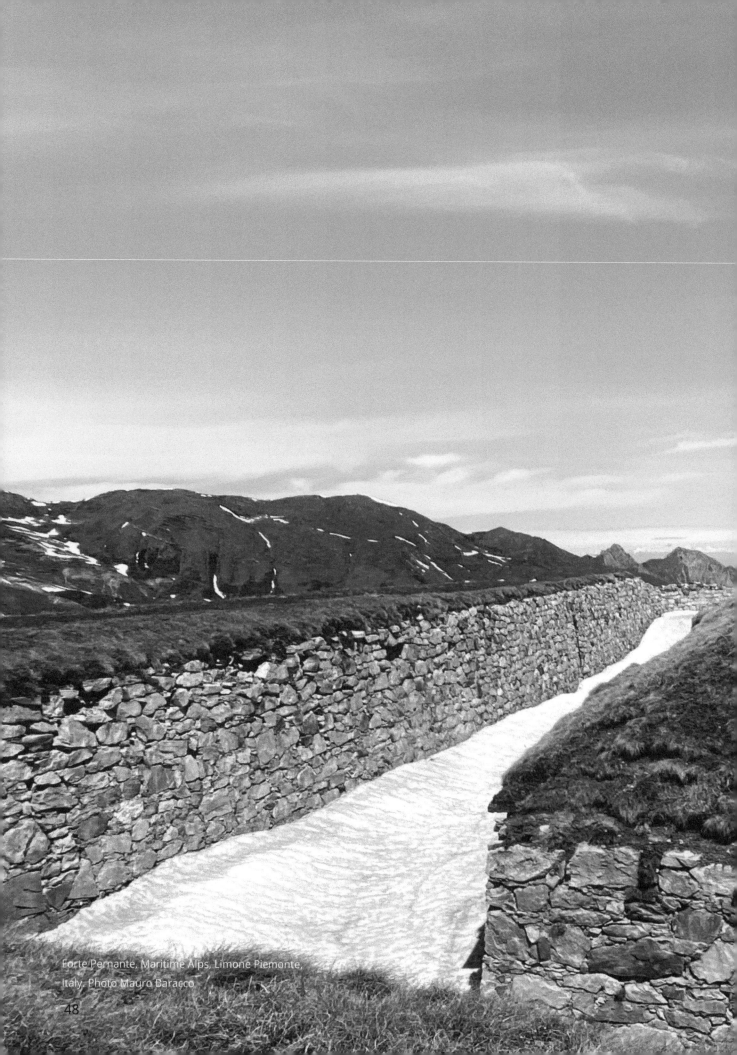

Forte Pernante, Maritime Alps, Limone Piemonte, Italy. Photo Mauro Baracco

48

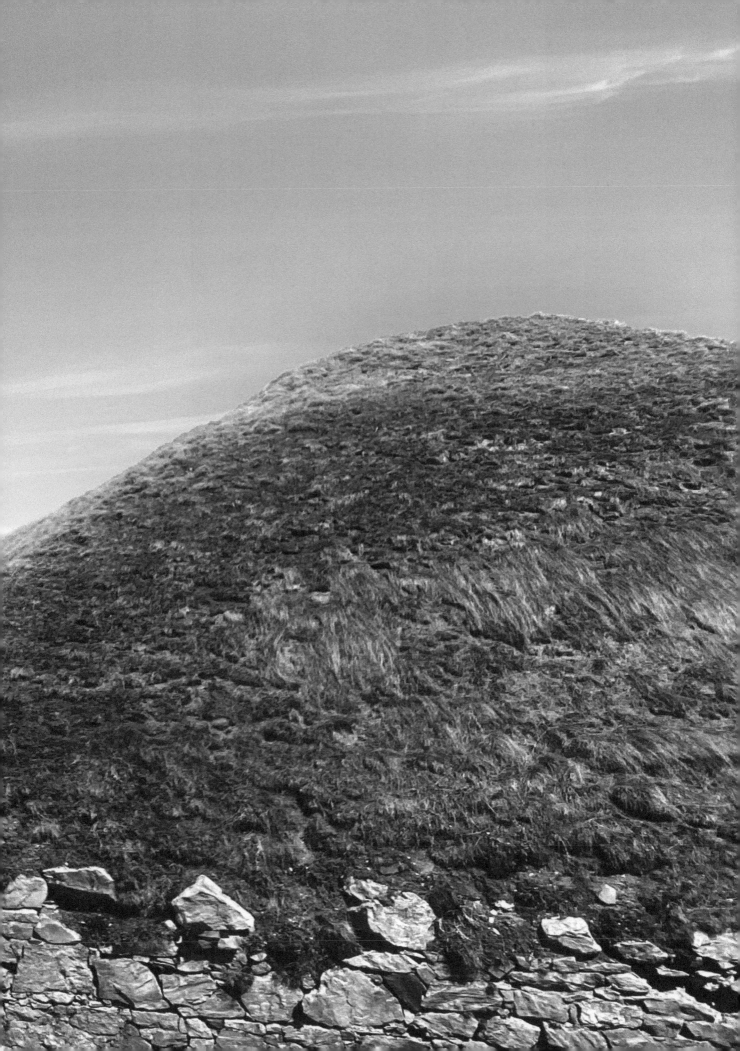

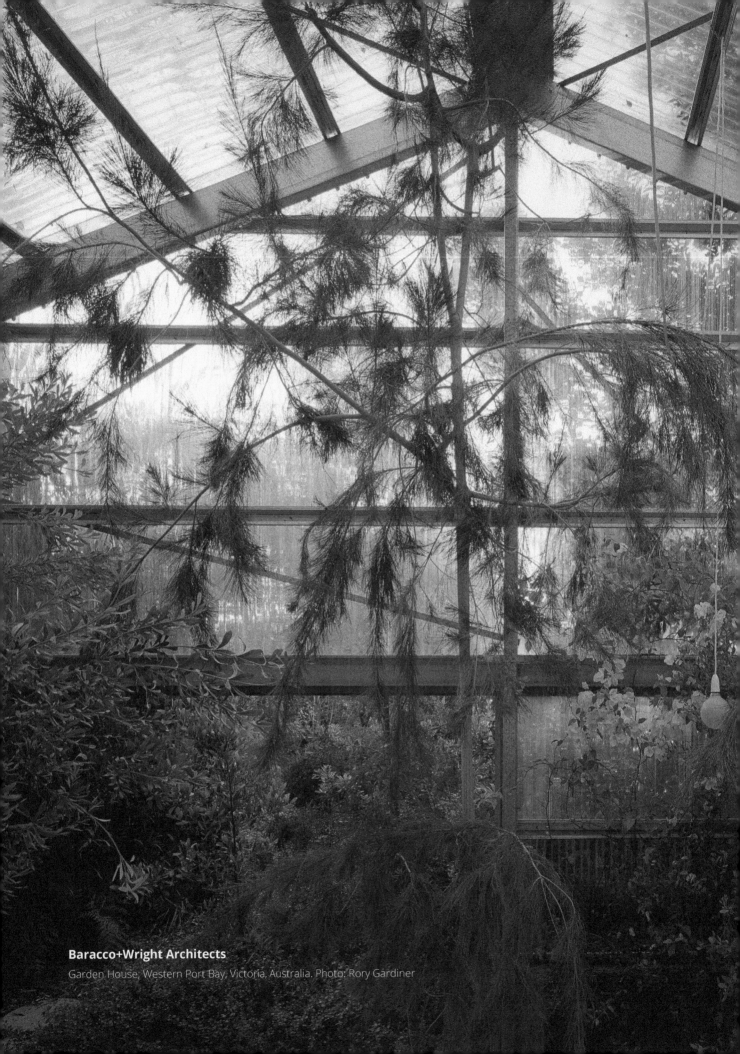

**Baracco+Wright Architects**
Garden House, Western Port Bay, Victoria, Australia. Photo: Rory Gardiner

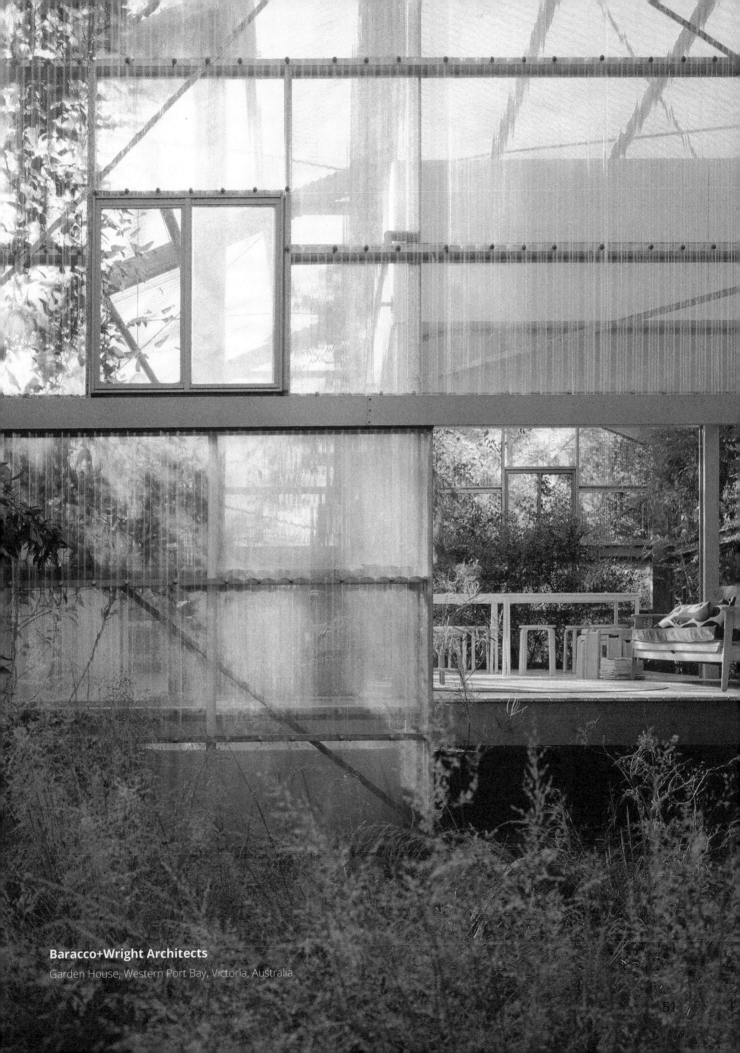

**Baracco+Wright Architects**
Garden House, Western Port Bay, Victoria, Australia.

51

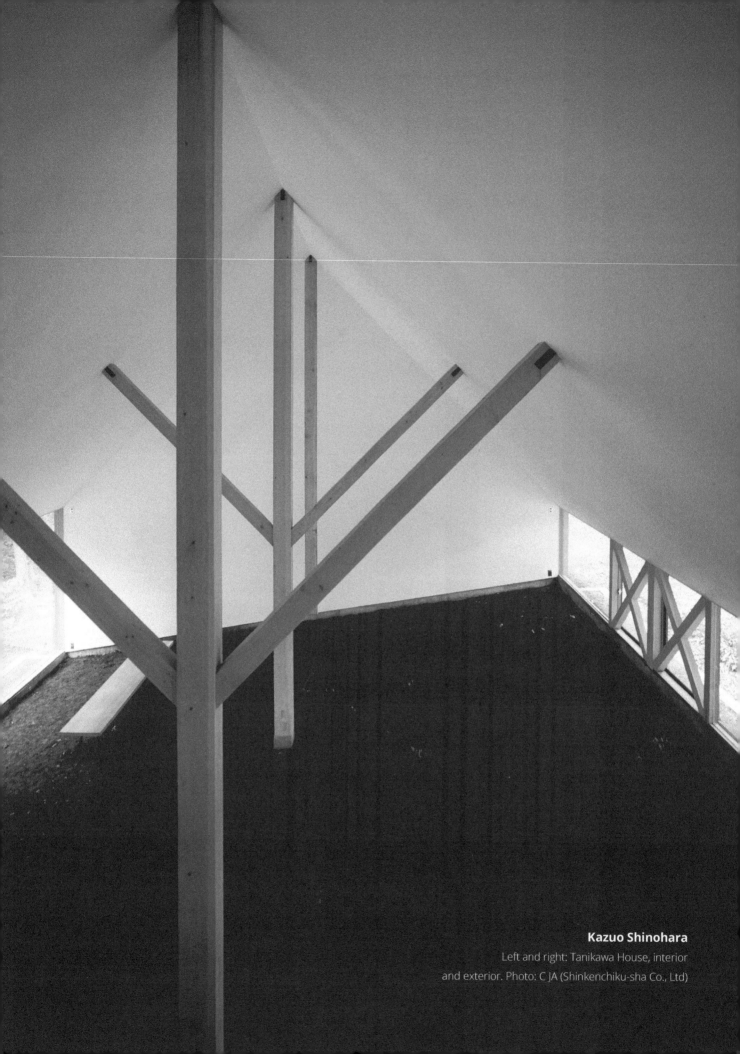

**Kazuo Shinohara**
Left and right: Tanikawa House, interior
and exterior. Photo: C JA (Shinkenchiku-sha Co., Ltd)

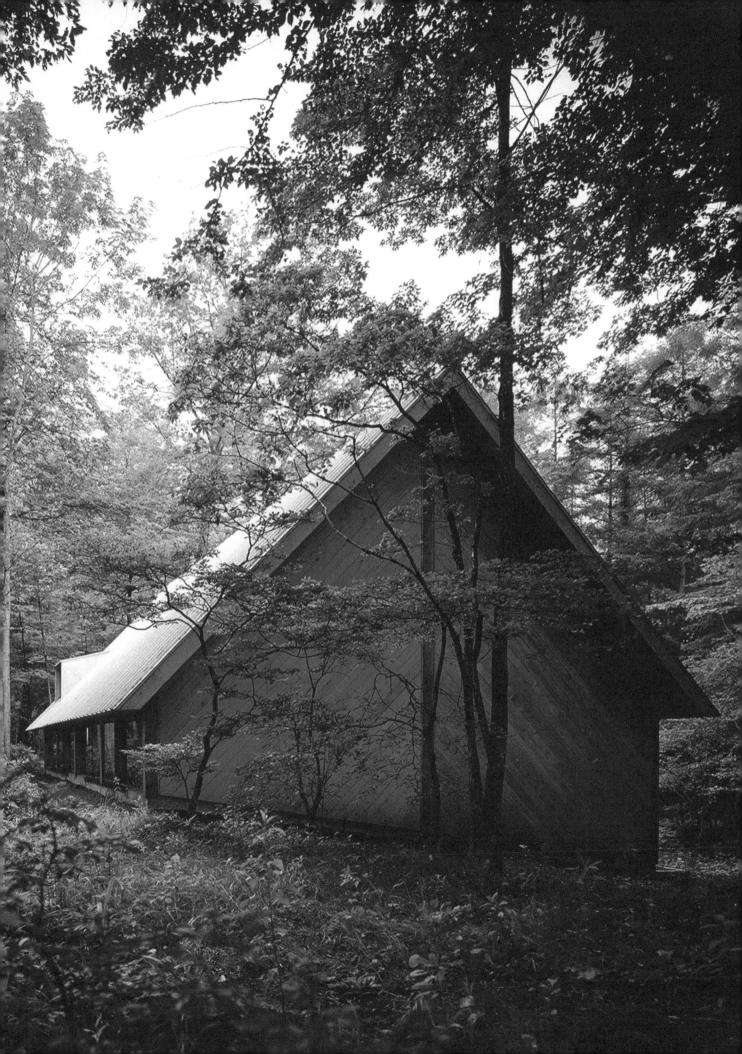

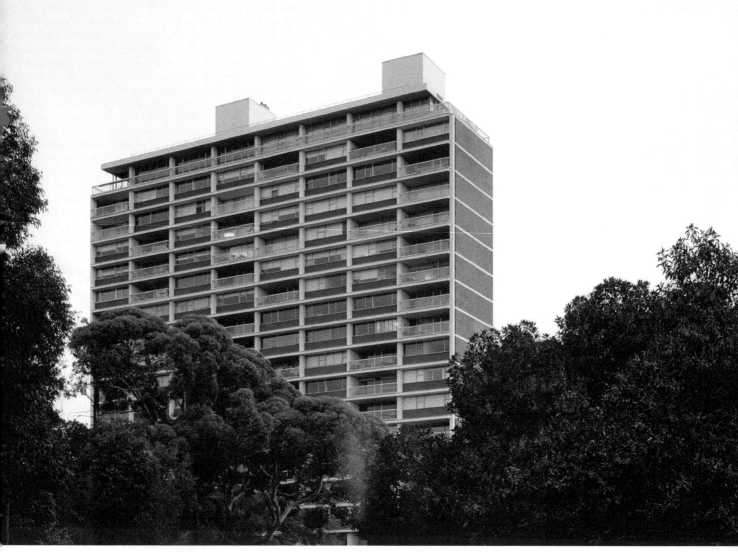

**Robin Boyd**
Domain Park Flats, Melbourne, Australia. Photo: Rory Gardiner

tained there. When coupled with a large open unbuilt space this potential is potent – *here goes the land we would have used*. In 1962, 18 additional grounds (9720m$^2$ or almost 1 hectare) were made in one of Melbourne's first high rise apartment buildings (Domain Park Flats, Robin Boyd, 1962) across from the Royal Botanic Gardens (38 hectares).

Common to these architectures, at times only available in their re-framing, is their being *of* the world, most potently in their spatial continuity, and so, requiring a considered relationship with their site, it's ground, and inherently the species supported there.

Japanese Architect Kazuo Shinohara describes the Tanikawa House (Kazuo Shinohara, 1972-1974, Nagano, Japan) as giving form to the 'gap' which opened up between the raw slope and the structure of the house, and an interest in discovering an 'anti-space'.[2] It follows from *House with an Earthern Floor* (1963) and *House of Earth* (1966) and before his essay "When Naked Space is Traversed".[3] The concept of *traversing* inherently shifts the point of view to simultaneously consider the building and that to be traversed.

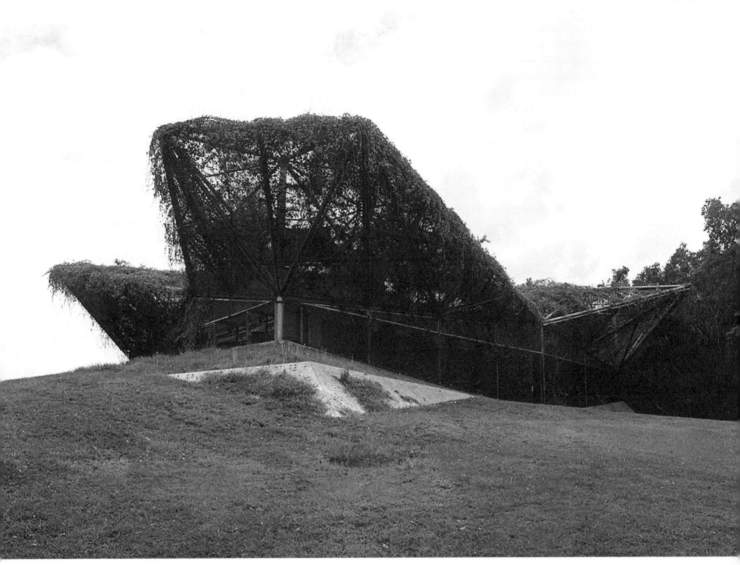

**Collins and Turner**

Weave Youth and Community Services, Waterloo, Sydney, Australia. Photo: Linda Tegg

### *Endnote*

[1] For an expanded description of how this house has been conceived see: Mauro Baracco and Louise Wright (Ed), *Repair*, Actar, 2018, p.143

[2] Kazuo Shinohara, Houses, 2G, N.58/59 , Gustavo Gili, 2011, p.133

[3] Kazuo Shinohara, 'When Naked Space is Traversed,' The Japan Architect, 1976

# Under the green slate

*Drawing on the experience of* Lotus International *magazine, through the contribution on its pages of landscape architects, as well as photographers, sociologists, philosophers, botanists, activists and artists, this essay traces a path through the inalienable relationship between urban environments, natural ecologies and different forms of "otherness". A series of radical projects engaged with sites left out of human control, from the small scale of urban fringes to the great landscapes of the wilderness, outlines an alternative history of landscape architecture, where the complex processes of natural ecosystems burst into the logic of the project, modifying linear approaches.*

*The full title of this essay is 'Under the green slate: otherness in landscape and architecture'.*

text by **Nina Bassoli**

*"Nature enriches itself wherever man has destroyed it. Even in the virgin forest, flowers bloom where large trees struck by lightning fall. Ponds with water lilies and urodeles form where grenades have exploded. Tahiti was not a rich land because lions grazed together with the sheep – which is also quite unlikely – but it was rich because there were men who worked the land and waged war"*[1]

Lucius Burckhardt

I t is quite typical for architects – including landscape architects – to approach the design of open spaces with the same optimism with which they approach the design of any other kind of space; that is, with the view that something can go from design to reality, just like you go from A to B, B representing the ultimate form. However, the landscape – and, to a lesser extent, architecture as well – cannot have an ultimate form, since we know that – despite the most daring and sophisticated means of containment that architects and engineers put in place – the landscape is alive, in hidden layers beneath, around, and above it; and as such it moves. This is an optimistic stance. We might even say a superficial one; and not only in the negative sense of lack of awareness, but also in the physical sense of two-dimensional extension, according to which the residual space between one construction and another would be identified as a volumetric void, as a pause, as a flat area without any depth. Perfect green slates, grids, patterns, textures, sheets of acetate, and airbrush hatches are the typical shapes that have filled the spaces between buildings for decades. The empty space is filled with green; a uniform island of set proportions, devoid of depth, movement, life, interferences: similar to architecture, but in two dimensions only.

However, as noted by Giuliana Bruno in *Surface. Matters of Aesthetics, Materiality, and Media*,[2] despite the negative hues associated with the superficial, the most important things in life and in art take place on surfaces. The surface, understood as the boundary between two different worlds – outer/ inner, subaquatic/aerial, subterranean/overland and so on – is a favored place of contact; it is where a hinted, erotic, sensual relation unfolds between beings and ecologies that do not fully belong.

If we consider the green slates that architects and urbanists see as voids through these lenses, we can begin to develop a completely different way of understanding the issue of landscape design.

### Coring in the third dimension #1.
### Do paradises in the metropolises still exist?

In 2016, upon the commission of Lotus magazine, I ventured together with the French photographer Edith Roux inside the largest railway yard in Milan, Scalo Farini, a 60-hectar urban void that will soon be transformed into a new piece of the city, 'filled' (so to speak) with new blocks, neighborhoods, districts, offices, schools, squares, and parks. The concept was that of creating a portrait of the area as it was before its transformations; proposing a reading of the location that could serve as a reference for those who would be tasked with its redesign: a sort of preliminary groundwork for future design competitions and projects on the one hand – like that of the magazine – and a sort of visual overwriting developed through the eyes of a privileged interpreter on the other. We took off for our inspection with comfortable clothing and a packed lunch, carrying with us the brief report made by Lucius Burckhardt during his walks in these areas in 1988.[3] Burckhardt – when invited to elaborate a project for one of the voids in Milan in the context of the 17th Milan Triennale, *World Cities and the Future of the Metropoles*[4]– had chosen to present a sort of performance along one of his 'promenades',[5] carried out together with some of his students from the universities of Kassel and Milan, in a large abandoned area adjacent to the

*Perfect green slates, grids, patterns, textures, sheets of acetate, and airbrush hatches are the typical shapes that have filled the spaces between buildings for decades.*

**Edith Roux**

*Scalo Farini,* 2016.

© Edith Roux,

Courtesy Editoriale *Lotus*

Scalo Farini. Through this action, Burckhardt sought to prove that 'nature' was part of the life of metropolises, and that the abandoned by humans areas within them "are perhaps the last places where a science teacher can still show his students rare species of plants or animals." Accompanied by the story of the 1988 tour as if it were our travel guide, about twenty years after that pilgrimage, we too found an incredible variety of plant and animal species, butterflies and bees, flowers, herbs, brambles, and fruit trees: ivy, buddleia, toadflax, evening primrose, verbena, artemisia, setaria, Canadian horseweed, mulberry, mint, pokeweed, Virginia creeper, figs, blackberries. But also some very peculiar species, typical of the Mediterranean vegetation, like the glaucium flavum, a yellow poppy originally from the south.[6]

The case of these railway yards is a particularly interesting example to be considered in opening today's considerations on the actual condition of these so-called 'voids', and perhaps try to overturn their perception. Already in the late 1960s, and for over a decade, the Swiss botanist and agronomist Ernesto Schick – working as a site assistant and then as a live plant transporter within the infrastructures of the Chiasso railway network – began to study the species that were present in the area, cataloguing them in a volume that would be published for the first time in 1980, with the title *Flora ferroviaria: ovvero la rivincita della natura sull'uomo. Osservazioni botaniche sull'area della stazione internazionale di Chiasso, 1969-1978*.[7] Schick also notes that in close proximity to the structures used for train transportation, all characterized by specific and similar soil conditions – a strongly anthropized landscape, the presence of stones, frequent vehicle circulation, massive use of herbicides, and the presence of non-native seeds taken there parasitically by trains and travelers – brought to the development of a singular habitat, in which it is possible to find a great biodiversity. A particularly relevant case from this point of view, confirming Schick's research, is that of the Natur-Park Südgelände in Berlin's Schöneberg-Tempelhof borough, which was developed upon what used to be one of the most important railway areas of Berlin up until 1945, later almost entirely abandoned after the division of the city. Over the fifty years of semi-abandonment, such a large number of species developed within this railway enclosure that it led to the issue, in 1999, of an environmental and landscape protection bond regarding the whole area. Specifically, according to the in-depth scientific surveys on the subject, they found 350 different kinds of plants, 49 species of fungi, 30 bird species (including a hawk in the old water tower), and – among the vast amount of insect fauna – no less than 95 species of wild bees, 34 of which are protected.[8] Naturally, railway yards are not the only places where a heavily anthropized area – suddenly abandoned and inaccessible – is capable of developing surprising biodiversities. Other unique cases that are particularly fertile from this point of view are those of so-called "biological corridors" developing along boundary areas, such as that between East and West Germany along the Berlin wall – defined by Burckhardt as "the largest national park in Europe"[9] – or that of the Korean Demilitarized Zone (Korean DMZ) that has been separating North Korea from South Korea since 1977, representing today a hotbed of about 3.300 animal and plant species, including many endangered ones; and, finally, the boundary area of the various Roman or Gypsy walls scattered throughout European and Middle-Eastern territories. Not surprisingly, Gilles Clément dedicated a specific consideration to these last ones: "In each of these places, the non-occupation of the soil by part of any human activity favored the establishment, between the two walls, of ecosystems open to a natural diversity that is banished from any other place. The progressive enhancement of these monumental 'biologi-

*Over the fifty years of semi-abandonment, such a large number of species developed within this railway enclosure that it led to the issue, in 1999, of an environmental and landscape protection bond regarding the whole area.*

**Edith Roux**

*Scalo Farini,* 2016.

© Edith Roux,

Courtesy Editoriale *Lotus*

cal corridors' [...] turned them into 'natural reserves' that were envied by ethnologists and botanists from all over the world. [...] Built in order to contain cultural diversity, they welcome, in the depths of their 'no man's land', a mad and disturbing natural diversity. In the midst of this diversity, various wandering species, with short life cycles and flying seeds, behave in the manner of nomads: constantly moving from one campsite to the next. This way, the places that have been rejected by the wandering of humans have transformed into places of encounter for all other species, triggering the risk of hybridizations and of a series of natural mutations".[10] Ethnographic landscape architects such as Ernesto Schick and Lucius Burckhardt were important references for the development of Gilles Clément's theories of the *Third Landscape,* the *Planetary Garden*, and the *Garden in Movement*, which were fundamental for the understanding of landscape as something alive, something 'in movement'.

Clément directs his attention to the areas that are removed from the despotic control of our society, where it seems like nature is taking back its freedom of expression, creating places of diversity and shelters for species that do not find a home elsewhere. The act of 'immersion' within this area clearly denies the possibility of understanding it as a flat landscape; just like claiming his role as gardener – rather than as landscape architect – tends to underline Clément's will to be a presence that operates from within an ecological context and not one that dominates it from the outside. "It is the artist-gardener of the ecological garden who belongs to the garden, not the garden that belongs to him; he would not be able to treat it according to orders and conventions. He listens and his presence expands over time'.[11]

The change that the activity of the French agronomist and theorist has imprinted in the aesthetic field is perhaps more easily recognizable in current practices, certainly also incentivized by the work of other landscape architects – such as Piet Oudolf or James Corner – who have contributed to develop a broader language for landscape design through a less-controlled use of vegetation, accommodating spontaneous species, their varieties, and their character. But the image of Gilles Clément immersed in the vegetation, intent on observing it and 'listening' to it, leads us to consider the issue beyond a mere visual extent.

What interests Giuliana Bruno about the exchange that takes place on the surface – that exchange between worlds or between species that Clément finds when he immerses himself in the vegetation – is the fact that it is not a purely visual exchange, but also tactile; or, more precisely, *haptic*. Haptic perception (from the Greek *Haptikos* = touch) indicates the sensitivity, the awareness, of an individual toward the world adjacent to his body; or, in other words, the ability to come into contact with something or someone.

If we understand ourselves – humans, gardeners, landscape architects, designers – as beings living within more complex ecologies, we might find the *haptic* approach as the most direct way to build a relation with these other ecologies, to literally get into contact with them. Of course, this involves a paradigm shift in our perception of the world and in our way to relate with what surrounds us, which – in addition to being an aesthetic reality – is also profoundly political.

## Other Slates for Other Species
### 1. Plants
Paris, 1985. The competition that was launched for the construction of a park in place of the old Citroën factories presents itself as a sort of response to the previous competition for the Parc de la Villette, which had

*In the midst of this diversity, various wandering species, with short life cycles and flying seeds, behave in the manner of nomads: constantly moving from one campsite to the next.*

**Edith Roux**
*Scalo Farini,* 2016.
© Edith Roux,
Courtesy Editoriale *Lotus*

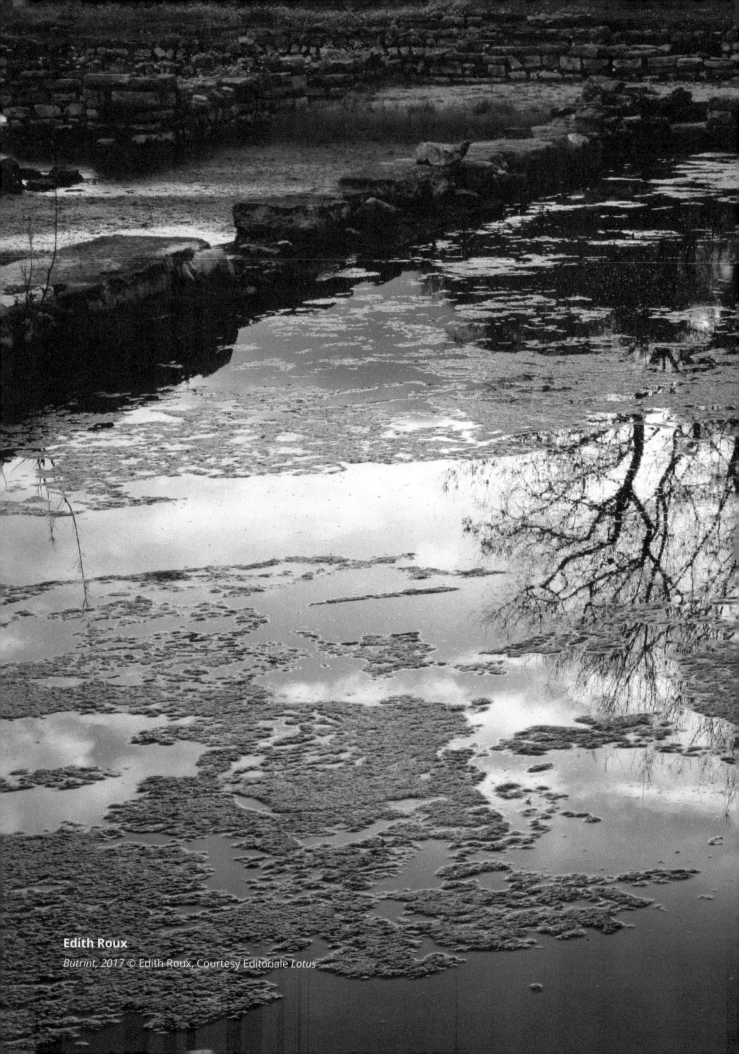

**Edith Roux**
*Butrint, 2017* © Edith Roux, Courtesy Editoriale *Lotus*

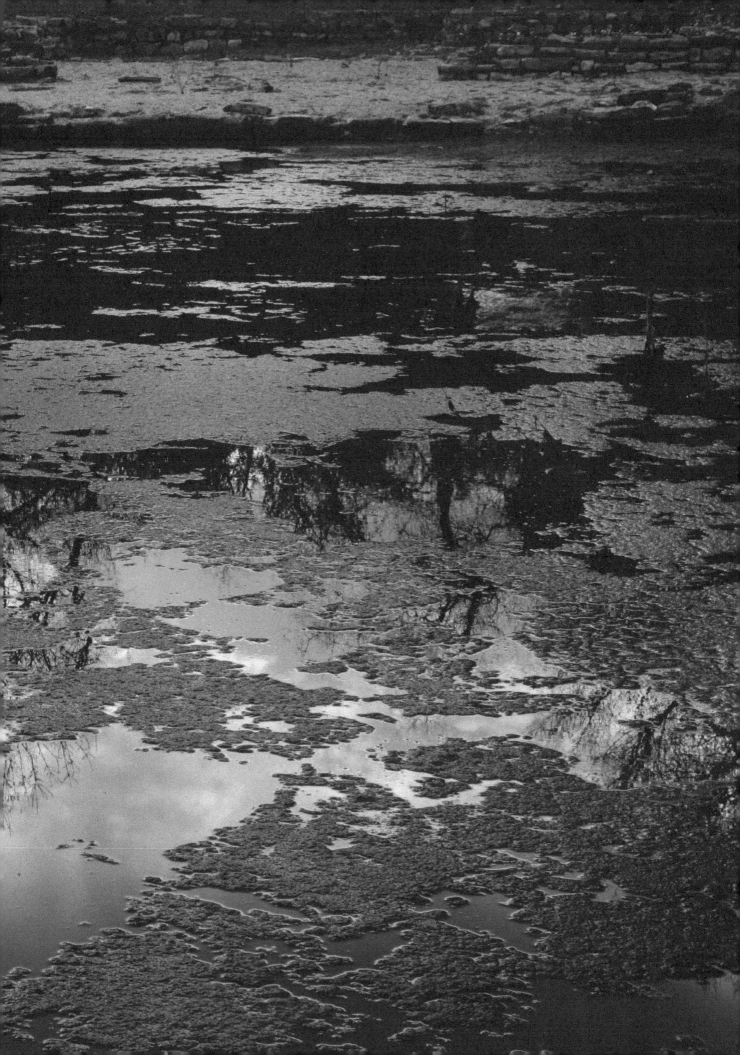

**Edith Roux**

*Butrint,* 2017 © Edith Roux, Courtesy Editoriale Lotus

witnessed an important defeat of the landscape artists in favor of the architects with their "interplay of random combinations in which the mineral triumphed over the botanical", as a celebration of the urban universe.[12] The competition for the new park, on the contrary, asked for the conversion of the industrial site into a place dominated by vegetation. However, in order to prepare the area for the possible transformations – even before deciding to turn it into a park – the municipality completely demolished the industrial buildings, freeing up a large and perfectly smooth parterre; a perfect, empty surface. Gilles Clément and Patrick Berger founded their project on the refusal to consider vegetation as a filler, as an element necessary for a theatrical production, refusing to reduce it to a mere representation of a place or myth. Here, nature represents nothing other than itself; and it is vegetation – with its biological life – that establishes itself as the central focus and theme in the park's design process. Visual order gives way to the idea of a dynamic management of vegetation – of a 'garden in movement' – free to grow spontaneously in its uncultivated land and oases of uncontrolled nature. Although it was neutralized by the shared competition win with the

**Edith Roux**
*Butrint,* 2017 © Edith Roux, Courtesy Editoriale Lotus

project of Alain Provost[13] – and therefore relegated to a less extensive and less assertive area at the north end of the park – the third landscape project by Clément-Berger undoubtedly represents a milestone in the development of a new view, which extends beyond the alternative English or French garden, presenting an ecological paradigm that outlines a new understanding of universality.

## 2. Animals

East Scheldt, 1991-92. The 9-km storm dam on the East Scheldt was completed in 1986 to protect the coast from possible flooding; yet another effort by Dutch engineering to try and control the relation between water and land. Due to lack of funds, however, the island that was used for the construction, along with the dry docks and the piles of rubble, was never cleared up. The ruins of the construction site were left abandoned since then, like unused wastelands: dead, uninhabited surfaces. In 1990, the Rijkswaterstaat (Dutch Ministry of Infrastructure and Water Management) commissioned West 8 to re-organize the area. The sand dunes were shaped into large plateaus and covered with shells and with waste from the Yerseke fishing industry that is normally pumped offshore. Thus

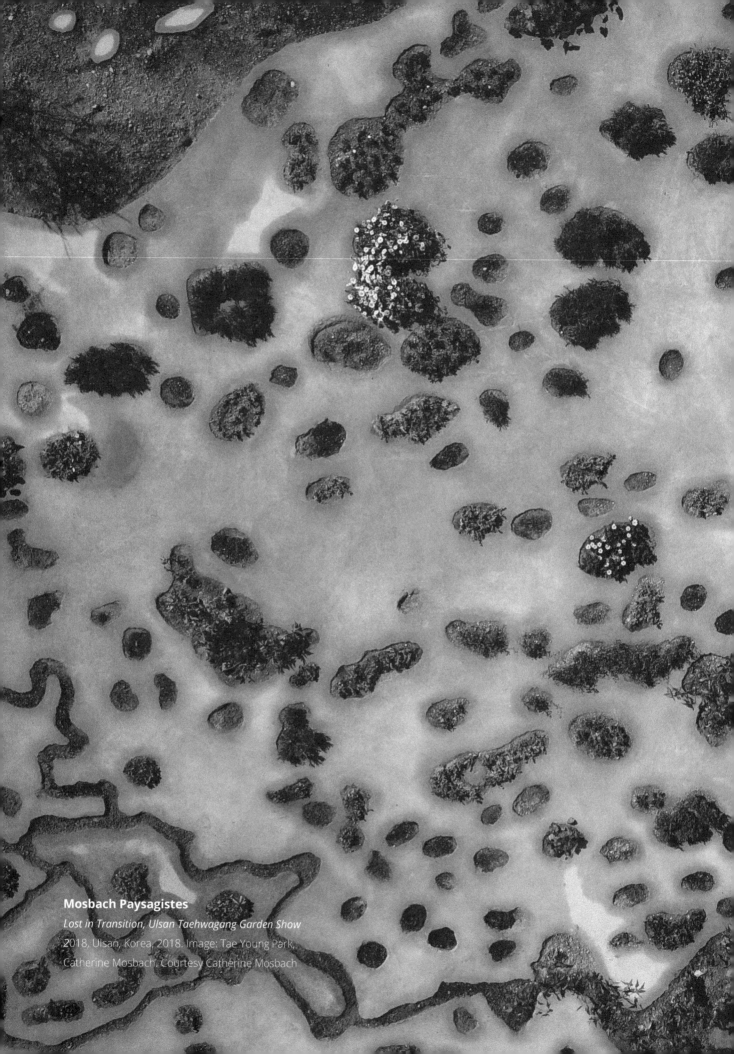

**Mosbach Paysagistes**
*Lost in Transition, Ulsan Taehwagang Garden Show*
2018, Ulsan, Korea, 2018. Image: Tae Young Park,
Catherine Mosbach. Courtesy Catherine Mosbach

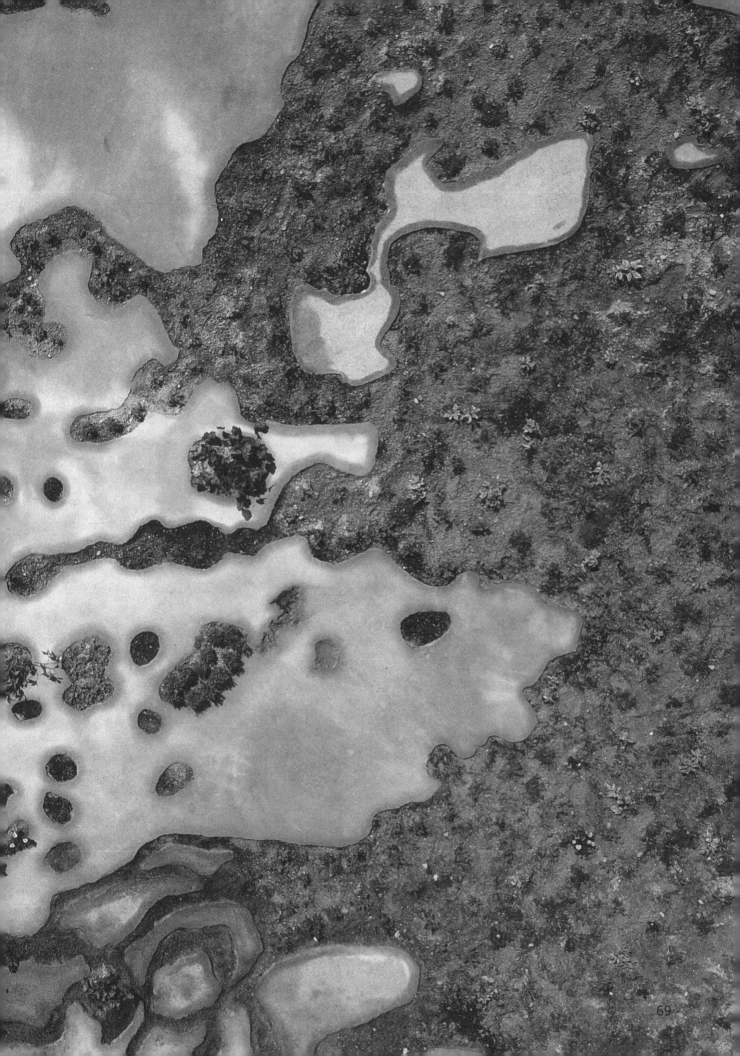

reshaped, the shell-sprinkled land becomes an ideal habitat for seabirds, for both nesting and resting during high tide. West 8's design composition provides a regular grid that alternates areas of light-colored shells – predominantly clams – and areas of dark-colored ones – like mussels – in a chessboard pattern. Although very abstract, the design is particular not only for its composition, but also – and above all – for its actual effect on nature. Birds tend to choose the area with the shells that offer them the best camouflage. Light-colored birds – like the tern and the herring gull – prefer the background of the white shells, whereas darker birds – like the kingfisher – prefer the black ones.

"In their triumphant advance down the expressway that runs along the dikes, the city dwellers glide above the polders of the Schouwen-Duiverland, which lie four meters lower down. In a long and gentle curve, the expressway rises thirteen meters to the height of the Oosterschelde-Kering. Halfway up, the impressive sight of the Oosterschelde opens up before the traveler's eyes, with a shrill and hysterical cloud of seagulls hovering above the horizon. On the ground there is a panoramic view of a myriad of birds of different species. It is the biggest, living Zen garden in the world: not just the city dweller but also nature reveal their own capacities for interpretations. The framework of the urban landscape constitutes the next phase of evolution".[14]

### 3. Wilderness (Deserts)

Nevada, 1969. Michael Heizer leaves the perceptive comforts of the urban scale to go to – and measure himself with – the boundless wilderness of the North American desert. Between 1969 and 1970 he created *Double Negative*: a 535-meter long and 15-meter deep trench dug into the side of a mountain in the Nevada desert. For the construction – or better, subtraction – of the trenches, 240 thousand tons of rock (mostly rhyolite and sandstone) were moved. Speaking of landscaping and landscapes, the desert is perhaps the most extreme case of all. Couldn't even a desert be considered a great void? Couldn't even this vast expanse be considered a surface? What are "earthworks" if not an attempt to affect this surface, engraving it so as to bring together into contact different layers, precisely where these would seem to not even exist? By digging up the desert, Heizer subtracts matter and creates an further void within what we thought was the emptiest surface possible. By doing so, he brings new depth to the area; not just physical depth, but historical, vital, ecological, and political. In excavating *Double Negative* Heizer physically immersed himself in the landscape; a landscape that was inhabitable, hostile, and abstract; a landscape where man, first and foremost, appears as 'otherness'.

Today, the website reads: "Part of the beauty of earthworks lies in their natural surroundings. Please do not disturb the desert ecosystem found around Double Negative. The surrounding area is public land belonging to the Bureau of Reclamation or the Bureau of Land Management. Collecting or disturbing plants, fossils, or artifacts on this land is prohibited".[15]

Ironically, what we are now able to recognise as a protected 'ecosystem of beauty' has been unveiled thanks to the human action performed by Micheal Heizer, who in turn has been weakened by the harshness of this landscape, with serious health problems.

So, one last unsettling question: Who is fragile? Who needs to be preserved? Who disturbs whom?

This seems to be a new version of the paradox highlighted by postmodern anthropology, related to the impossibility for the anthropologist to observe a cultural environment without becoming part of it and thus inevitably 'affecting' it. Scholars such as Clifford Geertz, James Clifford or Edward Said falsified the idea of a possible 'purity' in the identities of places, since

*Ironically, what we are now able to recognise as a protected 'ecosystem of beauty' has been unveiled thanks to the human action performed by Micheal Heizer, who in turn has been weakened by the harshness of this landscape, with serious health problems.*

**Clf 23**

A view into *Michael Heizer Double Negative* (1969) from the North end looking South, 2007 CC BY 2.5

interactions - *contacts*, we might say - contaminate identities, which, in an ethnographic sense, can only be mixed, relational and inventive. The anthropologist immerses himself in the environment he studies, just as Gilles Clément or, even more violently, Micheal Heizer dive into the environments, inviting us to a more intense, *deeper* relationship. All these practices bring us face to face with the evidence that around the *human* is neither nothingness, nor emptiness, nor void, nor purity, but an extremely complex set of vital and ever-changing ecosystems, which we are constantly influencing, as we are constantly coming into contact with them.

Let's try to be gentle, kind – and actually *human* - with our contacts; not necessarily superficial.

### *Endnote*

[1] Lucius Burckhardt, *Tahiti alla Bovisa*, in *Le città del mondo e il future delle metropoli/World Cities and the Future of the Metropoles, International Exhibition of the VII Triennale,* exhibit catalog edited by George Teyssot, Luigi Mazza, Triennale di Milano/Electa 1988.
[2] Giuliana Bruno, *Surface. Matters of Aesthetics, Materiality, and Media*, University of Chicago Press, 2014.

**Lotus International**

*Lotus International* 87, 'The Uncultivated Land', 1995; *Lotus International* 88, 'The Two Gardens', 1996;
*Lotus International* **128**, 'Reclaining Terrains', 2006

[3] Cf. *Il viaggio di Lucius Burckhardt / Lucius Burckhardt's Journey*, in «Lotus International», n. 161, 2016, pp. 35-36. See also Francesca Pasini, *In margine alla Triennale. Tahiti alla Bovisa*, in «Modo» n. III, Jan/Feb 1989 and Carlo G. Grossi, *L'itinerario "meraviglioso"*, in «Gran Bazar», Feb-Mar 1989.
[4] Le città del mondo e il futuro delle metropoli/*World Cities and the Future of the Metropoles, Inernational Exhibition of the VII Triennale*, exhibit catalog edited by George Teyssot, Luigi Mazza, Triennale di Milano/Electa 1988.
[5] Cf. Lucius Burckhardt, *Why is Landscape Beautiful? The science of Strollology*, edited by Merkus Ritter and Martin Schmitz, Birkhäuser Verlag, Basel 2015.
[6] Cf. Nina Bassoli, *Il grande Vuoto/The Great Void. Scalo Farini*, in «Lotus International», n. 161, 2016, pp. 30-34.
[7] Ernesto Schick, *Flora ferroviaria: ovvero la rivincita della natura sull'uomo. Osservazioni botaniche sull'area della stazione internazionale di Chiasso, 1969-1978*, Chiasso Credit Suisse editions, 1980. See also the recent new edition, with English translation, Ernesto Schick, *Flora ferroviaria / Railway Flora*, with essays by Graziano Papa, Florette, Chiasso/Humboldt, Milano, 2015.
[8] Cf. Annegret Burg, *Natur-Park Südgel.nde, Berlin-Schöneberg. Una imprevista vittoria della natura/An Unexpected Victory of Nature*, in «Lotus International», n. 144, 2010.
[9] "Nowadays, nature is no longer found in the countryside, farmers have long since destroyed it. Nature is in the metropolises, beyond the city center, in the belt of abandoned factories, in looted quarries, in landfills, between train tracks, and along the wall that separates the two German republics, representing the largest national park in Europe." Lucius Burckhardt, *Op. Cit.*
[10] Gilles Clément, *Breve storia del giardino*, Quodlibet, Macerata, 2011, pp. 116-117. (Translation by the author).
[11] *Ivi*, p. 105. (Translation by the author).
[12] Cf. Marc Bédarida, *Tradizione francese e paradigma ecologico/French Tradition and Ecological Paradigm*, in «Lotus International», n. 87, 1995, pp. 7-15.
[13] The Clément-Berger design tied in its victory with Alain Provost's project developed together with architects Jean-Paul Viguier and Jean-François Jodry.
[14] Cf., Adriaan Geuze, *Nuovi parchi per nuove città/New Parks for New Cities*, in «Lotus International», n. 88, 1996, p. 55.
[15] http://doublenegative.tarasen.net.

**Nina Bassoli** is an architect, researcher and curator, PhD at Architecture University of Venice IUAV, she graduated at Politecnico di Milano, where she teaches Architectural and Landscape Design. Since 2008, she is member of the editorial staff of "Lotus international" and she has been curator and co-curator of several architectural exhibitions and events, as, among others, *Recontructions. Architecture, city and landscape in the age of destructions* (with Alberto Ferlenga, Triennale di Milano, 2018), *Architecture as Art* (2016) and *City after the City - Street Art* (2016), within the XXI International Exhibition of the Triennale di Milano, and she coordinated the Italian Pavillion *Innesti/Grafting* at the 14th Venice Biennale curated by Cino Zucchi (2014).

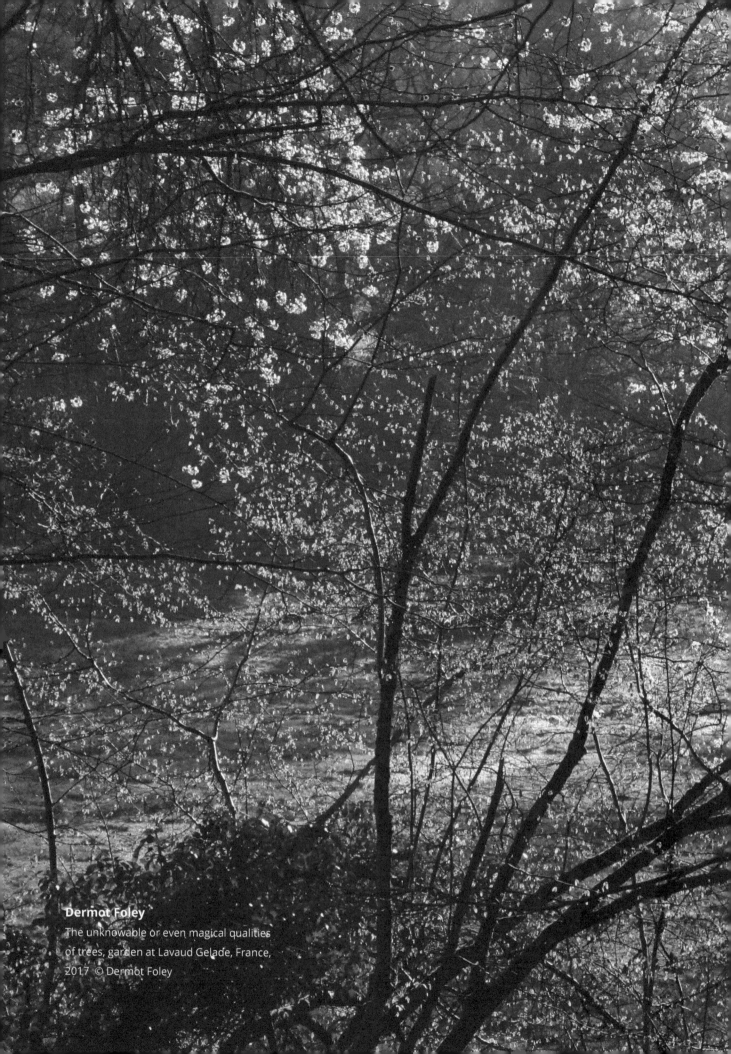

**Dermot Foley**
The unknowable or even magical qualities
of trees, garden at Lavaud Gelade, France,
2017 © Dermot Foley

# Observing-intervening

*Observing as-found conditions of ground and substrate can fine-tune our appreciation of secondary-raw-materials, as they interact with ecological processes. Dermot Foley's work is a response to the EU Waste Framework Directive (2008) and the EU Construction and Demolition Waste Protocol and Guidelines (2018), using secondary-raw-materials in public space. The outcome of the work endures not only in the space, but in modified drawing types which have the capacity to trigger embodied cognition. This neurological phenomenon, which links the observation of an action with the performance of an action, may be potent in eliciting an investment by others in uncertainty, so that the course of a (design) conversation is shifted toward a more nuanced understanding of our nature.*

text by **Dermot Foley**

oday a new public space is emerging in Dublin's city centre which belongs to a chronology of projects in our landscape architecture practice. The park is one outcome of a body of practice-based research. It has its roots in a deeper personal history but in more recent years can be traced back to *TURAS Transitioning towards urban resilience and sustainability (2011 – 2016)*, during which I was inspired by brown roof technology being developed by research partners at the University of East London.[1] TURAS was a response to a call for research that would, inter alia, propose artistic and creative design solutions to the grand challenges of natural resource depletion and climate change, in a way that would explore the interface between art and science. The acronym is derived from the Gaelic word turas, or, journey. From 2013 to 2019, I developed and partially implemented basic notions of foregrounding the use of secondary-raw-material in public space, at the *New Town House* project for Kingston University, London. This project was a case study as I elaborated the research for a practice-based doctorate (2016 – 2020) at the Royal Melbourne Institute of Technology (RMIT). Now, the research is further hybridizing with more action on the ground at the new Bridgefoot Street Park in Dublin.

The research is fundamentally about demonstrating how novel ecosystems can emerge and evolve on secondary-raw-materials in public space. If it could be considered in terms of work packages the packages could be described as, firstly, the aesthetic of the sensed aspects of ecology (the character, including appearance of novel ecosystems), secondly, the ecology of experimental substrates (the technicalities of using secondary-raw-materials) and, thirdly, the practice of constructing new cultural landscape (doing all of this in newly designed public space, with all that that entails, not least the sometimes crude provisions of public procurement). Of course, it is not as simple as that. Enveloping these so-called work packages is a fourth – research through studio and site-based drawing, conversing, mimicking, testing and redoing. This is the research that binds all of the other work packages together. It is the research that brings a wider group of protagonists into the fold and bestows upon them a kind of authorship.

## Horticulture and ecology – a personal journey

To contextualise the horticultural and ecological aspect of the research I call upon the legacy of William Robinson, or the Robinsonian style and in more recent times that of Gilles Clement or *le Jardin en Mouvement*. Both Robinson and Clement have broken the rules, so to speak, have meddled with tradition to create a fusion which in turn redirects the tradition. This kind of fusion is only possible through practice, empirical research, action on the ground. Plants have unknowable, almost magical, qualities which oblige us to work directly with them. For most landscape architects, however, this way of working is difficult if not impossible in the context of public procurement. There is a gap between the reality of working directly with plants, unknowable as they are, and that of working with drawings and other documentation required for the delivery of public space. This gap can remain unbridged or even unbridgeable. How do we draw novel ecosystems, or what I call synthologies? How do we draw plants in action, the plants responding to experimental substrates? How do we get this costed? How to we discuss this with contractors? One solution is not to draw the ecosystems, the synthologies, but to draw the new contexts within which plants and their symbiotic partners will exist and of which they are a generative force. And yet, how do we get to the stage where we can successfully work beyond the drawings with these realities, of how such complex living organisms as plants respond to their environment, and still further the complexity of these organisms as communities with associations? We have to advance, only partially knowing, by sprinkling or broadcasting literally and metaphorically, until we generate an output, an output which is not fully predictable, nor fully under our control.

*There are certain plants that I know as individuals and to which I am bound emotionally. At the same time, I have enough experience to know that I don't really know these, or other plants, in any way but superficially.*

**Dermot Foley Landscape Architects**

Aerial view of the one-hectare Bridgefoot Street Park under construction,  Dublin, 2020, photo Paul Tierney

© Paul Tierney

But let us go back a step, to our working relationship with plants. I have been gardening in one way or another for over 35 years. There are certain plants that I know as individuals and to which I am bound emotionally. At the same time, I have enough experience to know that I don't really know these, or other plants, in any way but superficially. They are, if you like, unknowable. Despite my background in horticulture and agricultural science I am continuously surprised by plants, their resilience, their endurance, their vulnerability, the way they grow into space, almost everything about them. Their predictability is even surprising and yet they are unpredictable as well. And so, over the years I have been letting go of knowledge and deliberately forgetting, in an attempt to cultivate a new way of relating to plants. And yet the science that I know helps me to create contexts within which plants will exist. My practice, therefore, exists within this reality of letting go on the one hand, and on the other, of manipulating the science in order to create new landscape.

As I write, I can see the tiny parcel of a possible ecosystem outside the window, in the garden to the front of the house, a fragment of what would be there on a grand scale if, as a community, we modified our way of observing and intervening. There is the notion of abandonment, which is anathema to some, but is gaining ground in our cultural arena. The use of almost every herbicide of the twentieth century is now forbidden and cities are relaxing what had been an obsessive and continuous process of tidying. Although I hesitate to polarize, it doesn't go unnoticed that the opposite is happening in

**Dermot Foley Landscape Architects & Grafton Architects**

Secondary-raw-materials were used as substrate and surface finish for the public space as well as the private terraces and roof gardens at the New Town House, Kingston University, London, 2013-2019, photo Ed Reeve © Ed Reeve

rural landscapes, where agriculture is developing ever more intensive practice, but my realm, at least for this research, is the city.

### Ambiguity and embodied cognition

The thrust of this essay is to contextualize our recent work as practising landscape architects at Bridgefoot Street Park in the dual realities of seeing and doing. Why do we observe? In my case I observe because I wish to intervene. To build a public space, however, requires a team of people so that the observing and the intervening is being done by many individuals across the life of the project, and in the case of a public park that life might extend for decades or centuries beyond its initial construction. We can think of observing and intervening as inter-dependent, as a kind of mutuality. The types of drawings that we make for Bridgefoot Street Park are responsive to given situations as the project unfolds. They always contain a hint of ambiguity. Layered plans, overlay sketches, and time-lapse images are types of documents that can be shared as part of an open conversation.

A hint of ambiguity in the drawing is enough to engage mirror neurons which trigger embodied cognition so that people become more active participants in the design process, feel part of it, and are more likely to make a contribution, rather than passively receive drawn information.

Fincher-Kiefer provides an easily assimilated view of embodied cognition as "one that proposes that the body, or specifically sensory and physical experiences, is essential in determining how we understand the world and build conceptual knowledge".[2] She suggests that "the unique features and attributes of our own bodies and emotions determine the capacity to acquire and use sensory information, give it meaning—make it knowledge. From this view, the representation of knowledge must be multimodal; the body is no longer peripheral to cognition".[3] I find this a direct parallel to my development of knowledge as a practitioner, from drawing to working with plants. The particular situations that I have found myself in as a gardener over many years have assisted me in giving meaning to sensory information – to make it knowledge.

## Consciousness – foregrounding and backgrounding

I find the fact that bryophytes and other organisms populate a degraded substrate both beautiful and emotionally up-lifting. The novel ecosystems, that simply happen on the tracked and compacted subsoils of an abandoned construction site, expand my world of practice. These happenings broaden the entire spectrum of practice. They are observed in the matter-of-fact world of demolition and construction and they take place in the equally matter-of-fact world of natural succession. The compressive forces of the machine's tracks create a slightly recessed, impermeable imprint, a depression, which traps water and becomes home to tiny but complex expressions of life. I refer to these places as synthologies and they have value that is unquantifiable. Their existence has an inevitability about it and, by the same token, their demise is inevitable. But a sort of fluctuating patchwork of ecosystem endures in the city as long as synthologies spring up with sufficient frequency to replace those that have disappeared. Synthologies appear, are destroyed, reappear and happen in different locations at different times throughout the city. A continuous turnover of land provides plenty of opportunity for ecological process.

Observing as-found conditions of ground and substrate in the city can fine-tune our appreciation of secondary-raw-materials, as they interact with ecological processes. My work in this field is a response to the EU Waste Framework Directive (2008) and the EU Construction and Demolition Waste Protocol and Guidelines (2018); a response from the realm of aesthetics which is practical and sensible. I am concerned with foregrounding and backgrounding the use of secondary-raw-materials in public realm, in a way that allows for ecological processes to play out. It is a useful thing that ecosystems can be encouraged to develop on experimental substrates by the manipulation of the type and grain of those substrates, in such a way that is artistic, composed, partly determined by geometry and even geometric. It is useful because it encourages biodiversity, thereby making our settlements more resilient, but the work is also useful because it makes explicit the idea that waste can host heightened biodiversity when compared to more conventional substrates and that the nature of that biodiversity is not always fully predictable, thereby leaving openness for change or the unexpected.

I have not yet found an opportunity to work directly with these found synthologies, whether by preserving them in-situ, or creating the track-like compaction on substrates in public space. Instead I am working with constructed or built (as opposed to found) techniques to trigger the process of colonization by plants and to bring that process to the fore in our work. At Bridgefoot Street Park we are not using compacted sub-soils, but we are using waste streams from the demolition process, pieces of broken or crushed concrete and brick, together with left-over stone and recycled glass, in order to construct synthologies.

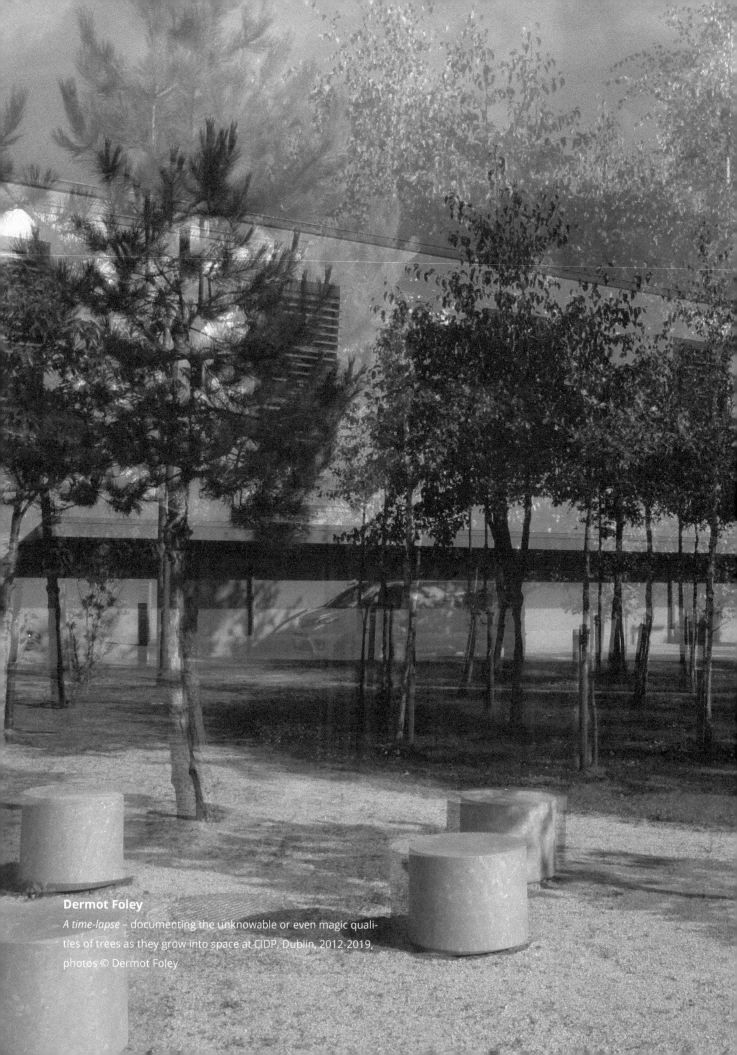

**Dermot Foley**
*A time-lapse* – documenting the unknowable or even magic qualities of trees as they grow into space at CIDP, Dublin, 2012-2019, photos © Dermot Foley

**Dermot Foley**

*The practice of abandonment,* garden at Lavaud Gelade,
France, 2011-2020 © Dermot Foley

These fragments of waste are abundant. They are freely available all
over the city, every day. They belong to the biggest waste stream in the Euro-
pean Union, yet in Ireland, our access to them as creative and resilient build-
ing blocks for new landscape is restricted. The materials exist in a commer-
cial and legal limbo, with the Irish legislature not yet having fully established
a clear framework within which the embodied energy of such materials can
be creatively reused. This is partly to do with the darker side of ecology, our
tendency to contaminate our world through relentless technological explo-
ration. Waste, therefore, must be analysed, de-risked, cleaned. And in an
ever more risk-averse world, ironically it is risk to humans that is holding us
back, not risk to the bryophytes, plants, molluscs, arachnids and insects that
will freely colonise secondary-raw-material. The de-risking of the material to
be used at Bridgefoot Street Park takes place on several levels, both phys-
ically and administratively. But there is also a kind of aesthetic de-risking
that occurs. This has to do with communicating the design intent by various
means to a variety of protagonists along the journey from the initial commis-
sioning of the project, through the statutory process of planning consent, the
costing process, the construction process and perhaps the most important
and lengthy process of all, the establishment, or nurturing of the syntholo-

gies through the early years following the so-called completion of the park's construction.

De-risking takes place as a series of processes. In fact, processing is the key to complying with EU waste directives. Waste ceases to be waste if it can be rendered safe by a given process. It is now what we call secondary-raw-material. In the eighteenth century the site on which we are building Bridgefoot Street Park was a depot for animal dung with the street bounding the north of the site aptly named Dunghill Lane. In fact the corridor of land between the River Liffey and the ridge a couple of hundred metres to the south is replete with Viking remains often in the form of middens, or mounds of waste hidden under centuries-old layers of fill. The older the waste the more interesting it is to our archaeologists. It seems as if time itself is a process through which waste ceases to be waste. As cities became larger and more complex the need to process waste became more pertinent. From human waste carted away by the night soil men for use as compost in early plant nurseries to today's process of fecal sludge management for fertilizer, our horticulture and now our ecology is predicated on the reuse or processing of waste.

**Dermot Foley**

*Machine imprints* - two synthologies at Lough Boora, Offaly, and Adamstown, Dublin, 2006-2012 © Dermot Foley

The work at Bridgefoot Street Park involves translating a message about waste and is linked to the simple principles of foregrounding and backgrounding. Making the process of colonization of waste a visible and foregrounded experience has totemic potential, but perhaps does not deal with the volume of secondary-raw-material generated throughout the city. Backgrounding has the potential to deal with volume (often unseen in large civil engineering works) and to normalize the experience (if it is seen but perhaps not recognized as such), so that the totemic foregrounding will cease to be important as time goes by. For the moment, in Dublin's current aesthetic and cultural context, the totemic gesture is my key consideration in designing and constructing Bridgefoot Street Park. Foregrounding, with the use of particular materials, that have particular connotations, calls into question the style of the park, but I have argued elsewhere that we can consider styles as not really styles, but as states, or factual scenarios.[4]

**Bringing this to life – translating and conversing**
In the introduction to Revealing change in cultural landscapes, Catherine Heatherington identifies how climate change is encouraging some of us to attempt to construct resilient landscapes but she points out that "little thought is given to how to make these landscapes legible".[5] I must admit that climate change is not my primary motive for what we are doing at Bridgefoot Street Park, however, the park is being built with resilience in mind. But the issue of legibility is one of my core concerns in this kind of practice.

Our role is to find a way of working with the contractor to best tra-

late the notions of foregrounding secondary-raw-material and establishing synthologies, so that the contractor can place the material in an artful way. Together with my colleague Simon Canz I have been trying to find a method for translating these notions, without physically doing the work itself. I want the contractor to successfully realise the outcome her/himself.

This translation succeeds only after a period of time has elapsed with the contractor, during which trial and error, aided by a diverse and evolving kind of documentation, slowly delivers promising portions of the constructed landscape. The unpredictability of the secondary-raw-materials, in terms of their shape and size, hinders the translation and at the same time ignites the imagination. The materials are brought to the site from all sorts of locations throughout the city. Every time a new batch of secondary-raw-material comes to the site we review the shapes and sizes, recalibrate and continue the construction process. This is about doing and seeing, doing again, taking apart and redoing. It's a sort of remembering. The overlay sketches are a kind of glue that keeps the translation between designer and contractor comprehendible. Embodied cognition, triggered by the initial layered plan, was sufficient to keep people curious and excited prior to the start of construction. During construction, this curiosity is sustained by use of the overlay sketches.

In laying out the pieces of secondary-raw-material our working method with the contractor has been one of suspending "'existing personal biases, beliefs, preconceptions, or assumptions in order to get straight to the pure and unencumbered vision'" of the essence of the thing or

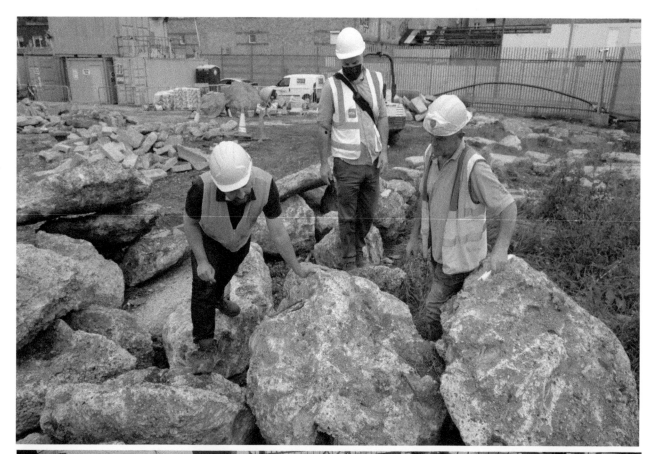

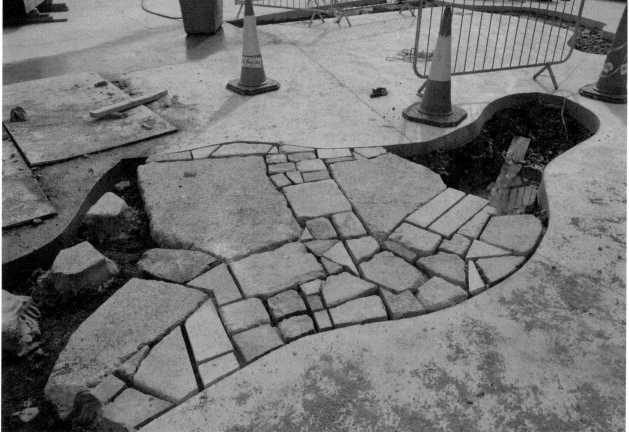

**Dermot Foley Landscape Architects**

Simon Canz and Dermot Foley with contractor John Cannon, selecting large pieces of recycled concrete (secondary-raw-material) at Bridgefoot Street Park, Dublin, 2020, photo Calum Kirkwood © Dermot Foley

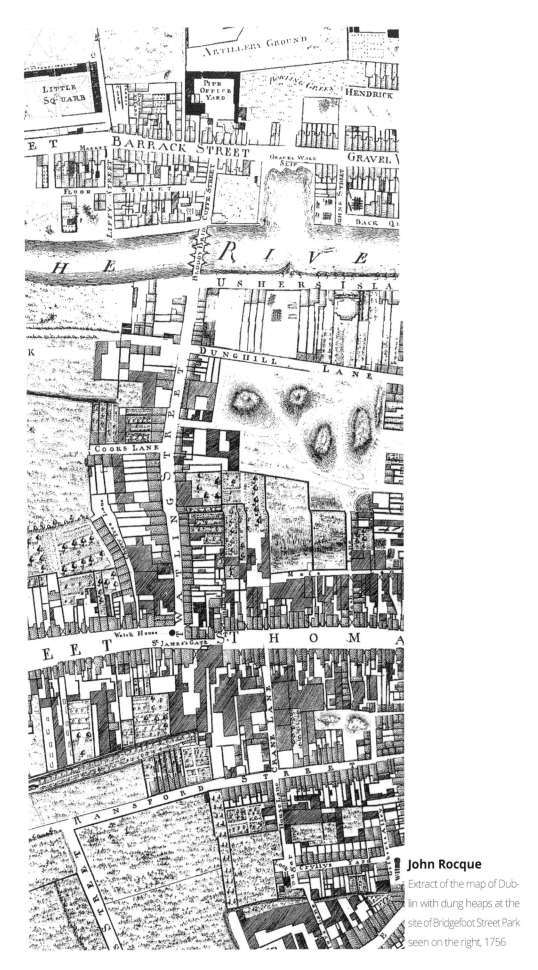

**John Rocque**

Extract of the map of Dublin with dung heaps at the site of Bridgefoot Street Park seen on the right, 1756

**Dermot Foley Landscape Architects**

A layered plan – each of the many detail design iterations for Bridgefoot Street Park are superimposed to express the certainty of the proposal while at the same time offering a hint of ambiguity, 2016-2019

© Dermot Foley

things.[6] In this case the thing is, say, a large piece of broken concrete. But at the same time, in contradiction, we find that we have to use comparisons or metaphors to keep the conversation going. 'Its like a boulder, isn't it?'... and so on. We are careful to limit this kind of conversation and always temper it with language of a more neutral tone, by describing the pieces as flat or large, regular or irregular. Our goal is to arrive at an assembly which is expressive of a deliberate and almost mechanical placing, with the idiosyncrasies of the secondary-raw-material evident where possible. This conversation with the builder is a conversation of talking and doing, drawing and seeing, together on site. It is a joint and shared embodied cognition. We are all getting better at it as we progress through the work, as if the '"unifying idea is that the mind and cog-

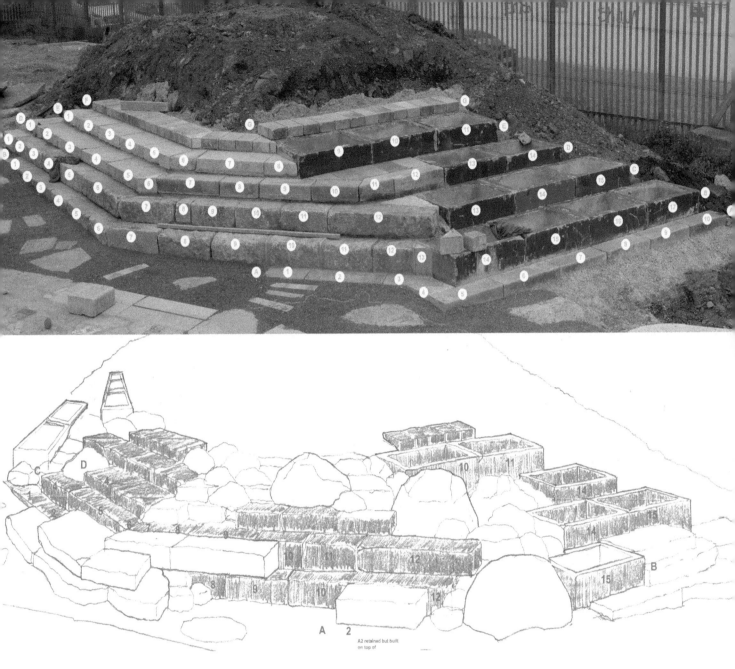

**Dermot Foley Landscape Architects**

An overlay sketch - drawing over work in progress at Bridgefoot Street Park – a novel way of critiquing or snagging the placement of secondary-raw-materials in order to agree changes with the contractor, 2020 © Dermot Foley

nitive processes are embodied, in that all aspects of cognition are grounded in the acting body and situated in reference to past experiences".[7] As I mentioned in the introduction, this gives a wider range of protagonists an authorship – a claim over the work.

### A final word on tradition

The work that we are doing as designers at Bridgefoot Street Park is embedded in several traditions including those of landscape architecture, horticulture, stone masonry, ecology and art. I have already mentioned a number of key moments in the horticultural tradition: William Robinson, Gilles Clement. And there are others. But to focus more on the second research work package, that of experimental substrate, there is the more

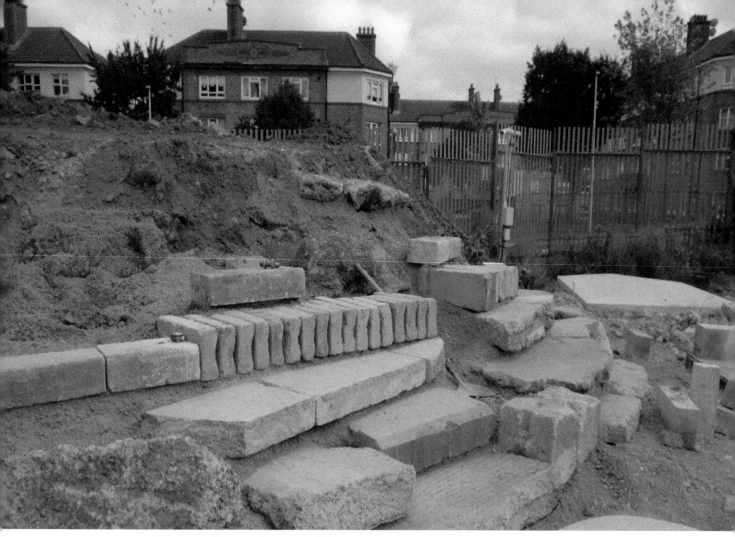

**Dermot Foley Landscape Architects**

Drawing and building as a way of learning. Work completed by the contractor after other areas had been critiqued with overlay sketches, 2020, photo Calum Kirkwood © Dermot Foley

immediate tradition of practitioners and artists using waste in a creative way, of the short-circuit economy, Louis Le Roy's Ecokathedraal and many works completed in the latter half of the twentieth century in Europe, particularly in Germany, as well as more recent work in the USA. There is also the tradition of temporary garden or public works in Dublin, although limited. Bridgefoot Street Park, however, is the first public space in Dublin to be built in this manner, with secondary-raw-materials, commissioned by the city and to be used fully publicly in a state which might be described as permanent as opposed to temporary.

From the horticultural fusion set in train by the likes of Robinson and Clement, the awareness of the mundane quietly present in the work of Alexandre Chemetoff, the countless generations of stone workers and artisans, the craft of the Japanese tradition, to the hyper specific yet magical observations of Albrecht Dürer, the work is typical in its derivation from a global collection of traditions. But this is not to say eclectic, rather there is an inevitable link to all things human. The work relies as much on our capacity to forget than on our capacity to remember. To say that a style is not a style, but a state or a factual scenario, is not to say that it is merely a state, or merely a factual scenario. It is not my intention to reduce what we do and experience to inarticulate material, but I think that our capacity to forget, and better still deliberately forget, allows us to see anew. In forgetting what has gone before, we can assimilate more rapidly what confronts us. But this

**Dermot Foley Landscape Architects**
Spontaneous vegetation on secondary-raw-material at Bridgefoot Street Park after construction of sample area prior to entering into contract, 2019 © Dermot Foley

forgetting has to be somehow temporary, or at least it has to give rise to a new departure which fills the void left by our forgetting. The layer-upon-layer of experience, of perception, or fact, or style and the fusion of these layers allows room for novel propositions such as that which is being invented at Bridgefoot Street Park. The risk of visitors to the park perceiving the waste as waste is, I hope, diminished, firstly, by the way in which the waste is artfully placed and secondly by the capacity of those people to forget.

In 1794 the Irish MP Samuel Hayes wrote his *Practical treatise on planting and the management of woods and coppices.* Hayes tells us that the scope of his book is firstly "to be strictly practical" and secondly to inspire people to love trees, or, even to take up the cause of tree planting.[8] The work that we are doing at Bridgefoot Street Park is a kind of practical treatise – a dissemination of research outcomes through multiple portals – the community workshops, the drawings, the construction, the park itself as an experience and the evolution of the park in the future. It is a treatise with firstly an undeniably practical scope, but secondly and more importantly, an intention to expand the way in which we collectively experience and love civic ecologies.

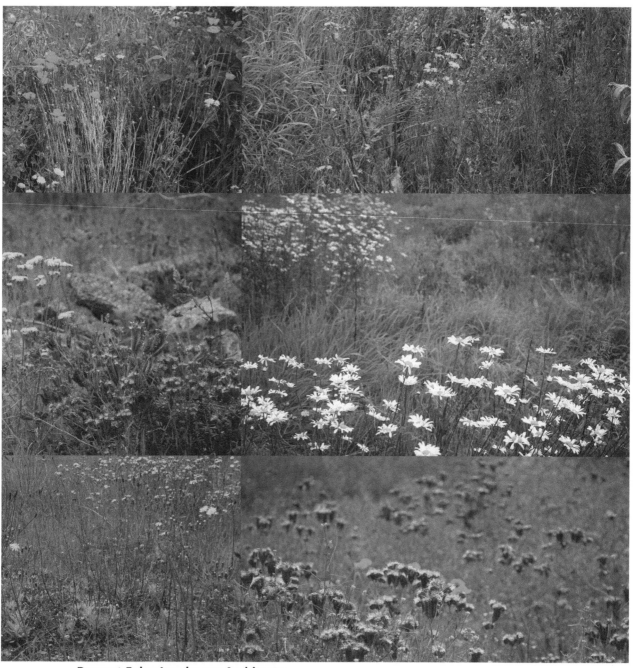

**Dermot Foley Landscape Architects**

Spontaneous vegetation at Bridgefoot Street Park after construction of sample area prior to entering into contract, 2019 © Dermot Foley

**Acknowledgement:** This essay is a development of practice-based doctoral research titled Preciseness, vagueness, which was carried out by the author as a candidate with the Royal Melbourne Institute of Technology (RMIT) and supervised by Dr. Mauro Baracco. The doctoral research was partly supported by the EU FP7 funded ADAPT-r programme. The author would like to acknowledge Dublin City Council Parks and Landscape Services for commissioning Bridgefoot Street Park.

## Endnote

[1] Collier, M. et al., Transitioning to resilience and sustainability in urban communities, *Cities*, 2013, pp. S21 – S28.

[2] Fincher-Kiefer, R., *How the body shapes knowledge: empirical support for embodied cognition*, (Washington: American Psychological Association) 2019, p. ix.

[3] Ibid, p. x.

[4] Foley, D., 'Small imperfections: a case study' in *Revealing change in cultural landscapes: material, spatial and ecological considerations*, (Abingdon: Routledge) 2020, p. 215.

[5] Heatherington, C., *Revealing change in cultural landscapes: material, spatial and ecological considerations*, (Abingdon: Routledge), 2020.

[6] Bowring, J., *Landscape architecture criticism*, (Abingdon: Routledge) 2020, p. 93.

[7] Coello, Y. and Fischer, M. (eds.), *Perceptual and emotional embodiment; foundations of embodied cognition* volume 1, (Abingdon: Routledge), 2016. (Accessed online 15th Feb 2020)

[8] Packenham, T., *Samuel Hayes practical treatise on trees* (Dublin: New island) 2003, pp. xiii-xiv.

**Dermot Foley** (BAgrSc BA MLA PhD MILI) is a practising landscape architect and an Assistant Professor of Landscape Architecture at University College Dublin. The work of Dermot Foley Landscape Architects, established in 2001, has been recognised internationally. Dermot was awarded *Europe 40-Under-40* in 2010 and was an ADAPT-r scholar during his PhD candidature with the Royal Melbourne Institute of Technology (RMIT). He published Artifice in 2011 and has contributed to several publications on landscape architecture, most recently *Revealing change in cultural landscapes*, edited by Catherine Heatherington. Dermot was a founding partner of the award-winning EU FP7 research project *TURAS (Transitioning towards urban resilience and sustainability)*.

# One True Time

*The concept of a plant out of place (a weed) exists outside of the interconnectedness of the Earth's systems capable of transporting a single seed across continents. It requires a singular official narrative of what belongs where at one point in time. The 'weed' has in some settings adapted more quickly than it might have to a new kind of ecological niche – the urbanized environment of the Anthropocene – to complicate notions of place and endemism.*

text by **Louise Wright**

I t's possible that until the foreshortening of space and time of the Anthropocene[1] weeds did not exist. A weed is a plant out of place often thriving on sites of disturbance, in their turn also a phenomenon of the Anthropocene. Somewhere it isn't a weed. Plants have always moved around, their progeny hitching a ride on an animal or the wind, finding themselves 'out' of their place. No humans involved. In (geological) time they might adapt.

Consider the deep time of the *Microseris* in Australia. The *Australian* species of the genus *Microseris* is thought to have evolved from one or a few diaspores (seed dispersal units) after a unique event of long-distance dispersal from western North America,[2] perhaps *Microseris paludosa*[3], a species endemic to California.[4] This seed at some point arrived via the wind or water to Australia. Evolving from a single species in a process called adaptive radiation,[5] it formed several species from its ancestor to occupy ecological niches becoming *Microseris lanceolata*, (and *M.* walteri and M. scapigera), also known as the Murnong[6] Yam Daisy. Until very recently (pre European colonization) they grew in abundance in southeastern areas of Australia. Considered endemic and central to certain language groups' customs, its tuberous root was a staple food of Aboriginal people harvested and cultivated by women on the plains grasslands.[7] It was we might say a plant out of place that given time adapted to at least three endemic[8] subspecies and to gain cultural significance. The concept of a weed as a plant out of place is perhaps only possible with the physical disturbance and accelerated displacement of species experienced in the Anthropocene.

Consider the ecological opportunity in Australia of the *Hypochaeris radicata* (and, or *glabra*), also known as false dandelion and endemic to Morocco[9]. It underwent a similar migration to evolve over time in Europe and then more recently it was *displaced* to Australia. In the absence of (deeper) time and opportunity to adapt to (now absent) ecological niches it is now listed as an environmental weed in Victoria[10], and considered a threat to *Microseris*.

In Australia, *Hypochaeris* and genus *Microseris* have often been misidentified for one another:[11,12] both in the Asteraceae family, in the order of Asterales, superorder of Asteranae, class of Magnoliopsida, phylum of Tracheophyta, kingdom of Plantae and in the form of life.[13] One imagines these genera met at some point around 1835 when European settlement began in Melbourne in the Port Philip Bay area, attracted by land suitable

**Hooker J.D.**

*Microseris Lanceolata*, illustration W.H. Fitch

Hooker, J.D., *Botany of the Antarctic voyage of H.M. discovery ships Erebus and Terror in the Years 1839-1843, under the command of Captain Sir James Clark Ross* (1844-1860)

Bot. Antarct. Voy.

vol. 3(1): (1860)

Plate LXVI

Fitch del. et lith.

Vincent Brooks Imp.

Tab. 2.

*Hieracium dentis Leonis Tournefort 470. Hypochaeris Linn. Spec. Pl. 1140 —*
*Ital. Teracio con foglie di Condrilla Gall. Piloselle —*

for grazing sheep, the same plains which sustained *Microseris lanceolata*. Within 5 years, the overgrazing processes, in turn, created the disturbance that supported the displacement of *Microseris*. Today, in their place and in many places, *Hypochaeris radicata* grow happily.

Despite the lack of opportunity to be of the place, the weed ironically has in some settings adapted more quickly than it might have to a new kind of ecological niche – the urbanized environment of the Anthropocene – to complicate notions of place and endemism. The fragmentation of plant communities into small isolated patches in leftover, unsealed soil of urban environments favors seeds considered to be non-dispersal, that is seeds that do not go far from the parent plant in for example the side of a road because they won't grow on the bitumen a few centimeters away. Rapid evolution within 5-12 generations towards non-dispersal has been shown in studies of plants in the fragmented plant communities of cities.[14] We could say they become *hyper* endemic.

The concept of a plant out of place exists outside of the interconnectedness of the Earth's systems capable of transporting a single seed from California to what we now call Australia.[15] It requires a *singular official narrative* of what belongs where at one point in time: One True Place[16] where there is One True Genus at One True Time.

*Originally written for* A-Z of Shadow Places Concepts, *see https://www.shadowplaces.net/concepts*

### Endnote

[1] Human activity has accelerated and geographically expanded in the Anthropocene so that "key components of the Earth System have moved beyond the natural variability exhibited in the last 12,000 years, a period geologists call the Holocene." The new planetary dashboard shows 'great acceleration' in human activity since 1950, https://www.sciencedaily.com/releases/2015/01/150115142223.htm
[2] Vijverberg, Kitty, Lie, Louis and Bachmann, Konrad. 'Morphological, evolutionary and taxonomic aspects of Australian and New Zealand Microseris (Asteraceae)', *Australian Journal of Botany*, CSIRO Publishing, Vol. 50 (2002), p. 128
[3] This idea is made with literary license of the author. After Author's correspondence with Neville Walsh , Senior Conservation Botanist at the Royal Botanic Gardens, Melbourne Australia, 15th September 2021, where Walsh communicates a theory put forward by Professor Kenton Chambers: "I looked back through emails from Kenton – he rather liked M. borealis as a possible ancestor. I guess it's highly likely that whatever made the journey was not an extant species but a recent ancestor. He believes it arrived first in NZ (possibly/probably on birds' feathers – he likes snipe, but others have been tracked to make the USA-NZ trip)."
[4] Chambers, K.L. Microseris paludosa, in Jepson Flora Project (eds.) Jepson eFlora (2012) https://ucjeps.berkeley.edu/eflora/eflora_display.php?tid=4159, accessed 10th September 2020
[5] Adaptive radiation refers to the adaptation (via genetic mutation) of an organism which enables it to successfully spread, or radiate, into other environments. Adaptive radiation leads to speciation and is only used to describe living organisms. Adaptive radiation can be opportunistic or forced through changes to natural habitats. https://biologydictionary.net/adaptive-radiation/, accessed 05th March 2021
[6] As Walsh observes, "The Koorie name 'Murnong' (or 'Myrnong') has long been applied (e.g. Gott 1983) in Victoria, and 'Garngeg' or 'Nyamin' in southeastern New South Wales (Blackburn et al. 2015)." Walsh, Neville, 'A name for Murnong (Microseris: Asteraceae: subfamily Cichorioideae)', *Muelleria*, Vol. 34, Royal Botanic Gardens Victoria (2016), p. 63
[7] https://www.anbg.gov.au/aborig.s.e.aust/roots.bulbs.html, accessed 05th September 2020
[8] Endemic (of a plant or animal): native or restricted to a certain area
Oxford Dictionary, Oxford University Press, 2001
[9] https://www.cabi.org/isc/datasheet/27895, accessed 05th September 2020
[10] White, M., Cheal, D., Carr, G.W. Adair, R., Blood, K. and Meagher, D. *Advisory List of Environmental Weeds in Victoria*, Technical Report Series No. 287, Arthur Rylah Institute for Environmental Research (2018)
[11] The taxonomy of the Australian *Microseris* was only defined as lately as 2015, see Walsh, Neville, 'A name for Murnong (Microseris: Asteraceae: subfamily Cichorioideae)', *Muelleria*, Vol. 34, Royal Botanic Gardens Victoria (2016)
[12] As observed by Walsh, "Smyth (1876, p. 171) reported at Coranderrk Mission (Healesville, Victoria) that 'the natives' ate the roots of non-native *Hypochaeris glabra* L. ('Nareengnan' in the local language) which does not have tuberous roots. This is interesting as, today, *Hypochaeris glabra* is not a particularly common plant in these parts (but *Hypochaeris radicata* L. is), suggesting perhaps misidentification. However, Smyth notes that the species listed were identified by Ferdinand Mueller, the Government Botanist at the time, and Mueller was certainly aware of *Microseris* (which he identified as a food plant elsewhere in Victoria in the same work) and *Hypochaeris radicata*. It is possible that, recognising the similarity between *Hypochaeris glabra* and *Microseris*, the Coranderrk aborigines adapted to the weed as it appeared in the district, suggesting further that they may have been accustomed to consuming non-tuberous species of *Microseris*." https://www.friendsgbg.org.au/uploads/images/Plants-in Focus/Microseris%20walteri.Murnong.Sep%202017.1.9.a.pdf, accessed 06th September 2020
[13] https://vicflora.rbg.vic.gov.au/flora/taxon/5b3ddfa7-d2ea-4ed8-9072-d774239bc6cf, accessed 05th September 2020
[14] Cheptou, P.-O., Carrue, O., Rouifed, S. and Cantarel, A. *Rapid evolution of seed dispersal in an urban environment in the weed Crepis sancta*, PNAS March 11, 2008 105 (10) 3796-3799; first published March 3, 2008; https://doi.org/10.1073/pnas.0708446105, accessed 6th March 2021
[15] See note 3
[16] Plumwood, Val, 'Shadow Places and the Politics of Dwelling', *Australian Humanities Review*, Issue 44 (2008), p.145, ANU Press

**Giorgio Bonelli**

*Hypochaeris radicata*, G. Bonelli, Hort. Rom., vol. 8 : t. 2 (1772-1793), Missouri Botanical Garden, St. Louis, U.S.A.

# Common ground

*Monica Gagliano is a pioneer in the research of plant cognition. Some of this work has focused on the ecological processes by which organisms are able to gather information on the variable conditions of their surrounding environment in order to thrive. There is the orchid and the pea who are sensitive to noise, and the mimosa that is sensitive to touch. We approached Monica wondering what the invisible processes of a city such as sound might be like for a plant. The conversation led to a call to unknow a Western scientific understanding and of the world and a bringing into process different ways of knowing that might change how we share space with species.*

text by **Monica Gagliano, Louise Wright and Mauro Baracco**

Monica Gagliano is an evolutionary ecologist whose daring and imaginative research has expanded our perception of plants and animals. Persevering against the scientific establishment, she pioneered the field of "plant bioacoustics," the study of sounds produced by and affecting plants. The results of her groundbreaking experiments suggest that plants may possess intelligence, memory and learning, via mechanisms that differ from our own. Gagliano is a Research Associate Professor at the University of Western Australia, and is the author of *Thus Spoke the Plant*. Her work has been featured by Michael Pollan in *The New Yorker* and on the RadioLab episode, 'Smarty Plants'. She is currently based at the University of Sydney.

**Louise Wright:** This issue of *Antennae* is titled 'Spaces and Species' – a play on Perec's *Species of Spaces*. It's a very wide inquiry about relationships between the built and the non-built world. We have been thinking very pragmatically about just the site of architecture, being the ground, the physical ground. We've been talking to Indigenous Australian spatial thinkers and designers, international architects, thinkers, artists, etc., just around these sorts of ideas.

**Mauro Baracco:** I think it's probably fair to say we got in touch closely with Giovanni two or three years ago, when we curated an exhibition at the architecture Venice Biennale with Linda Tegg, for representing the Australian pavilion. And that exhibition was called *Repair*.

**LW:** Linda Tegg's work is very much about looking at things from a different perspective, one that you might not have considered before. And so, to put a Western Plains Grassland in a cultural institution is to say it's valuable. And we were saying that usually those sorts of landscapes are overlooked, because they're the first ones to be grazed and then built on and so on.

**Monica Gagliano:** It's just grass, right?

**LW:** It's just grass. So ,we were pointing at what's displaced. And if we could see things in a different way, people might just start to think differently about land

that they occupy, and change their processes. We have a couple of lines of inquiry. One focuses around the sentience of plants, and their agency, and what that means for a plant in an urban environment. The second one centers around this idea of ecological justice — something you have written about. We are interested in the idea of an ontological shift. For instance, we are interested in questions like what would a plant learn and signal in an urban environment? If we think of the pea, who is sensitive to noise or vibration, what's it like for a plant in an urban environment?

**MG:** There are a few things to consider here. I guess, one is a personal story. And, actually, it takes me all the way back to Italy. I left Italy when I was 18. Then one year I went back. It was several years later. I landed in Turin, took the train to where my parents live. And I had taken that train many times before when I used to live there. It is very close to the mountains, so, when it snows, you see it. The mountain were always there. And I never cared less. It was just the mountain to me. I was so attracted by the ocean, that the mountain to me felt boring. And, yet, I was living right at its feet. And so, that day, after many years of not living there, the train heads straight for the mountains. For the first time, I realized I really noticed them; I really saw them. It's the Alps, so they are pretty pointy, and beautiful, and big.

While on the train, looking out of the window, and looking at these mountains approaching, this thought came to my mind. I had this image of a little dandelion. They are everywhere around here. And dandelions are particularly good, because they are one of those flowers that you find growing through concrete. This dandelion that is desperately trying to get through concrete. And it's going to do it. And it does it. And it's still beautiful when it comes out. Under the ground, under wherever we build, and under whatever concrete we pour, the roots are actually embedded in the same ground that makes those big mountains.

**LW:** It's the same place.

**MG:** Yes, the same place. And those roots and that soil are the ones that nurture the flower, to then it eventually emerges.

**LW:** If I'm understanding correctly, there's this idea that is bigger than the city, or that there's this connection underground and they're just sort of moving through.

**MG:** Yes.

**LW:** Let's think about this a bit more. I'd like to ask about that connectivity of plants in the ground and just that impact of fragmentation by urbanization, because I suppose it's not just the sealing of the ground. Quite often, there's a lot of urbanization happening under the ground.

**MG:** That's right.

**LW:** Plants have to now share the changes that all that urbanization brings to systems. But it seems that at least conceptually, you're feeling that those connections are still sort of happening underneath, or maybe it's through the air as well?

**MG:** Yes, and this is not to justify that, well... let's cover everything with concrete, because it doesn't matter. That's not my point. But I'm also say-

ing that, especially at this time, where it feels to me there is a big shift for humanity, in general, that a lot of people are changing their mind about their relationship to places. One of them, I think is our relationship to space and how we occupy spaces. People were stuck in cities during the pandemic lockdowns, suddenly they felt trapped. They didn't realize that often they were trapped already anyway, they just didn't know. They craved nature? I think that once we recognize that under the concrete, no matter how much you pour, the earth is underneath.

**MB:** Although the biology of the soil is diminished in health.

**MG:** Absolutely, but because we are always looking through human times-cales. It won't be supporting us, but it's still here, and it's doing its thing, and it just redesigns itself. Then the question really is not so much whether nature is able to respond to vibration or is doing well or not, or is growing well or not. But it's, 'are we responding appropriately?' We have these interspecies and interrelationship with the place, the space that we are occupying, literally. If we want to pour concrete, that's fine, nature is still there, you've just covered it.

**LW:** Well, in fact, we would think that a lot of built space, certainly over the 20th century, is about separating us from nature that exists 'outside'. That has definitely been part of our current crisis of detachment. A coming together might mean plants, or the natural world has an equal consideration in what we're doing and our decision-making, including buildings and where to pour concrete.

**MG:** I need to learn about the human, so that the human can interact with the rest of the space in a way that is in cooperation, rather than always in an aggressive way, because we are very aggressive in what we do. In this sense, the ontology shift needs to come from that space of 'we are not here to control or dominate the space'. The space has already its own dynamics. If we are invited in, and only if we're invited in, which means that we need to learn how to ask permission to enter.

**LW:** Our frameworks for making human spaces, urbanized spaces, and our frameworks of knowing land, which are titles and artificial boundaries – cadastral sort of ways of cutting up and understanding the land – which are what we use now, and how we know the world. They're in conflict, directly, with this, because the line on the paper doesn't really, almost always, take into account where the tree is.

**MG:** That's right.

**LW:** Then the land, the shape of the land, the square, or the rectangle say in more Western contemporary, 20th centuries of industrial cities, then dictates the building because one has to be inside that square. How can we unknow this way of knowing the world? That's what's required?

**MG:** But how many years, or decades, have passed since that way of drawing the square has been in place?

**MB:** It's a capitalist thing, related to techno-scientific 'progressive' thinking. It's a speculative model. It's very easy to sell a parcel of land in this way. It goes hand in hand with economic rationality.

**MG:** But again, these are relatively recent modules. These are rules that we created and we can change them. It's like an economic system. We are all being told that this is the only way in which an economy can work, but actually that's not true and until we believe that that's the only way, of course, we're not going to find any other way because that's the way, right?

**LW:** I suppose that's this moment that we're in, we have a new layer of knowledge or information – an understanding of plants as beings that need to be brought into those frameworks and critical systems thinking and, as you would say, ecological justice. So, we're not using them to our ends for only beautification or food, but trying to consider them on their own terms. Then with this kind of unknowing of the world in this recent way, this couple of hundred years way, it wouldn't suffice to just adopt some pre-industrial method. You need to bring this new ingredient into the mix. How does that change?

**MG:** It doesn't really matter which system you're working in. Ultimately we face the same challenge and so I can speak for my own system and my science, I could just do science. Write the papers, publish the papers, and so on. But, now, for example, right now I am working on projects involving an Indigenous community that are requiring me to act differently. Of course, my mind as the scientist is already thinking, "we could measure this". But is that what is needed? And yes, it was very clear that something else is needed here. To be engaged and present – the project is actually already happening in this way. We are trying to ask permission, ask for advice from the land itself, from the plants themselves.

**LW:** How do you know that? Is it a time and spatial thing?

**MG:** That's right. We need to spend time and like with any relationship we need to ask, and you can't just ask them and wait for it and then if the answer doesn't come, well, nothing came, so 'let's go'. I know that this is the right direction. We need to give it time and then it will just happen like this. But that for now it needs to sit and allow. Obviously, I'm not ready because I'm still concerned that I'm not ready to really let it be what it needs to be, but I also know that it will happen when the time will be right, and it will be soon as well.

For example, I have this feeling that there are ceremonies that need to be done in this space for this Country and I don't know what ceremonies need to be done and the elders don't know either. I feel that the Country is the one that knows, but it requires both worlds. The old world and the new world to come together in agreement that we are going to both together listen to what is required, and I suspect that the ceremony that will emerge will be a new ceremony, something that belongs to both and in that sense then, a project that stands on that ground is bound to be successful because it's delivering something that it belongs to the future already...and of course there is a risk that I might not be able to fulfil my progress report for the university!

**LW:** You're thinking in big time instead of academic time. It's a very exciting idea that it can be a new ceremony. I suppose that's really the hope of where Australia finds itself in at the moment, and what an amazing position to be in.

**MB:** We started the conversation about the orchid who is sensitive to noise, can we share the space with the orchid? What do you think about this as a scientist?

**MG:** Ultimately the question is: we are in relationship with the space, regardless of what choice we make. So wouldn't it be reasonable to just simply ask the space and then we can choose not to listen and build our thing, whatever, or we can choose to listen and maybe be inspired to build something that is actually honoring the relationship.

**LW:** The question for us, our profession, is how to listen. What can listening… be like. I think it's indigenous involvement, engagement. It's time. I suppose, we're also interested in what that might be physically, back to the ground and being very specific, so we try to materialize those ideas. Is it getting out of the way? Is it raising up? Is it emitting light through buildings to not make shadow? Or all these things. Those last things do require a kind of quasi-scientific knowledge in some part. So, it's not just kind of tokenism. Ultimately it would just be better probably not to build there. How do you make a quiet architecture that could be scaled up to a city?

**MG:** The inspiration of what kind of building can come in conversation with the rest of the world, the non-human world, and I think that this is really, at the end, the crux of the matter. We have been behaving as if there is no one else, and that's not true. We need to engage in spaces that allow us to learn how to learn, how to enter in these conversations. Listening will provide exactly the right answer for that space, and it will be very space-specific and embodied in that ground. Different places will need different things, and it's demanding us to engage. That's what I mean. To engage with the space and the conversation with all others. And if we don't know how to do it, then we ask for help. And I guess, again, I have said this before, but to me, the amazingness about the fact that there are a lot of indigenous people around the world that still remember exactly how they used to do it. It's our blessing.

**MB:** In our experience there aren't many people who would be interested in stopping and listening, in the way you're saying. Unfortunately, while we are having this conversation, virgin bush is being bulldozed.

**MG:** For example, you, as your practice, when someone comes to you, you tell them up front, "This is how we do it." So, we can't do anything until we go to the land, and we sit together, and you make it as a practice as, "You want to work with us?" And I know it's risky, because maybe some people will be like, "Well, fuck it, then I'll just go somewhere else."

**MB:** We try to work like that, but we're a small practice. And, as you probably know, the majority of building is not in the hands of architects. And then not all architects are even interested so much in these ideas.

**LW:** I feel like those old anthropocentric systems will just dissolve or crumble. In time, in 100 years or 50 or 200. Other ways of working will emerge. It's about trying to minimize the damage in the meantime.

**MB:** My hope is that ecological science could become, then, so important and so relevant, in order to also start to dictate or to advise, let's say, or to drive some decision in urban policies in the way we build.

**LW:** On the other hand, I think Monica what you're saying is that we have to unknow the world in this scientific way and find different understandings... otherwise it's just another form of colonization.

**MG:** We've been conditioned to think that these are the ways in which things are done and known. Suddenly, we will be doing different things from what we used to, and nobody would have noticed. Those you enact the change would know, but most of the other people would say, "Oh, we've always done it this way." Because that's what they say all the time.

**Monica Gagliano** is research associate professor of evolutionary ecology and research fellow of the Australian Research Council at the University of Western Australia.

**Louise Wright and Mauro Baracco,** both PhD, are architects and directors of Baracco+Wright Architects (*B+W*). They build, publish, research and teach, also undertaking built and speculative projects in integration with their research laboratory *B+W+* through which they collaborate with ecologists, landscape architects and artist among others. Some of their outcomes include: Garden House; Rose House; *Robin Boyd: Spatial Continuity* (Routledge 2017); *Repair* (exhibition at Architecture Venice Biennale 2018 with artist Linda Tegg, and book, Actar); *Geometry, Simplicity, Play: Exhibiting Vico Magistretti* (exhibition, 2019 + book, Actar 2020); participation in the exhibition *Broken Nature*, Milan Triennale 2019, with Linda Tegg; *Unknow* (participation at *The Climate Imaginary* exhibition, Melbourne Design Week 2021).

# Architecture as proto-ethic entanglement

*This artist portfolio builds on a performative investigation of Gruinard Island, Scotland, taken place in 2018. Having served as a testing site for biological agents during World War II, the island's soil and atmosphere remained a lethal environment for humans and non-humans over decades. The affirmative encounter with this specific architectural condition, building on Bracha Ettinger's "Matrixial Theory", enables to depart most sensitively into the ambiguous strata of our planet. In this venture, architecture unfolds its human, non-human, trans-human, and unknown entanglements, and motivates a co-emerging and proto-ethic thought amidst the present ecological crisis.*

*The full title of this essay is 'Architecture as Proto-Ethic Entanglement: Matrixial Encounters with Gruinard Island, Scotland'.*

text by **Christoph Solstreif-Pirker**

**Christoph
Solstreif-Pirker**

*Gruinard Island,* Performance,
ca. 360 minutes, 2018

© Christoph Solstreif-Pirker

When I disembarked the boat and set my feet on the rocky sandbanks of Gruinard Island, I realized that I had encountered a place that was fundamentally revising my understanding of space. This was, at first, a paradoxical observation, for this island, off the northwest coast of Scotland, seemed conspicuous for nothing other than its inconspicuousness. It merged, as it were, with the surrounding vegetation and topography, and was never a topic of conversation, even among the few locals. Only later, in the course of my artistic investigation of this place, I discovered that this habit was not just a given, but that it was the locals' deliberate decision not to talk about it. For, in the bay of Gruinard, a space manifested that made visible nothing less than the ambivalence of the anthropocenic present. Gruinard Island was an architecture of incomprehensibility and inconceivability, a space without spatial boundaries and spatial expression. Precisely herein lay its particularity and immediacy. What became apparent was an architecture not of designed geometry, but of designed atmosphere – a dynamic environment that embraced and penetrated me every second of my encounter with it. In the spatial sublimity of Gruinard Island, however, there was also fear for, despite my loneliness, I was not alone. I entered the space of an interspecies dialogue, not with language, but with every breath and movement I took. I witnessed an encounter with the deadly spores of Bacillus anthracis, which thoroughly determined this island's architecture.

According to Peter Sloterdijk (2009), Gruinard Island exemplified "the basic idea of terrorism in the more explicit sense" as it contributed to the fact that "the 20th century will be remembered as the age whose essential thought consisted in targeting no longer the body, but the enemy's environment"[1] – a lineage that continues and grows in magnitude through global pandemics in the early 21st century. Under the direction of the microbiologist Paul Fildes, several experiments were conducted on this island between July 1942 and September 1943, aiming "to disseminate an aerosol of lung-retention size particles from a liquid suspension of bacteria in

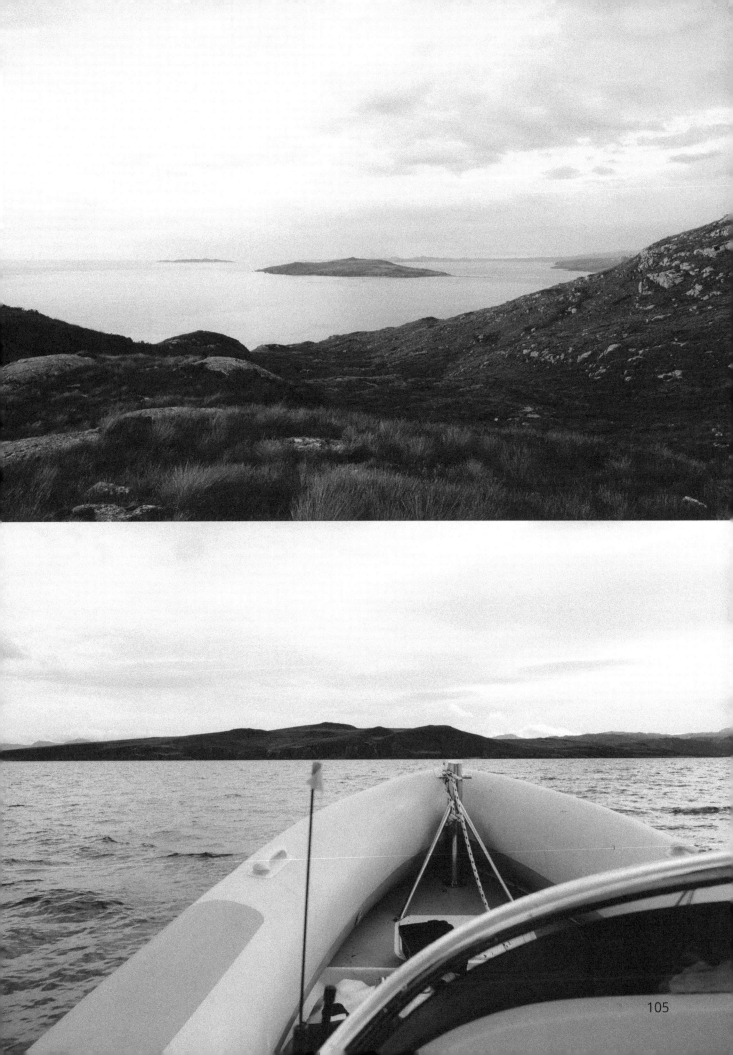

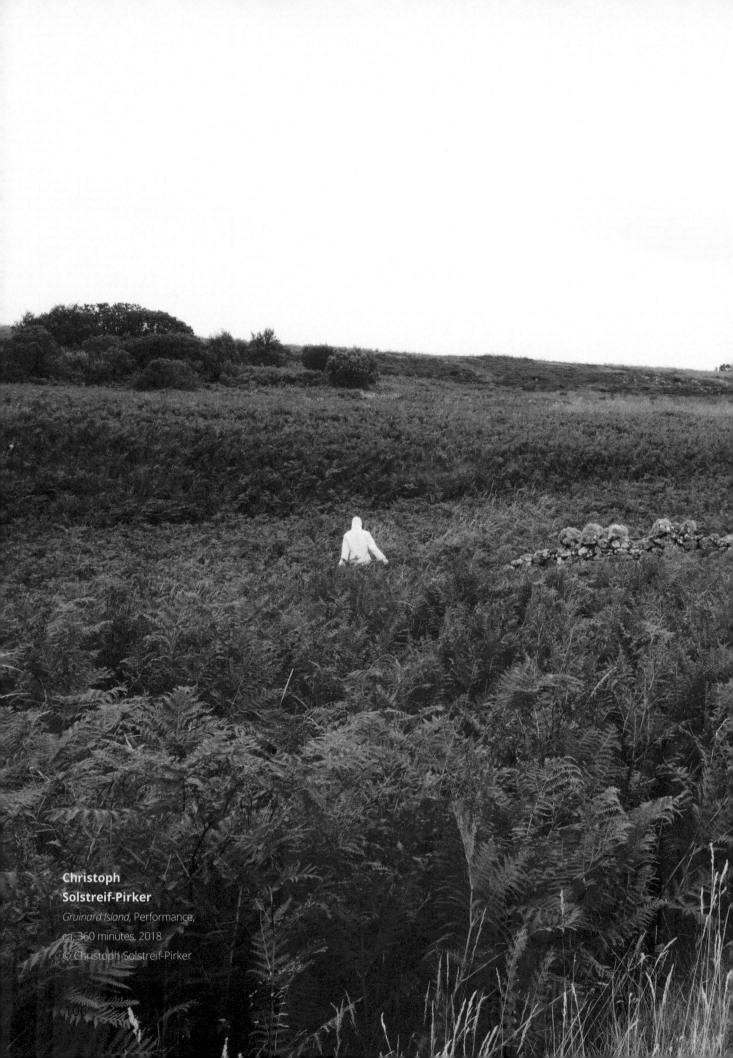

**Christoph
Solstreif-Pirker**

*Gruinard Island,* Performance,
ca. 360 minutes, 2018
© Christoph Solstreif-Pirker

a bursting ammunition such as a bomb, delivered so that effective concentrations would be inhaled by anyone in the target area".[2] In order to test this airborne weapon and its invisible destructive power under real conditions before its planned application against Nazi Germany, scientists from the British research facility *Porton Down* exposed the island and its atmosphere to the highly infectious anthrax bacteria, attempting to develop a biological weapon with a far-reaching and invisible extent of destruction. The experiments on Gruinard Island, though lasting only a few days, were of such otherness and deadly potential that the bacteria released by several targeted detonations turned the island's environment into an isolated, restricted area until the present day.

Embedding myself into this proto-terrorist context, it became clear that architecture is continually permeated and determined by non-human, more-than-human, trans-human and unknown agencies. As such, space bears an autonomous vibrancy that carries both the trauma of human-induced violence and novel narratives of planetary hope. With my "feminine-based performative praxis",[3] I aimed to affirmatively embrace this spatial ambivalence and to make the manifold dependencies between body and space – along with a fragilized view on subjectivity – newly visible and applicable.

The performative investigation of Gruinard Island caused me to turn to the floor and ceiling of this space – the earth and the air – and realize that space cannot be traced back to the creative authorship of the architect, but rather to the marginal, peripheral and molecular multiplicities that *are already there*. This view considers that I have always been embedded in and carried by an existing – often highly contradictory – contextual agency. Through such an understanding of space, there is no hierarchization of a passive "natural" background against which the supremacy of human life

**Christoph Solstreif-Pirker**
*Gruinard Island*, Performance,
ca. 360 minutes, 2018
© Christoph Solstreif-Pirker

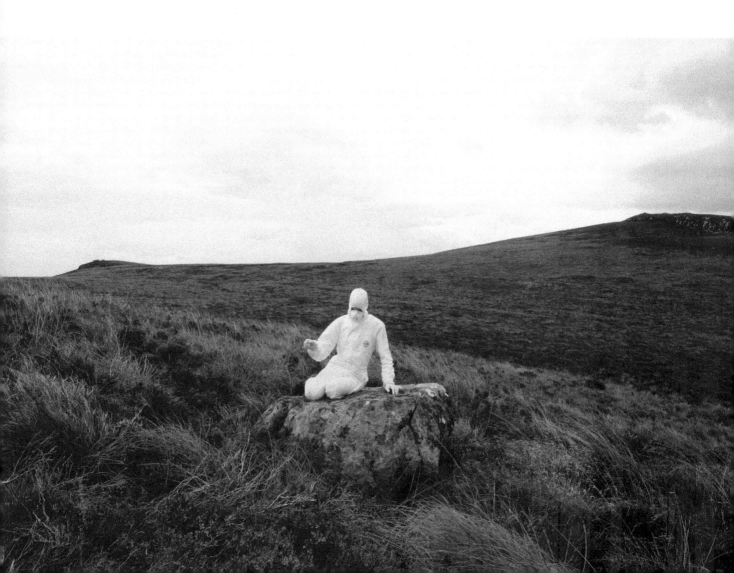

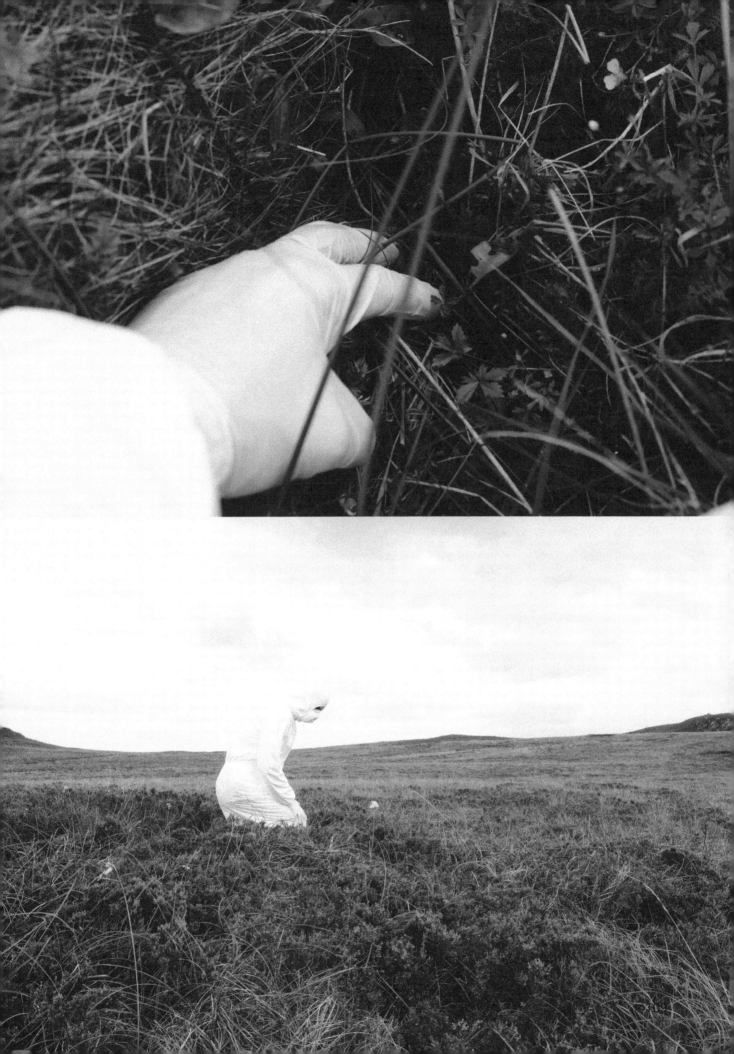

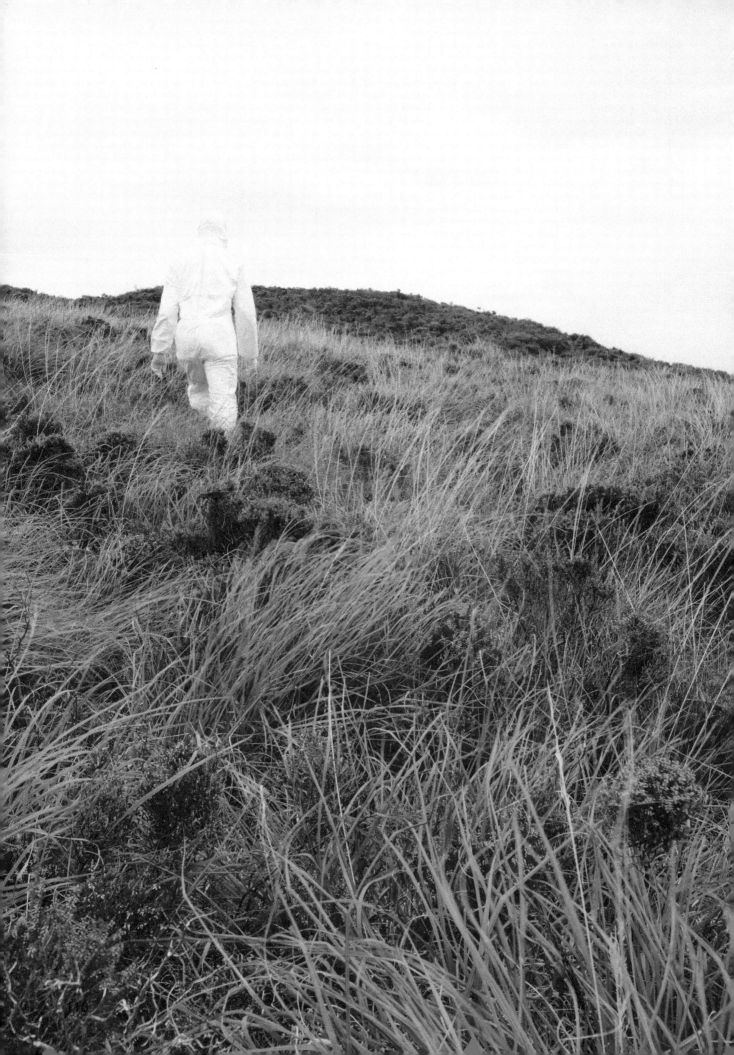

emerges. Instead, what takes place is an intensive dialogue between me and the unknown Others. I perceive that I have always been dependent on these Others – the deadly spores – just as the Others are, in turn, dependent on me: an evolving co-existence and co-emergence. For this understanding to manifest, the analogy of the prelingual and trustful exchange between mother and unborn child in the womb-space is evident. The psychoanalyst Bracha L. Ettinger based her feminist approach on this phase of human development, which she famously introduced as *Matrixial Theory* (1992). My artistic research praxis and my investigation and conception of space primarily refer to this matrixial view and attempt to recalibrate established spatial paradigms through a specifically feminine lens. If architecture is to be seriously involved in a hopeful reorientation of the relationship between humans and nature, it must establish non-reductive, feminine-based relations to the otherness of the anthropocenic environment. Actors and practices must begin to fragilize themselves and ally ourselves with that which could even kill us: "We can look in the pain's eye and connect to the sorrow of the Other and to the wounds of its oblivion only by fragilizing our own self. Only by self-fragilization, we can attain the vulnerability and the Other and the fragility of the earth".[4] With every breath I took on Gruinard Island, I became aware of this vulnerable dimension between humans and space or even subjectivity and cosmos. The encounter-investigation with this site of anthropocenic atrocity enabled me to claim that architecture is not a form, but, first and foremost, a vibrating and fragile proto-ethic entanglement between me and the unknown Others. Here, with utmost subtlety, an architecture of fragility unfolded, building its space on dependencies, resonances, performativities, bonds of trust, as well as sorrow, grief and hope. Eventually, I participated in the emergence of a new aesthetic paradigm that anchors the notion of space deeply in the feminine: an architecture that oscillates between trauma and beauty.

### Endnotes

[1] Sloterdijk, Peter. 2009. *Terror from the Air*. Translated by Amy Patton and Steve Corcoran. Los Angeles, CA: Semiotext(e), p. 14.
[2] Carter, Gradon B. 1992. "Biological Warfare and Biological Defence in the United Kingdom 1940–1979." The RUSI Journal 137:67–74.
[3] Solstreif-Pirker, Christoph. 2019. *Being-Together-With the World-Without-Us: Performative Investigations Into the Traumatized Planetary Space*. PhD diss., Graz University of Technology, p. 211.
[4] Ettinger, Bracha L. 2018 'Possibilities for a Non-Alienated Life', paper presented at the Kochi-Muziris Biennale, Kochi, India, December 13

**Christoph Solstreif-Pirker** is Assistant Professor at the Institute of Architecture and Landscape at the Graz University of Technology (since 2017), and a practicing artist working on performance, painting, drawing, music, and text. His research focuses on (post-)anthropocenic subjectivity, ecofeminism, copoiesis and their connection to architecture and the planetary space. His work was published in *GAM – Graz Architecture Magazine, Ruukku: Studies in Artistic Research*, and *JAR: Journal for Artistic Research*. Solstreif-Pirker received his PhD in contemporary art and artistic research (with distinction) from Graz University of Technology, after having studied at the University of Music and Performing Arts Graz and the Royal Danish Academy of Fine Arts in Copenhagen, Denmark.

# Architectures
# of becoming-animal

*From childhood games to ancient cave paintings, animal representations across time and space offer us an affective crack in rational consciousness by which to slip into a larger-than-human earth and share affinity with a range of animal life. Animal lives and animal images echo between external landscapes, cultural scaffoldings, and interior architectures of the mind. This essay is a modified excerpt from Animal Revolution forthcoming with University of Minnesota Press, March 2022.*

text by **Ron Broglio**

"Goodnight dear readers. Go home, lock your cage well! One never knows what may happen. Sleep with one eye open. At any rate, sleep well. Pleasant dreams". And so ends part one of J J Grandville's satire of Victorian manners in *Public and Private Life of Animals*. Let us consider what might happen in the lull toward sleep.

At night a child recalls the not so distant memory of a day of manufactured wonder at Disneyworld before all the lockdowns and closures. She puts her head to the pillow thinking of all the magical events as if they are still happening in the commercial utopia. Visiting a national park, this same child might draw toward sleep imaging the roaring waterfall or some timid and unusual wildlife. Some time later and having already arrived at the age in which one begins to disbelieve in Santa, she may go to sleep realizing the Disney machines shut down and performers go home but the national park waterfall does not turn off and hasn't since well before she was born and perhaps long into the future. And the wildlife? They or their offspring are still there. They are not performing and are not paid. And then they started appearing... not out there, not in her memory but actually there, on the street. It started with the coyote rumored to roam the neighborhood – it appeared one dawn on her very front yard. Some days later he returned with others, a pack. After that came the deer in the garden. She saw it before anyone else. The world out there started to appear right here at home.

The girl may think—as children do—that adults do not know this. It is a secret she alone has discovered. Like a door to Narnia, it opens to a place that older humans do not understand because they are preoccupied with jobs and houses and groceries and being adults. This secret is not simply that animals have worlds beyond our grasp. Rather, these worlds reflect back to us an image of ourselves that is unrecognizable. We are not the civilization we think we are, and we are not who we think ourselves to be. With wonder and a measure of cautious apprehension, the child stepping through the door to animals' worlds returns with a crack in her perception of humans.

Adults sitting leisurely on a sofa with feet propped up and with especial cozy socks designed for evening reclining can feel rather comfortable and secure. Bricks and drywall provide insulation from the unpredictability of the great outdoors. If the coyotes do come, we are inside. If a bear or mountain lion appears in the exurbs we have our fortress. Later in the evening, the leisurely seat becomes uncomfortable and the socks too warm. The walls close in as does a general feeling of unease. On yet another night, the

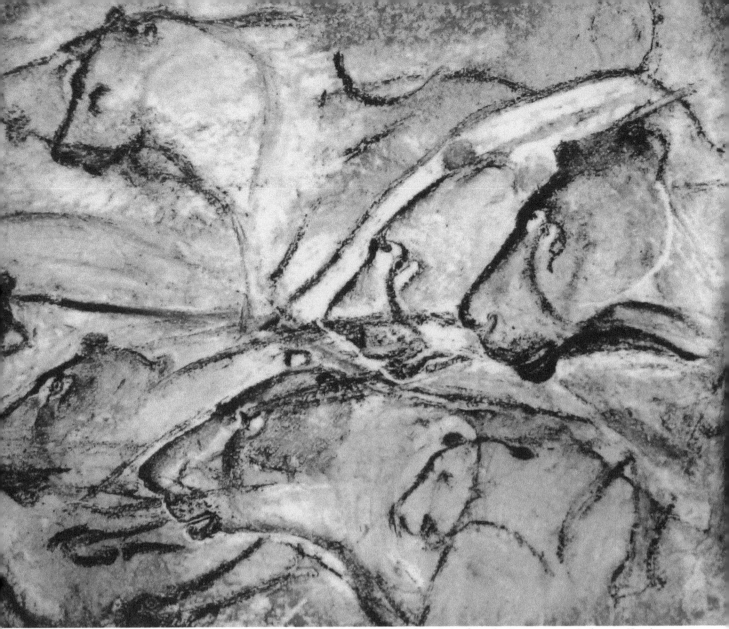

*Lions painting,* Chauvet Cave, (Ardèche, France). This is a replica of the painting from the Brno museum Anthropos (Czech Republic). Museum replica, original 30,000BCE, public domain,

eerie feeling returns but with more focus this time. A claustrophobia. We have created cages for ourselves. Our range of motion becomes limited by the confines of self-domestication. All the while, the child with a crack in her perception feels nature going on without us. Slipping from the domestic zoo, her mind goes feral.

Maybe it starts with the stuffed animals that swarm her bed, or it begins with the phrase "Reindeers are better than people..." that still echoes from repeated watchings of *Frozen*. The crack appears and then unteathers her from commercial interpolation of the animal kingdom to the animals that have arrived on her very own front lawn. Creatures lure the girl. In such moments her legs alight across the yard moving at her earnestly very highest speeds and leaping while repeating "I'm a deer. I'm a deer. I'm a deer..." The intensity of the child's insistent repetition and the affect of her gate make the divide between humans and animals more of a mobile border. Then, the border that was once a divide becomes an affinity which she can leap across. Sometime later, returning to her little girl self, she feels not herself as a daugh-

ter at the kitchen or student in her laptop classroom. The ways deer see her haunts and slightly unhinges her place in the civilized world.

In the mineral-stained limestone cliffs above where the Ardèche River once flowed, there is an almost imperceptible crack. Stepping across its threshold one walks from the sunlight into the darkness of a narrow chamber that tilts precipitously downward. Descending, the cavern opens in all directions. Stalactites and stalagmites populate remote corners and calcite walls sparkle. Further along, in a large chamber images and flattened figures appear on the walls. A single bear is outlined in ocher and then another. One or two bison reveal themselves in charcoal black and then herds show up as if they are roaming the open plain. Layers of horses stacked one upon another seem to gallop with their motion caught by repetition of line and pattern as they push from folds in the stone. The great curved horns of an ibex move along a side of a rock then its full corpulent body comes into view. Simple, strong lines accurately render lives that have unfolded on the other side of the darkness.

Out there, animals roam along forest and valley. Humans carefully watch and carry their sightings into the cave and then the animals are there, transposed onto stone walls. The outside is folded inward—from observations in the field to the caves of the mind, then in the darkness of the stone cave, and into the culture of a people. Thirty-five thousand years later, the animals are here in the minds of contemporary visitors.

While access to the Chauvet Cave remains heavily restricted, filmmaker Werner Herzog was permitted to make a movie that would give the rest of the world a glimpse of this other space and time. With minimal crew and restrictive filming conditions, Herzog created *Cave of Forgotten Dreams*. Today we can see the primordial cave and watch the animal paintings in darkened theaters or streaming home viewing where moving pictures appear on the walls.

The film nears its conclusion as the camera lingers on images found in the farthest chambers of the cave. Past a bear skull placed tens of thousands of years ago as a totem or sacrifice on an alter-like stone slab, and then into the far recesses of the End Chamber, a well-wrought bison looks into the distance. Following the animal's gaze to the Sacristy there hangs a column from the ceiling with a curious image on it. On the backside is a bison's head in profile and featuring a singularly attentive white eye. The line from its neck extends into a human arm, hand, and fingers. Below the bison-human is a woman squatting with legs spread open and straddling the stalactite like a phallus. Animals move outward from the woman's loins as if she is endlessly giving birth to them.

Beyond the long arc of human history, there are the animals. Today, while we stay inside locked down due to a pandemic from a virus crossing species barriers, the animals maneuver a bit closer—irrespective of our white-lined roads, our parks, our real estate property lines, and all our cultural architecture that keeps the nonhumans at a distance. Again the crack appears in our walls and in our psyche as the animals lurking just out there become a lure calling to some deeply felt becoming in our very animality.

*We are not the civilization we think we are, and we are not who we think ourselves to be. With wonder and a measure of cautious apprehension, the child stepping through the door to animals' worlds returns with a crack in her perception of humans.*

**Ron Broglio** writes books and essays on nonhuman phenomenology and animal studies. He has curated and produced a number of exhibitions on contemporary environmental art. Broglio is director of the desert humanities initiative and associate director of the Institute for Humanities Research at Arizona State University.

# Westbrook Artists' Site

*The mission of Westbrook Artists' Site (WAS) is to seek the creative potential in the rural post-industrial condition. It is an exploration of the tension between control and that which escapes or eludes our control, and it suggests how we may reconnect to hidden or lost dimensions of the post-industrial rural environment. Tending to these fragments is a designed effort for co-habitation. One particular focus in the spring is controlled burns that are essential for the biodiversity and native ecology of the land in the regic*

text by **Kevin S Lair**

The Westbrook Artists' Site (WAS) is located in southcentral Iowa in Madison County on five hundred and fifty acres of forest, woodland and prairie. The mission of WAS is to seek the creative potential in the rural post-industrial condition. It is an exploration of the tension between control and that which escapes or eludes our control, and it suggests how we may reconnect to hidden or lost dimensions of the post-industrial rural environment. The leftover of industrialization is small fragments, hybrids and remnants of native ecology. Tending to these fragments is a designed effort for re-discovery and co-habitation. One particular focus in the spring is controlled burns which are used as a requirement for the establishment and continuation of the ecology that existed prior to European settlement.

Architectural theorist, Yona Friedman (1923-2019) argued that, "We build too much" which is driven by the profession largely tethered to the economic imperative to build. However, in speaking to the discipline of architecture Friedman asserted that "Architecture is not simply the art of building: it is rather that of space management." We might add various amendments to this claim since there is some level of responsibility to the occupants of that space. Inhabitation negotiation might be one way to include a land ethic into the art of space management. Negotiation is a process that begins with questioning our assumptions and the reality of our position. It requires listening, fact finding, and trust building moving towards the relationships we desire. Mutual benefit and shared interest is a cornerstone of negotiation. However, the key from Friedman is to untether architecture from building in order to become managers, stewards, negotiators, and/or caretakers, something that deals not just with building but the entire ecology of building. Tending sets aside building in architecture to explore the role of inhabitation negotiation. In this negotiation everything is on the table.

On a personal level, tending is a potential solution to afford a direction other than building on a land with which I have a deep connection. What tending might be beyond that is an open question. Like Friedman and others, I am interested is revising building towards smaller, slower, lighter, local, and less so it can be more. In the book, *Sacred Ecology,* Friket Berkes explored how we can value and learn from other cultures in realigning ourselves with nature through "Traditional Ecological Knowledge" or TEK. TEK and similar perspectives seem to be gaining ground. Our collective admiration at WAS for traditional ecological knowledge has led to foraging excursions, burns and a general framework for inquiry. The return of fire as an ecological practice to the land of WAS is certainly something that has not been in practice for nearly

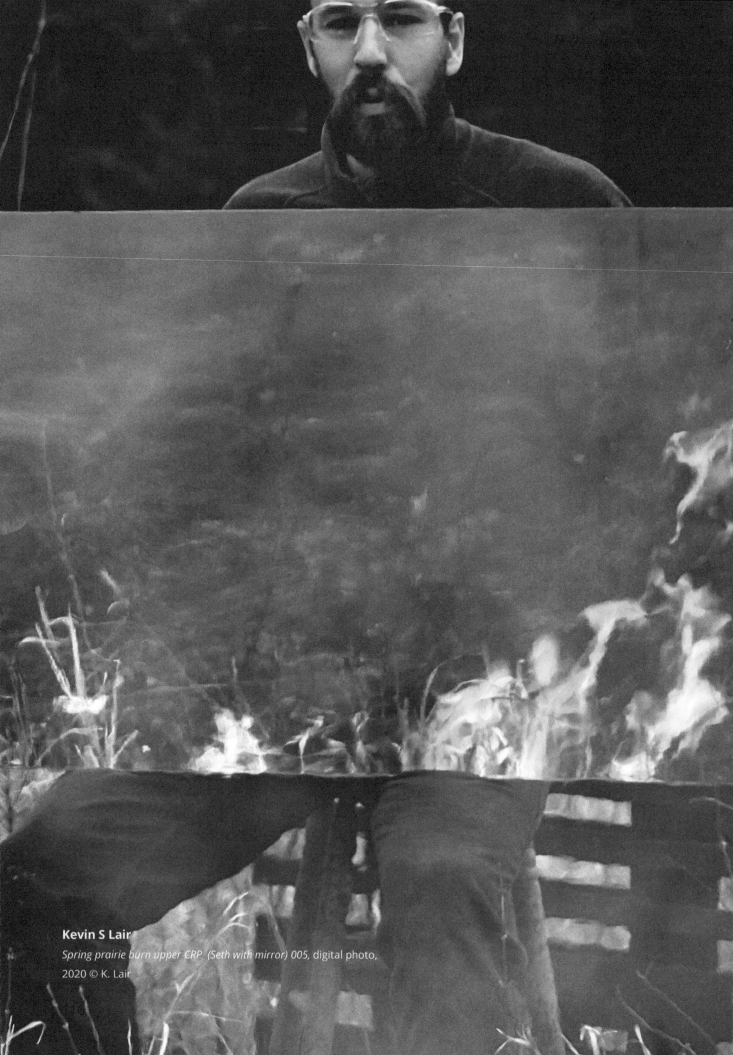

**Kevin S Lair**
*Spring prairie burn upper CRP  (Seth with mirror) 005*, digital photo,
2020 © K. Lair

two centuries. The existence of the once dominate but now highly endangered tallgrass prairie and oak savanna is dependent on fire. The prairie serves as an historical marker of land dispossession and cultural transformation. However, in the practice of tending to our obligations, we might re-imagine our place in the rural.

A meaningful working relationship with the landscape that will reveal how we can co-exist with wild processes is rooted in the relationship between WAS and education. Along with myself the main burn tenderers Devin Walker and Seth Andrews have come from the design and architecture program at Iowa State University. In addition, the fall 2019 students observed the burns and executed various independent studies along the periphery. As an unknown question tending seems to be critical within those who are receptive, willing and engaged in the pursuit of "space management" at early stages. The notoriously unpredictability and destructive power of fire to people, homes and property ill-suited for it contrasts with the potent creative energy it brings to the prairie. Fire is not welcome in building so it seems to be a promising tool for re-imagining architecture. Along with other climate change factors we are facing architecture's relationship with transformation and adaptation may expand as its association with durability and permanence fades. Architecture that embraces change may find unexpected new opportunities.

For a landscape, often consumed by the monotony of industrial agriculture fire is charismatic. In the process of tending to prairie fire, wind becomes the most critical aspect to be understood and managed. The wind during the period in which spring burns occurred at WAS shows there is little consistency in direction and speed. Less than 10% of the time were winds suitable for burning during our spring season. Within this limitation we managed to execute burns on 18 different fields over 6 different days from the end of March to the start of May. The burn fields are on the property site map including the plot ownership from the first property map of the area published in 1875. This was a period of great transformation of the Iowa landscape in which resources were extracted and prairie plowed under. Listed owners and number of acres of each field: 14.2 G. Halliwell, C. Armbrest; .36 Halliwell; .1 Halliwell; .4 Halliwell; 1 D. Henley; 3 Halliwell, D. Henley; 2.15 W.N. McKnight; 2.37 McKnight; 2.92 McKnight, F. Peabody; 4.83 McKnight, Peabody; 2.57 McKnight, Peabody; 2.42 Josiah Banks, McKnight, Peabody, John Rogers; 6.15 Peabody, Rogers; 1.21 Geo. Breeding; .96 Breeding; 2.88 Breeding, John Wilkinson; 1.84 acres Breeding, Wilkinson; .42 acres Wilkinson.

The need for tending tools including gear such as masks, goggles, drip-torches, and fire resistant gear prompted the idea of a conceptual storage/utility frame with the addition, of mirrored surfaces to observe and document the burns. In the 18th century Claude Glass (black mirror) created an image of the landscape and perhaps fostered our desire to shape it accordingly. The mirrors are not fixed but could be carried along or reposited on the frame as the black mirrors were also transported and even viewed while walking similar to how we engage our cellphones. The mirrors used during the burns may disrupt our habit of seeking the panoramic, timeless or frozen view of the land. Architects have been fond of locating or perching their work in a strategic site of prominence with a corresponding advantageous viewing frame of the land. Rather than being set-back as passive viewers, if we are engaged, experiential observers, we may value the gaps, fragments, and patterns inherent in the land.

Always dependent on key factors such as the quality of one's fire breaks and burn team, the micro conditions of topography and wind become the most dynamic and require the closest tending. The burn is a management challenge, a space management exercise.

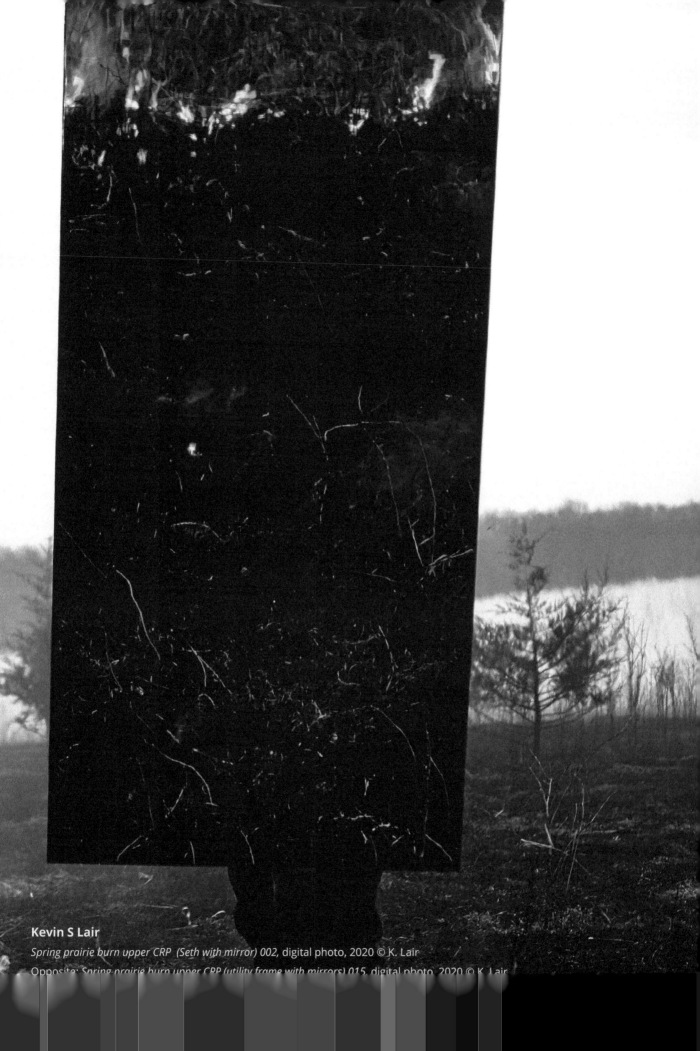

**Kevin S Lair**

*Spring prairie burn upper CRP (Seth with mirror) 002, digital photo, 2020 © K. Lair*

*Opposite: Spring prairie burn upper CRP (utility frame with mirrors) 015, digital photo, 2020 © K. Lair*

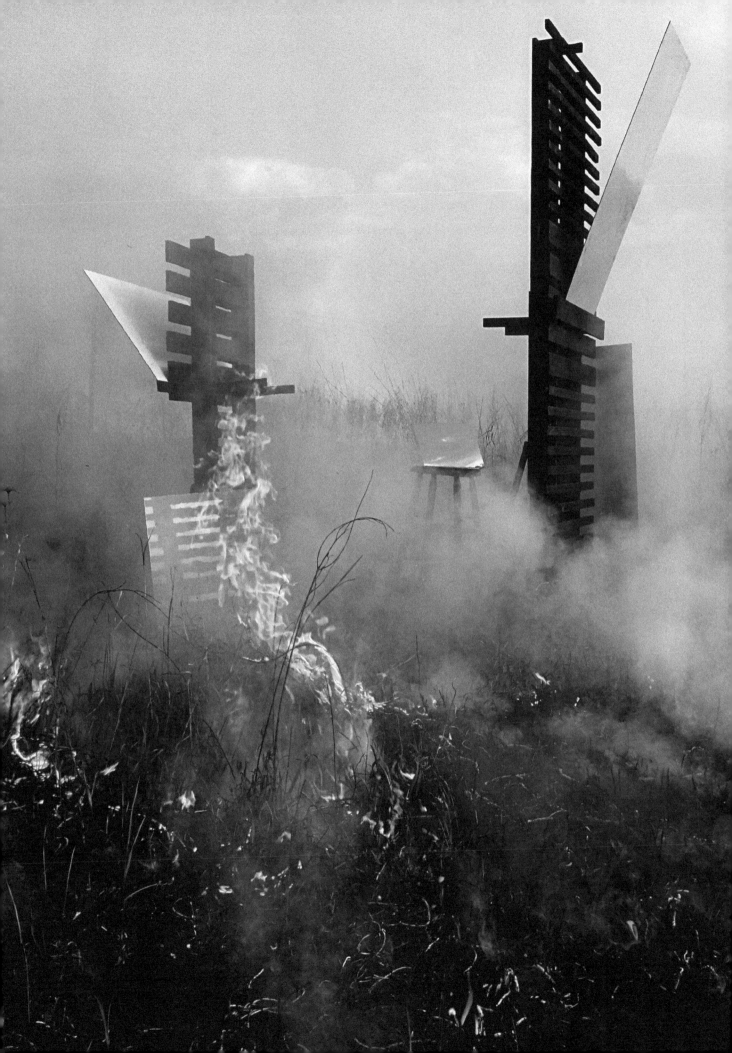

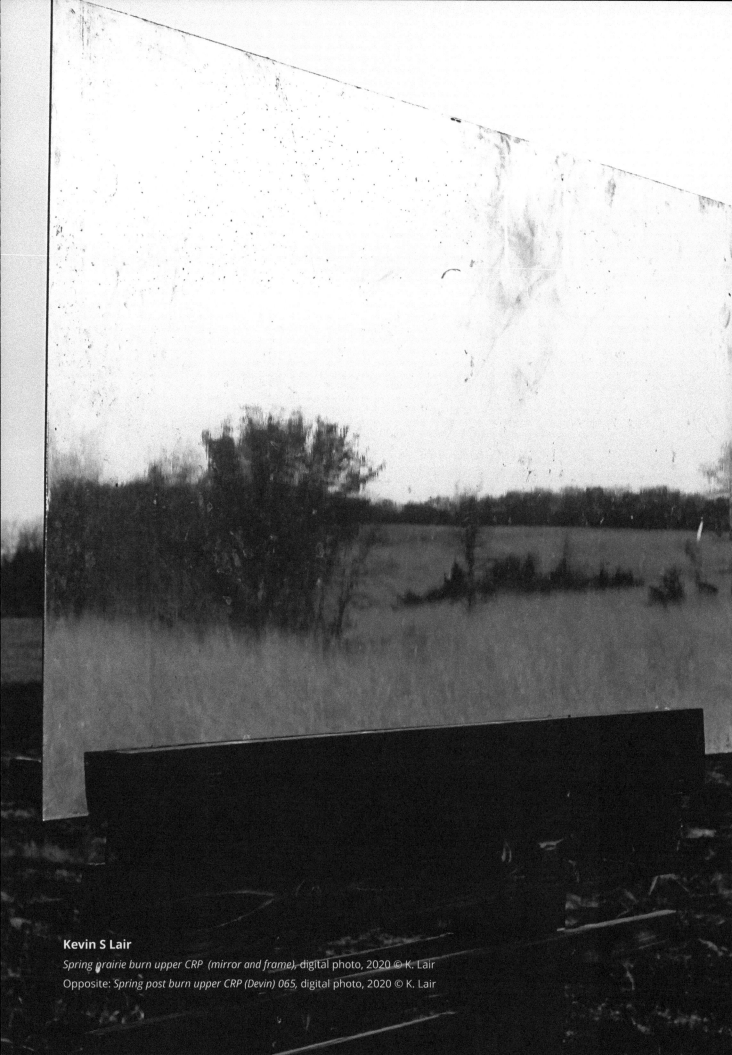

**Kevin S Lair**

*Spring prairie burn upper CRP (mirror and frame)*, digital photo, 2020 © K. Lair

Opposite: *Spring post burn upper CRP (Devin) 065*, digital photo, 2020 © K. Lair

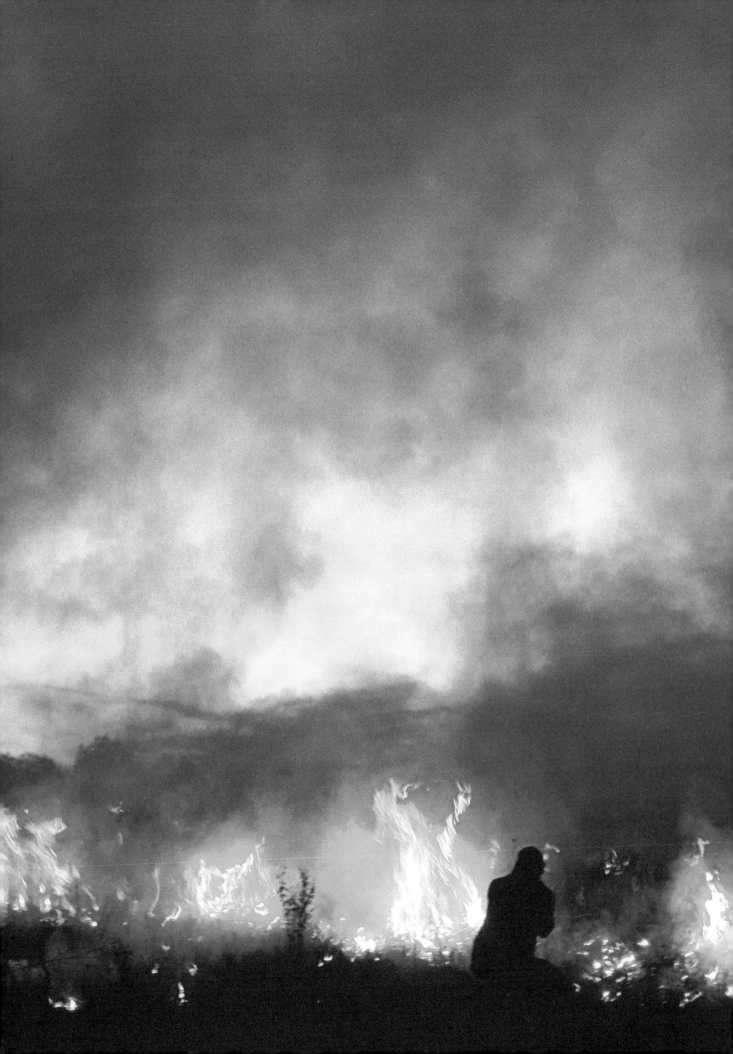

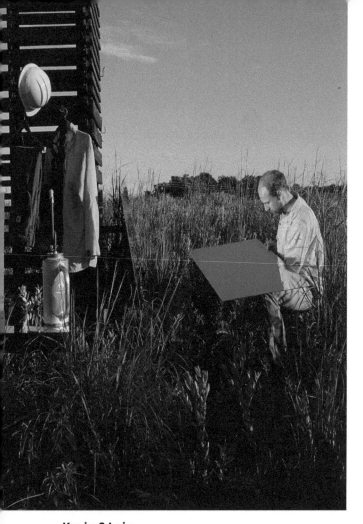
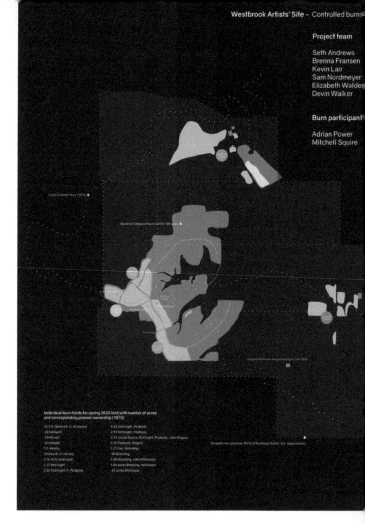

**Kevin S Lair**

*Summer post burn upper CRP  (Seth with mirror at frame) 022,* digital photo, 2020 © K. Lair

*Westbrook Artists' Site* burn field diagram for spring burn series, 2020 © K. Lair

A design challenge is when and where to burn and manner to help create opportunities for particular flora. It is tending that addresses the co-habitation opportunities by communally bringing people to a working landscape. A full restoration of burn practices hints at a less permanent more mobile inhabitation.  We may need to leave pieces behind if we are to collectively embrace a more charismatic landscape.  Fire practices foster diversity of species and a resilient self-sustaining ecology contrary to a fragile, exploited and over used landscape that has been in development since European settlement. The return of fire requires some sense of renewal and wonderment to the lands for its unpredictability and our relatively novice skill and understanding as to what a fire is going to yield over time.

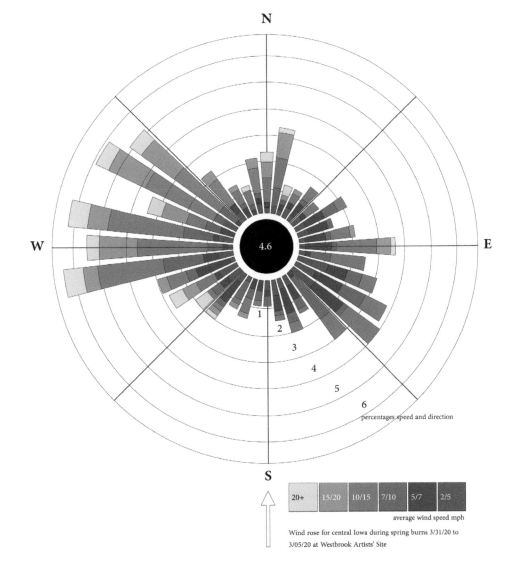

N

W            E

4.6

1
2
3
4
5
6

percentages speed and direction

S

| 20+ | 15/20 | 10/15 | 7/10 | 5/7 | 2/5 |

average wind speed mph

Wind rose for central Iowa during spring burns 3/31/20 to
3/05/20 at Westbrook Artists' Site

### References

Berkes, Fikret. *Sacred Ecology* 3rd edition, (NY: Routledge) 2012
Iowa Environmental Mesonet, Accessed April 12th 2020 http://mesonet.agron.iastate.edu/sites/dyn_windrose.
phtml?station=CWA&network=WI_ASOS
*Iowa Geographical Map Server*. Accessed April 4th 2020 https://www.arcgis.com/apps/webappviewer/index.html?id=47a
cfd9d3b6548d498b0ad2604252a5c
Maillet, Arnaud. *The Claude Glass: Use and Meaning in of the Black Mirror in Western Art, Princeton* (NY: Zone Books) 2009
Ludwig Museum. "yona-friedman-architecture-without-building" Accessed July, 15th , 2020, https://www.ludwigmu-
seum.hu/en/exhibition/yona-friedman-architecture-without-building
Watson, Julia, Lo-TEK – *Design by Radical Indigensim* (Cologne: Taschen) 2020

**Kevin Lair** is an interdisciplinary designer, architectural educator and artist. His work focuses on cre-
ative, social, and entrepreneurial practices. He is the co-director of the Westbrook Artists' Site (WAS). At
WAS, he has been engaged in land rehabilitation through alternative agriculture practices, establishing
an apiary, native orchard, mushroom logs and other efforts supporting biodiversity and local econo-
mies. He is in the process of planting 1000 native trees in the next two years. He holds degrees in Fine
Arts and Psychology from Drake University and a Masters in Architecture from Harvard University. His
current academic appointment is at Iowa State University.

# The city in nature

*The periods of greatest economic expansion were invariably accompanied by an explosion of cities. But can cities legitimately claim to be the destiny of the world? Must they always be obsessed with their own past, with their own imperium? Must they always be set principally in history? Can they not be set, too, and with greater urgency, in geography?*

text by **Irénée Scalbert**

The fundamental idea of geography is that of terrestrial unity. The idea has been expressed throughout human history, by Ptolemy, by Alexander von Humboldt, in Apollo 8's classic 1969 photograph of Earthrise. For the geographer, the individual forms of the Earth and the labyrinth which, together, they compose are subject to universal laws. As an integral part of the "geography of life", humans, too, are subject to the same laws.[1] Like plants and animals, humans combine their actions with the forms of the Earth and the conditions of climate. They participate in the play of nature, overcoming obstacles and selecting what is useful to themselves. A mountain offers protection. A river is a convenient means of transport. A river delta becomes a base for commercial exchange.

The geographical role of humans does not stop at preying upon the Earth's assets. Nor is it limited to introducing new elements, for instance, docks, cities, and frontiers. Humans alter the balance of nature. A farmer, a winegrower, a gardener appropriate land for themselves, they prune a tree or a shrub, causing a suspension of life, a kind of crisis in nature. A field, a meadow, an orchard are examples of associations created for human convenience. In the process, humans inject intelligence into the Earth and make a lasting impact upon its physiognomy. They have done so for as long as reflective thought has defined what it is to be human.

At the beginning of the 20th century, a full century before the coining of the word 'Anthropocene', humans were recognised as geographical agents of the first order. "Upon humans," Paul Vidal de la Blache observed with prescience, "depends the present equilibrium of the living world."[2] By their continuous action, humans carve a furrow that constrains later generations. They orientate future activities in a particular direction, giving rise to specific *genres de vie*, or "ways of life". The simplicity of the wording conceals the central importance of the concept for Vidal de la Blache. There exists between the forms of the Earth and human activities a closeness, an intimacy that is as comprehensive as the bond uniting a milieu and a society in a Balzacian novel.

Paul Vidal de la Blache died in 1918, but his influence continued to dominate the field of geography well into the mid-twentieth century, at a time when geography competed with sociology for first place in the humanities. The list of scholars indebted to him is long and impressive. Among them, Lucien Fèbvre, co-founder in 1929 of the Annales school, adopted

the original concept of *genre de vie* and attributed the same importance as Vidal did to the detailed observation of human societies within their milieu. Fernand Braudel, another historian of the Annales school, author of classic works including *The Mediterranean* and *Civilization and Capitalism*, devoted like Vidal much of his work to the bond between material life and the economy. More familiar to architects, J. B. Jackson, founder of the magazine *Landscape* in America, acknowledged the French School of Geography as the source of landscape studies.

Vidal's influence was considerable but few texts by him are available in English translation. The singular exception is *Principles of Human Geography*, a posthumous work based on notes made by him towards the end of his life. The seminal articles published in *Annales de Géographie* - the journal he started in 1891 - and the *Tableau de la Géographie de la France* of 1903, a work described by Braudel as "one of the major works not only of the geographical school, but also of the French historical school",[3] are barely known outside France. In addition, Vidal de la Blache, a classicist by training, expressed himself in a restrained, luminous prose that served a bold and original thought.[4] To this day, the *Tableau* impresses with these qualities.

## In the labyrinth

Whereas plants and animals live in specific natural conditions, humans can live almost anywhere. They are cosmopolitan and they have become almost universal in their distribution. This fact constitutes their geographical singularity and makes them unique among other species. The only exceptions are species living in close proximity to humans, notably the dog among animals and the nettle among plants. The ubiquity of humans manifests itself most eloquently in the multitude of dwellings dusted on the surface of the Earth, in patches of red tiles, grey slates, brown thatch, and grey asphalt. These are the most prominent sign of the humanized landscape, first accounted for as a geographical fact in the early 20th century under the quaint word of "maison", a term which described equally, when used by geographers, the simplest hut and the tallest skyscraper.

Two pupils of Vidal de la Blache are credited for laying the foundation for the scientific study of the relationship between humans and nature: Albert Demangeon with a monograph on Picardy published in 1905 and Raoul Blanchard with a no less remarkable monograph on Flanders in the following year. In 1920, Demangeon proposed to classify rural dwellings into types, laying the foundation for the study of vernacular architecture. He distinguished them according to their plans and to the relationship which these revealed between humans, animals, and things. The rural dwelling was seen as an integral part of the geographical milieu and the rural economy, as an eloquent expression, evolved in the course of centuries, of rural life. Its plan in particular was the tangible evidence of "an internal order which breathes into lifeless things an idea and a personality".[5] The monumental multi-volume collection, *L'Architecture Rurale Française*, published from 1977 to 2001 by the Musée des Arts et Traditions Populaires, testifies to Demangeon's lasting influence.

The rural dwelling is subject to two competing imperatives: a natural imperative which forces the dwelling to adapt to climate and ground conditions, and a human imperative aiming to ameliorate the comforts of existence. Often this obscures evidence: that all things made by humans are necessarily "natural" insofar as a human condition is also a geographical one.[17] To circumvent the apparent contradiction, geographers borrowed from naturalists the notion of "habitat". The term was first used in 1925 at the Congrès International de Géographie du Caire. Demangeon may have been responsible for this, having created a "Commission for the study of rural habitat" on the occasion of the same Congress.

*The rural dwelling is subject to two competing imperatives: a natural imperative which forces the dwelling to adapt to climate and ground conditions, and a human imperative aiming to ameliorate the comforts of existence.*

16. — LA VALLÉE DE L'ARC OU MAURIENNE SOUS LES NUAGES (Isère).

Au premier plan, l'Isère, en amont de son confluent avec l'Arc. Sous une mer de nuages, fréquents surtout en automne, le
de la Vallée de l'Arc ou Maurienne, vaste cluse ouverte dans les grandes Alpes de Savoie. A quelque 50 km à vol d'oiseau, au dernier
les trois Aiguilles d'Arves qui font partie de la zone intra-alpine (et qui seront vues du Sud sur la Photo 77). Aujourd'hui la vallée
Maurienne est une grande voie de circulation entre France et Italie, plus importante que la Tarentaise; elle est suivie par la
Nationale 6, qui traverse le col du Mont Cenis (Photo 22) et par la voie ferrée qui, après Modane, la quitte pour atteindre l'Italie,
Rome, — par le tunnel de Fréjus (appelé à tort tunnel du Mont-Cenis). La Maurienne est, de plus, l'une des vallées alpines le
intensément équipée au point de vue houille blanche et industries. — Cl. coll. Seive.

Architects eventually caught up with geographers. Le Corbusier first proposed the drafting of a "Charter of Habitat" at CIAM 7 in 1949. It cannot be insignificant in this connection that the architect's work had been featured in Demangeon's *Les Maisons des Hommes. De la Hutte au Gratte-ciel.* Published in 1937 for a mass audience, the slim volume offers the outline of a comprehensive, global theory of architecture. The last chapter entitled "The townhouse today" includes a photograph of a prototypical kitchen designed by Le Corbusier, Pierre Jeanneret, and Charlotte Perriand and another of the Salvation Army building recently completed by Le Corbusier.

At CIAM 9 in 1953, architects close to Le Corbusier and soon to be affiliated with Team 10 proposed to replace the Athens Charter with the elusive Charter of Habitat. Familiar with housing conditions in north Africa, they imagined habitat as an "evolutionary process," one specifically evolving from squatter settlements in Casablanca to state-of-the-art apartments of the kind found in the Unité d'Habitation in Marseilles.[7] Demangeon had also referred to "la maison de type evolutif" - the notion that may have originated with Le Corbusier who used the idiom - in contrast to the "geographical type" (the tent in the desert, the igloo in the Arctic, the hut in the forest, etc.) which was cast outside history.[8]

Helped by the fact that it was largely undocumented, the geographical type seemed to reach the beginning of time. E. Estyn Evans's wonderful work, *Irish Heritage: The Landscape, the People and their Work*, illustrates the point. Evans describes how, in the mind of the Irish peasant, the past remains actual in such a way that time appears foreshortened into the present. This is arguably true of all peasant cultures and it further explains the absence of historical perspective in vernacular studies. Evans, a geographer and an anthropologist by training, had studied under H. J. Fleure, the leading geographer in Britain during the interwar years. Fleure himself had worked with Demangeon in the Commission for the study of rural habitat and he made no secret of his debt to the French school of geography.

First published in 1942, *Irish Heritage* is to my knowledge the first detailed study of a complete human habitat, of its landscape, villages, houses and artefacts. The margins of the book are filled with Evans's tiny, charming sketches illustrating pots, a rattle, a butterfly cage and a potato skin, oatcake toasters, ploughs, clips, spades and much else besides. As such, the book anticipates Superstudio's late project, "The conscience of Zeno", which documents by less scholarly means the tools and the life of a Tuscan farmer.[9]

Ireland is one of the most treeless landscapes in Europe. Throughout the country, cottages were scattered without plan or order. In Donegal, according to one of Evans' sources, building sites were selected by the simple process of "throwing up a hat on a windy day and letting the wind decide by noting its resting place".[10] When a house was built - this is Donegal again - a fiddler was hired. In no time, Evans writes, neighbours (for house building was a communal affair) brought stones and timber to the site, working and dancing until dusk and often still dancing at dawn. The pastoral vision was hard to resist but it had another side in which dirt and smell were the inevitable consequence of accommodating under the same roof men, women, children, cows, horse, and poultry.

Cottages consisted of a low rectangle, some 4 to 5 meter across, with an open fireplace in the middle. They were built of stone, mud or turf, whitewashed inside and outside, with a hard mud floor and a thatched roof. Two doors faced one another, helping to regulate the fire and ventilate the house. In this way a cow, it was said, could enter through one door, be milked inside the house before leaving through the other door. Cottages showed little variation - some had a porch over the front door while oth-

**Pierre Deffontaines, Mariel Jean-Brunhes Delamarre**

*Atlas Aérien,* Gallimard, 1955-1964 © Gallimard

127

ers did not, while some had one or two rooms added at the ends - and the type was repeated throughout the country. Like dice thrown onto the land, the siting of cottages may have been the result of chance but everything - houses, people, animals, carts - appears as if in its rightful place.

The condition is pre-industrial, perhaps even Neolithic in part (Evans was also an archaeologist). What lies outside the pastoral, for instance a village or a town, seems an anachronism. Families gather by the door, mothers sit with an infant on a stool, men and children stand still and upright. Like in a painting by the Le Nain brothers, a classical sensibility presides over the scene. Ireland was fortunate in not having coal and was not scarred by the industrial revolution. With the exception of salt and iron which could only be obtained in market towns, households were self-sufficient. The permanence of rural lives is regularly idealised, the more so when the sustainability of modern lives appears to be today so uncertain.

### Excursus among the natives

To this day, most architects are introduced to vernacular architecture by Bernard Rudofsky's book, *Architecture without Architects* - no small achievement for a catalogue published more than 50 years ago. The provocative title, the striking photographs, and the simple captions help explain the feat. The preface spells out the author's position. The architecture profession, Rudofsky claimed, had been exclusively concerned with "buildings of, by, and for the privileged" (in today's terms, the 1%).  It has been driven by a desire to commemorate wealth and power, profit and prestige. In the process, ordinary people (the 99%) have been excluded.

Rudofsky called for a counter-architecture, one that does not pay lip service to the elites and their experts but is motivated instead by the welfare of the many. Unsurprisingly given the inclusiveness of the notion (it is estimated that some 95% of the world population live in dwellings that are not designed by architects),[11] he admits not having a specific name for it. "We shall call it," he says, "vernacular, anonymous, spontaneous, indigenous, rural, as the case may be." Paul Oliver who devoted most of his life to the study of vernacular architecture likewise objected to the exclusive interest of historians in monuments, palaces, churches, mosques, etc. He, too, contrasted these buildings with constructions that were "indigenous, tribal, folk, peasant and traditional".[12]

Oliver further recognised that these terms, taken individually, were either too narrow ("indigenous" excludes buildings by immigrants) or too inclusive ("traditional" includes some monuments). "Vernacular" (*vernaculus* is the latin for "native") best suited his purpose. First used in the mid 19th century to describe the language used in a particular country or region, the word had the appropriate resonance, describing in the context of architecture "the local or regional dialect, the common speech of building".[13] By extension, it evokes a specific place or region and a collectivity living in it.

Oliver defines vernacular architecture as "the architecture of the people, and by the people, but not for the people"[14] - unmistakably an adaptation of Rudofsky's reference to "buildings of, by, and for the privileged." He does not exclude the contribution of experts so long as they have the knowledge of the cultures within which they work. But his insistence that vernacular architecture should not be *for* the people (meaning that it should not be made for them but *by* them) made clear that professional architects and especially commercial builders were targeted. The authenticity of vernacular traditions, the purity of self-build were necessarily undermined by delegation, the more so when they were exposed to the corrupting influence of money. It is not difficult to understand why, at a time when activists in Extinction Rebellion press for transparency in the democratic process,

*The authenticity of vernacular traditions, the purity of self-build were necessarily undermined by delegation, the more so when they were exposed to the corrupting influence of money.*

**Pierre Deffontaines, Mariel Jean-Brunhes Delamarre**

*Atlas Aérien,* Gallimard, 1955-1964 © Gallimard

7. — PAYSAGE TYPIQUE DE L'AVANT-PAYS SAVOYARD : L'ALBANAIS, ENTRE ALBY (Haute-Savoie) ET ALBENS (Savoie).

Erosion jeune, vallées en tentacules, étroites, toutes boisées. Prairies, cultures de céréales, tabac, arbres fruitiers, haies et boqueteaux. Peuplement par petits hameaux et maisons dispersés. Au milieu, à droite (Est) vers la tête des vallées, Chainaz-les-Frasses, à gauche, en contrebas, Saint-Girod et les herbages humides (vers le Nord) de la vallée du Sierroz. Les vallées apparaitront plus nettement en creux en regardant la photographie d'Est en Ouest. — Cl. I.G.N.

Photo IGN, Haute-Savoie, 1954

self-build and vernacular architecture should once again be popular.

So broad a definition as Oliver's begs the question as to who are "the people." Cultures and societies are so numerous (several thousands according to him) that they cannot all be represented, not even in the 3-volume *Encyclopedia of Vernacular Architecture of the World* which he edited. But Oliver's early writing on the blues offers a clue.[15] It suggests that his interest in the vernacular had an emotional and political underpinning. The blues was the music of American Blacks, of millions of nameless and illiterate people. It grew together with black society on American soil and it became the folk expression of a racial group. But it was not associated with a particular place - it was sung and played in districts that could be very far apart, in the countryside as well as in cities. Its vocabulary was terse and free from hyperbole. It gave a voice to the violence, to the bitterness and the poverty experienced

by American Blacks and the raw quality of its expression precluded self-conscious artistry.

Oliver did not call the blues "vernacular" (the term was not widely used at the time) but the blues shares folk and indigenous qualities later attributed by him to vernacular architecture. It shares, too, the anonymity, the spontaneity, and the lack of self-consciousness praised by Rudofsky. It was heard in widely different social conditions, among farmers and factory workers, vagrants and entertainers, in houses as well as taverns, in tenements and at street corners. It continued to thrive in spite of, or perhaps because of migration, in the wanderings of Blacks in the American South and their flight to the American industrial cities of the North. Moreover its transmission was greatly helped by the affordability of the phonograph. This proves or at least suggests that the vernacular is not limited to traditional rural societies, that it can also be urban and open to modern life.

Like the blues, vernacular architecture in North America was exposed to the effects of migration.[16] The shotgun house was the most distinctive African American building type. It is said to originate in Haiti, in the *bohios* built by freedmen - one-room structures flanked on the narrow side with an entrance porch. Refugees from the island imported the form to New Orleans at the beginning of the 19th century, replacing the earth podium (*banquette*) on which it stood with a raised timber floor.

Similarly, the Louisiana cottage was an adaptation of the French Creole cottage in Haiti. Like the shotgun, it is indebted to the *bohio*, its porch now transformed into a gallery running along three sides of the house. To confuse the story further, its steep roof and its chimney (superfluous in the Caribbean) are said to originate from Acadia (today's Nova Scotia). Fleeing after being defeated by the English, Acadian refugees whose ancestors had emigrated from Normandy in the 17th century imported these features to Louisiana. Here they mixed with descendants from Haiti's buccaneers (who themselves are said to originate in Normandy). The Louisiana cottage was not timeless, and its development was anything but straightforward.

Sybil Moholy-Nagy had anticipated Rudofsky by a few years. In her 1957 publication, *Native Genius in Anonymous Architecture*, she refers to buildings that are alternately anonymous, spontaneous and indigenous, to buildings that "speak the vernacular of the people". She looks not to Le Corbusier or Buckminster Fuller but to Frank Lloyd Wright whom she quotes at the beginning of her book: "The true basis of a serious study of the art of Architecture", Wright claimed, "still lies in those indigenous, more humble buildings everywhere that are to architecture what folklore is to literature or folk song to music and with which academic architects were seldom concerned". Most of the buildings featured in *Native Genius* were built by settlers in the US, Mexico and Haiti. They are vernacular not by virtue of the simplicity of their form but because they are *original*, or in Wright's lexicon *radical*, meaning "of the root". They reflect the invention of settlers, stimulated by new environments and by the development of new ways of life.

Moholy-Nagy's understanding has little in common with the static, timeless and obsolete conception of the vernacular to which we have become accustomed. Indeed, it is the opposite of that conception in that it assumes an eventful past, customs that cannot be taken for granted, and a future that remains uncertain and open. No house form can be explained by soil and climate alone. The spirit guiding a construction must be found elsewhere, in human invention and resourcefulness. "Necessities are nowhere. Possibilities are everywhere," Lucien Fèbvre wrote. "Man, as the master of these possibilities, is the only judge of their employment... humans, not the earth nor the influence of climate, preside over the elaboration of the house".[17]

## On the highway

In 1904 Vidal de la Blache travelled to North America to attend the International Congress of Geography (he would do so again in 1912, this time with Demangeon). The journey made a strong impression on him and he recorded it in a wonderfully vivid article.[18] New England where "the country, left to its own device, spontaneously assumed the aspect of a park", was elegiac. But the prairies further west in Illinois disappointed him. Trees were rare and most were planted by Man. Grain silos rose besides railway stations and their silhouettes marred the landscape. Next to them were billboards, one or two hotels, a general store, a chemist, a bank and a barber. Commercial elements were scattered throughout the country: *urbs in rus*. From these crude agglomerations, roads struck out in straight lines across the country, punctuated at regular intervals by telegraphic poles. Vidal was shocked to find not the countryside but the marks of the city everywhere. The separation so familiar in Europe between city and countryside did not apply in America.

Whereas in Europe the variety in the stonework lent variety to buildings and a specific physiognomy to a region, Vidal found no such diversity and harmony in America. "The classical disposition which is in every one of us," he wrote, "the qualities of harmony, of proportion, of finish and completion to which our eyes have long been accustomed, are trampled underfoot with a kind of unconscious abandon."[19] Houses, bridges, silos, railway platforms and sidewalks were made with timber, not stone, and seemed ready to be dismantled and shipped to new destinations. The mobility of people, not their physiognomy, and a certain uniformity in buildings impressed him everywhere. In place of the rural and local character of much of Europe, people and things partook in a common, nationwide civilisation. The physiognomy of the US was anonymous, spontaneous and indigenous, constituting a kind of vernacular at the scale of a country.

In his *Tableau Géographique de la France* published in the year preceding his journey to America, Vidal de la Blache described France as a collection of "pays", of regions made distinct by specific customs concerning diet, costume and habitat, work habits and dialect. But this did not account for all aspects of France. With far-reaching consequences, he also described how the river and sediments in the valleys of the Rhine and of the Rhone form a "bridge" between the North Sea and the Mediterranean. This highway for which the origin was "evidently commercial" connected Flanders with the plain of the Pô, the estuaries of both regions forming an exact pendant to one another. It cut across the "labyrinth of forms" which characterised the local *pays* and the infinite variety of their physiognomies.

Whereas this "labyrinth" accommodated local currents with markets, fairs and seasonal migrations, the highway formed by the Rhône, the Rhine and their sediments facilitated currents of a more general nature. It was the route of choice for the currents of *general life* - a striking expression coined by Vidal de la Blache as if in anticipation of the flows and networks that have since become so familiar. The valley of the Rhine in particular constituted for Vidal an ideal landscape, one in which long distance fluvial traffic and thriving cities combined with the individual forms of vineyards and castles rising along its flanks. In such a setting, the geographer observed, the inhabitant feels profoundly at home but is never isolated.

The valley of the Rhine was less a natural given than a route consciously planned by humans. For two millennia, it had been the preferred route for the commerce of amber, for that of salt and metals including bronze, gold and iron. When supplemented with a channel along its length, it became in itself a vast harbour penetrating deep into the European continent, stocked with timber, stone and cereals, with hemp, stuff, salted fish and

**Pierre Deffontaines,
Mariel Jean-Brunhes Delamarre**

*Atlas Aérien,* Gallimard,
1955-1964 © Gallimard

— SUR LES RIVES DE LA DURANCE, PAYSAGE TYPIQUE DES PLAINES COMTADINES D'AUJOURD'HUI. IRRIGATION, PRIMEURS, ET HAIES PROTECTRICES CONTRE LE MISTRAL, AUX ENVIRONS DE CHATEAURENARD (Bouches-du-Rhône). Photographie prise en février. Légende ci-contre. — Cl. I.G.N.

Photo IGN, Bouches-du-Rhône, 1944

the wines of Alsace. Its federating force was so great that, in spite of reaching across several nations and their borders, it became de facto an international route.[20] By the end of the 19th century such commercial routes had gained unprecedented importance, prompting Vidal to anticipate that space, for centuries the principal obstacle to trade, was about to become a force.[21]

The greed for space witnessed in the prairies of Illinois was not so novel after all. Nor was it an exclusive attribute of American modernity. It reflected a fundamental need of human communities. For centuries humans have kept in check the exuberance of forests and resisted the invasion of plants and animals. They have made space for dwellings and gardens, for orchards, meadows and fields which are constantly threatened by the return of unwanted species. They have made space for the ox which lent them strength and for the horse which contributed its speed. Without

space, humans could neither thrive nor prevail in their competition with other species. In time humans satisfied this need with the creation of roads and railways facilitating settlement, commerce and conquest.

The resulting mobility constitutes the geographical singularity of the human species (our "privilege" says Vidal). Winds, currents, rivers and animals all play a role in connecting the diverse parts of the Earth and in disturbing the equilibrium of life. However, in the transformation of the Earth, humans are far and away the most industrious agent. Cutting across local variations in landscapes, they make its surface increasingly uniform. They tame rivers, flatten hills, lay motorways and railways and build cities, leaving behind them the marks of what they rashly call civilisation.

Vidal referred to the view from the mail coach, meaning the view afforded by those who travel at speed on the highways cutting across the labyrinth of local forms. More recently, an American photographer, David Plowden, referred to the view from the train window as having had the greatest influence upon his work. What he saw was the unguarded, unself-conscious aspect of places, practical ordinary things including farms, silos and bridges, clumps of buildings as if sprung from windblown seed - by and large the same things which Vidal saw and commented on in the prairies some 70 years previously. Plowden liked to focus on the middle ground between the tracks and the hills, on "that ordinary, disorganised, common-place world of plain existence".[22] He pointedly referred to Rudofsky and to his idea of a non-pedigreed architecture. He praised structures that were found throughout America and reflected the nature of the people who built them. These inspired in Plowden this striking oxymoron: "America is a *place* and it is everywhere".[23]

In the 1960s, the notions first articulated by Vidal in the 1900s' - space, distance, scale (*étendue*) - became dominant among a new generation of geographers. Increasingly aware of the growing dependency of regions on a few large cities and on long-distance commerce, their ambition was to correlate space with the economy. "One must count with space...The material foundation of human activities counts for less than it did in the past...The region becomes confused with the metropolis and its suburbs".[24] Henceforth the task would be to establish a "general geography of markets", to quote the title of a 1963 book by Paul Claval, who chose as an exergue to the work this melancholy phrase by Teilhard de Chardin: "The thin film of colours and places bores me to tears. What I love is no longer visible." Nothing more could be obtained from the observation of local places. Future insights would entail numbers, statistics and come from economists, especially the economists of cities.

## In the city

Unlike a hamlet or a village, a city represents an emancipation from the local milieu. Nature may have prepared its bed, prompting it to be situated where it is convenient for humans, for instance where a river can be bridged or at the entrance of a valley. But in the city, human priorities take over natural ones. No longer founded upon the cultivation of the soil, ways of life are shaped by human relations. The local advantages which prompted settlement in the first place become less visible. Minor features in the landscape disappear. Rivers are banked and the topography is made progressively more even. The role of humans increases in inverse proportion to the decline in the role of nature.

A city offers stability and permanence. It confers upon a community something akin to the solidity of the stone of its monuments. No less than a rural habitat reflects a specific rural way of life, a city reflects a specific urban way of life. Independent from the rhythm of the seasons, freed from

*Rivers are banked and the topography is made progressively more even. The role of humans increases in inverse proportion to the decline in the role of nature.*

the servitudes of climate, its inhabitants depend upon a complex social and economic organisation. The mere gathering of people demands coordination that was not needed when they were dispersed. From the necessity of organisation comes a mentality that is particular to the city, a sense of civility, of urbanity.

If only for their food, cities remain in constant contact with their hinterland. But aided by the combined advantages of power and money, they break free from the country. "Money, you might just as well say cities," Braudel exclaimed.[25] Cities grow with markets. They quicken the pace of exchange, not only of the products of farming and industry but also of labour, of real estate and of money itself which circulate faster than any merchandise. Braudel's conception of the market was fundamental and inclusive. It embraced equally the primitive markets that appeared as quickly as they disappeared in the mountains of Kabylie, and the complex forms of exchange taking place in the exchanges of Antwerp, Amsterdam, Genoa and London. Braudel saw the market as a liberation, as an opening that gives access to other worlds. "Between production where everything is made, and consumption where everything is used up", he wrote, "the market economy serves as the link, the driving force, the restricted but vital area from which flow encouragement, energy, innovation, entertprise, new awareness, growth, and even progress".[26] Braudel's admiration is palpable. While not indifferent to the "tyranny" of the Uniprix (what could he possibly have thought of Carrefour or Walmart?!), the historian envisioned the market economy as an essentially creative force.

The market has since become associated with a much darker vision. Its presence is manifest in "non-places", in spaces that are indifferent to place and that could be located anywhere. Braudel would have disagreed. For him, the market had a geography. It was accommodated in innumerable distinct places that were organised for the purpose of commerce, for instance in fairs, shops, market squares and exchanges. These places formed so many points of rupture between material life and economic life, between a life of self-sufficiency and another beginning at the threshold of exchange value. They formed "perforations" in the inhabitable part of the Earth - the *ecumene* of geographers. And far from being nowhere, these places attract what is most durable and urban in the city. Think for instance of the Palazzo della Ragione in Padua (a building singled out by Aldo Rossi in *The Architecture of the City*), a monumental building framed on either side by the Piazza della Fruta and the Piazza delle Erbe. Or of the "trou des Halles", once the central market of Paris and now an all too literal perforation in its ecumene.[27]

In *Material Civilization and Capitalism*, Braudel repeatedly emphasized the concrete nature of economic activity. If numbers themselves have no consistency, the economy is deeply embedded in the fabric of daily life. From the markets of Kabylie to the most sophisticated forms of capitalism, all economic activity is carried upon the enormous back of "material life", upon a sub-economy that includes domestic work, the black market and bricolage (this last adding according to Braudel's estimate 30 to 40% to the national product). Material life and economic life complete one another like city and countryside, money and barter, luxury and subsistence economy, general life and local life.

But cities have increasingly lost sight of material life. Their connections with their hinterland have become more complex, more distant and abstract. Few among their inhabitants are familiar with the sites where the luxuries of cities are manufactured. Who knows for instance where and how food is produced, clothes and shoes are made, books are printed, computers are assembled, or where energy is sourced and how it is transmitted. Alexandre Woeikof, the Russian geographer who first correlated de-

**Pierre Deffontaines, Mariel Jean-Brunhes Delamarre**

*Atlas Aérien,* Gallimard, 1955-1964 © Gallimard

forestation with climate change, was alarmed by the growing dissociation of humans from the Earth. Only peasants, he claimed, retain a connection with the soil. But even this is undermined by the culture of cities.[28] Cities are commonly looked upon as a panacea, as the (unlikely) solution to the problems which they themselves create. Urban expansion threatens green field sites? Make cities denser and build them higher. Urban life pollutes the hinterland? Export their waste to remote developing countries.

Braudel noted the essential bond between city and country, the countryside being to the city a source of food and labour. "To exist, the city must dominate an empire, however tiny".[29] The periods of greatest economic expansion were invariably accompanied by an explosion of cities. But can cities legitimately claim to be the "destiny of the world"? Must cities

Photo IGN, Loire Maritime, 1952

always be a rupture, a "perforation" in the ecumene of the Earth? Must the city always be obsessed with its own past as it is in the writings of Aldo Rossi and Colin Rowe, with its own imperium as it is in the writings of Rem Koolhaas? Must it always be set in history, as in Lewis Mumford's book, *The City in History*? Can it not be set, too, and with a greater urgency, in geography?

## Afterword

I recently visited Castile. My wife and I had seen the wonderful film by Luis García Berlanga, *Bienvenudo, Mister Marshall!* shot in 1953 in a Castilian village. Its inhabitants, principally peasants, the Mayor, the priest and an aristocrat, dream of riches soon to be brought to Spain by the Americans under the Marshall plan. Being curious to know what had survived from this en-

gaging and at times hilarious portrait of rural life, we took the school bus to the village of Ampudia. The village (a different one from the one chosen by Berlanga) stood in the middle of corn fields reaching as far as the eye could see. It was sleepy but not in the way we had anticipated. Almost all the houses had their blinds drawn down and the streets showed no sign of life. The sense of desolation was sharpened by the continuous arcades of rough-hewn timbers which had seduced us in the first place. We later learnt that most houses were owned by people from Palencia, a city some 30 km away, and were lived-in only during weekends if that.

As we settled down in the local Casa Rural, some 30 young people with Down syndrome filed out of the house after being hosted for lunch. We walked down the street to the local museum. We were the only visitors and the person at the reception desk was the only staff. On the ground floor, models of farming machines and art works made by children were on display. The upper floor hosted a permanent collection of old medical chairs and instruments, many of them not easily forgotten (think obstetrics and dentistry). Undeterred we pushed forward past a large medieval castle. A red sports car was parked on a gravel lane, beside which a couple were taking photographs of their young children in their Sunday best.

We continued up an escarpment to the plateau which dominated the plain. Across the fields, all the way to the horizon, wind turbines marched some 200 meter apart in small formations, converting interest into monumental boredom. By then we were overwhelmed and weary. We retreated to the village and stopped at the local shop. A handful of people stood under the arcade, drinking beer from the can. Here we struck a pleasant conversation with a Brazilian woman who clarified a little of what baffled us.

Back at the Casa Rural, we were the only diners in the bottega improvised in the basement of the house. Our hosts had prepared a meal - I think it was ox tail. The owner offered to sing for us. After speaking fondly of his teacher many years ago in Barcelona, he sat with a guitar, switched on the mic and sung sad arias. Sitting with us at the table, we could see that his wife was moved. Meanwhile we struggled to reconcile sympathy, embarrassment and mirth. The episode was the climax of a visit that was spectacular foremost for its bewildering lack of sense.

People who had little in common had been thrown together for no clear purpose, some for an hour, others for a night, others still for retirement. In its impromptu mix Ampudia was like a city in miniature, but one that did not have the necessary critical mass to achieve a sense of order. Ampudia had no social or cultural project. It had not even an economic project. Instead it countenanced as many conceptions of itself as there were individuals passing through it. Only the relative permanence of buildings and the efforts of conservationists contributed a deceptive impression of unity to the setting. Houses aside, nothing could be said to be vernacular, indigenous or even rural. The ways of life and the human types depicted in *Bienvenudo, Mister Marshall!* had vanished. In a distant echo of Vidal de la Blache's observations during his American voyage, it was the city that one found everywhere.

Ampudia is hardly an exception. Incoherent places can be found throughout Europe and beyond, accompanying modernity as it spreads across continents. It was fashionable in the 1990s and 2000s to enthuse about the chaos of human settlements, and it was seductive and convenient to assume that this chaos will regulate itself. After all, the most unpredictable of all phenomena, the weather - the same weather which kept humans guessing day after day for millennia - follows patterns which can now be confidently predicted with mathematical models. But prediction does not guaranty comfort or safety. Think of the weather tomorrow. Think

*Only the relative permanence of buildings and the efforts of conservationists contributed a deceptive impression of unity to the setting. Houses aside, nothing could be said to be vernacular, indigenous or even rural.*

of climate change. Clearly the science of chaos is not a substitute for order.

Likewise with globalisation. Between the multiple ways of life colliding in Ampudia and the forms of its houses, its streets and its fields, there is a connection. This connection is inevitable but it is not given. Rather it is constructed by people with the means at their disposal and according to their inspiration. Vidal de la Blache showed how this connection contributed a *personality* to a place. He sought to explain how a country becomes differentiated, how it acquires an identity "like a medal stamped with the effigy of a people."[30] In the course of a century, the people of Ampudia have changed. The novelty which Vidal had observed in America appears today like a prophecy. The marks of the city are now everywhere and the distinction between rural and urban ways of life is disappearing. But the manner in which the urban falls into place remains haphazard and wanting in direction.

At times the city appears to extend and complete its empire over the countryside. At others it is this empire that seems open to question. This helps to explain the renewed interest in the village. In a powerful polemic Christophe Guilluy, a geographer, asserts the resurgence of the village and see in it a symptom of resistance against globalisation, a revolt against Braudel's "villes-monde".[31] Eric Charmes, a sociologist, announces the "revenge of villages" and the end of the opposition between cities and country.[32] He observes how settlements cohere into spontaneous garden-cities consisting of a myriad of villages and small towns, now at the vanguard of an ecological transition. Either way, the village is presented as a site of choice for experimentation, for new combinations of nature and culture.

Drawing for the most part from sociology, statistics and political science, these studies lack the concrete, living detail, so valuable to architects, that was once central to the work of human geographers. I relish the sensitivity of human geographers to the forms of the Earth. No-one before Vidal de la Blache better showed how humans nestle within the labyrinth of local forms and the ingenuity with which they enlist the participation of other species. In this way they created habitats gifted with a remarkable permanence. I subscribe to an architecture that is truly geographical, that is vernacular in a refreshed, contemporary sense; to an architecture that is sensitive to local conditions yet responsive to human curiosity and aspirations. I subscribe to Vidal's ideal of a habitat (found by him in Alsace) where one is profoundly at home but never isolated; where small-scale autonomies are sharply defined in their forms and personality yet embrace the rejuvenating currents of general life.

I have on my desk the *Atlas Aérien* of France (one of its authors, Pierre Deffontaines, studied under Albert Demangeon).[33] Superbly illustrated with black & white aerial photographs, it conveys the diversity in the forms of human settlements (not excluding cities) and the suppleness with which humans have adapted to particular landscapes. Bruno Latour describes human geography as a layer superimposed over physical geography, the former being "on" or "in" the latter. Accordingly humans would be segregated in a kind of apartheid *avant la lettre* with humans on one side and non-humans on the other, for the most part unacknowledged and unrecognized.[34] As every image and accompanying caption of the *Atlas* testifies, it is, to the contrary, precisely the imbroglios (a word often used by Latour) between landscape and settlement which hold the attention of human geographers. The more intricate the imbroglio, the more it will reward study. The strength of the *Atlas*, and of Vidal's *Tableau Géographique de la France* before it, is to articulate the dynamic character of a particular landscape, of its geology and its vegetation, with the ingenuity of humans who combine their actions with it.

"The subject of human geography is the terrestrial physiognomy

**Pierre Deffontaines, Mariel Jean-Brunhes Delamarre**

*Atlas Aérien*, Gallimard, 1955-1964 © Gallimard

140

237. — LE MARAIS MOUILLÉ ET LA « PLAINE ». IRLEAU ET LE VANNEAU (Deux-Sèvres).

Le Marais Poitevin est entouré de plateaux calcaires qui ont reçu des habitants le nom de « Plaine »; ce sont les zones qui apparaissent ici en clair. Le contraste est grand entre celles-ci et le Marais mouillé qui ressemble, vu d'avion, à un grand filet aux mailles irrégulières et qui correspond à la partie orientale, non asséchée, du Marais Poitevin. Le Marais mouillé a un aspect bocager; il est sillonné de canaux sur lesquels on circule en barque, d'où l'expression de « Venise Verte » qui lui est parfois appliquée, mais bien inexactement car il manque « la ville » et chaque fossé est une avenue d'arbres (frènes et surtout peupliers, d'un intéressant rapport), que l'on chercherait en vain dans la vraie Venise! Le Marais mouillé a été mis en valeur au XIXᵉ siècle (cultures de lin et de chanvre aujourd'hui abandonnées) A présent 60 % de la surface sont en prés irrigués (souvent insuffisamment entretenus) et consacrés à l'élevage (lait et viande). Les récoltes de haricots sont abondantes, ainsi que celles de l'ail, des melons, des plantes fourragères. Les villages exploitent le Marais et la Plaine; à la limite l'un de l'autre, on voit Irleau (en demi couronne) et au Sud-est, Le Vanneau; ces petites agglomérations se reconnaissent aisément, car elles sont construites non pas avec l'argile du marais mais en belles pierres blanches de la plaine (Jeanne Gravier). La Sèvre Niortaise, canalisée, principale artère du Marais Poitevin, est bordée d'une file ininterrompue de petites maisons blanches. Propriétés de petites dimensions, exploitation directe, revenus importants. De plus les coopératives laitières (surtout beurreries), ici, comme dans toutes les Charentes, assurent la qualité des produits et leur importante diffusion. — Ph. I.G.N. prise à 6.000 m. d'altitude (1/40 000 env; juillet 1945).

Photo IGN, Basses-Pyrénées, 1945

**Pierre Deffontaines,
Mariel Jean-Brunhes
Delamarre**

Left: *Atlas Aérien,* Gallimard,
1955-1964 © Gallimard

as it is modified by Man".[35] Vidal's definition suggests that traffic goes only one way, from Man to Earth. But he himself provided ample evidence of a broader vision. In the same article, he argues that the most delicate task facing the human geographer is the study of the influence exercized by a specific milieu upon a particular way of life. This task belongs to the science of local milieux, namely ecology, which was being instituted at the turn of the 19th century by botanists. Articles on ecology were published in the *Annales de Géographie* which Vidal edited. In effect, the foundation of human geography during the same period prepared the ground for a conception of architecture in which humans and their habitat are fully naturalised.[36]

VUE VERTICALE DE LA VALLÉE DU GAVE DE PAU, EN AVAL DE PAU (Basses-Pyrénées). PAYSAGE BÉARNAIS.

Du Sud-est au Nord-ouest, le ruban sinueux des méandres morts ou vifs du Gave de Pau. Multiples anévrismes instables, qu'encadre une bande
, large de 3 à 4 km, difficile à franchir (un seul pont ici vers le Nord-ouest) —, zone inondable qu'occupent aulnes, saules, peupliers, ainsi
pâturages appelés « saligues »; de chaque côté de cette zone, la riche plaine alluviale plus sèche, la « rivière » ou « ribère », où alternent
maïs. Le contraste est frappant, au point de vue habitat et paysage, entre la plaine et les versants et plateaux qui la bordent et qu'on appelle,
osition, les « coteaux. » Dans la « rivière », habitat groupé en gros bourgs, openfields ou champs ouverts, de forme rectangulaire mais
as de champs laniérés comme en France du Nord-est); absence de haie; pour protéger les récoltes de la voracité du bétail, on ne clôturait les
que momentanément lorsque « les fruits étaient pendants », mais « à fruits cueillis » on pratiquait la vaine pâture. Sur les « coteaux »,
dispersé quoique dense, sans doute plus récent que celui de la plaine; des forêts y subsistent, en général domaines communaux (chauffage,
euvre); elles étaient autrefois plus étendues, mais le surpeuplement rural du XVIIIe siècle accrut les défrichements en clairières qui apparaissent
nt, avec un parcellaire très morcelé; dès cette époque se généralisa, comme système de culture, l'association terres cultivées (polyculture
aquitain) - bois-touya. Des vignes sur hautains eurent au XIXe siècle une belle prospérité qu'elles ne retrouvèrent pas. Arbres fruitiers nom-
En contrebas des coteaux, dans les parties les plus humides et dans le sens de la rivière, des prairies encloses de haies. Les haies « descendues
eaux » ont aussi envahi certaines parties de la plaine, là surtout où l'openfield céréalier a cédé la place au bocage viticole et herbager
t, S. Lerat.) Dans la « rivière », sur la route toute droite qui va de Pau à Orthez en passant par Lacq (tout à fait dans le coin Nord-ouest
à gauche et ci-après, Photo 63), on aperçoit des bourgs très concentrés : Denguin (310 hab. au chef lieu de la commune sur 396 hab. que
au total la commune); Labastide-Cézéracq (325 hab. sur 325, c'est-à-dire que tous les habitants sont au bourg); Artix (425 hab. au bourg sur
r la rive gauche se succèdent Tarsacq (139 hab. au bourg sur 150); et, plus éloignés du Gave, Abos (366 sur 371) — c'est entre Tarsacq et
e l'openfield est le moins « dégradé » par les haies —; Pardies (542 sur 548) et Noguères (100 sur 100... c'est-à-dire que personne n'est
dans la campagne)..... Au contraire, sur une haute terrasse, les quelque 148 habitants de la commune de Labastide-Monrejeau sont tous
s (vaste clairière au-dessus et au Nord-est de Labastide-Cézéracq). Photo prise à 6 000 m d'altitude. — Cl. I.G.N. (1/40 000 env., juillet 1945,
8142).

## Endnotes

[1] Paul Vidal de la Blache, "La géographie politique d'après les écrits de M. Fr. Ratzel", *Annales de Géographie*, vol. VII, 1898, p.103

[2] Paul Vidal de la Blache, "Des caractères distinctifs de la géographie.", *Annales de Géographie*, vol. XXII, 15 July 1913, p.298

[3] Fernand Braudel, *Ecrits sur l'Histoire*, 1969, p.31

[4] Albert Demangeon, "Vidal de la Blache", *Revue Universitaire*, June 1918, p.4

[5] Albert Demangeon, "L'habitation rurale en France. Essai de classification des principaux types", *Annales de Géographie*, vol.29, no.161, 1920, p.353

[6] Lucien Fèbvre, *La Terre et l'Evolution Humaine: Introduction Géographique à l'Histoire*, 1922, p.284

[7] Eric Mumford, *The CIAM Discourse on Urbanism. 1928-1960*, 2000, p.236

[8] Albert Demangeon et Alfred Weiler, *Les Maisons des Hommes. De la Hutte au Gratte-ciel*, 1937, p.120

[9] 2A+P/A, "La Coscienza di Zeno": Notes on a work by Superstudio", San Rocco 8, Spring 2013

[10] E. Estyn Evans, *Irish Heritage: The Landscape, the People and their Work*, 1942, p.48

[11] *Encyclopedia of Vernacular Architecture of the World*, Paul Oliver (ed.), CUP 1997, vol.1, p.viii.

[12] Ibid, p.xxi.

[13] Ibid, p.xxi

[14] Paul Oliver, *Dwellings*, 1987 (reprinted 2003), p.14

[15] Paul Oliver, *Meaning in the Blues*, 1960

[16] Alan G. Noble (ed.), *To Build in a New Land. Ethnic landscapes in North America*, 1992

[17] Lucien Fèbvre, *La Terre et l'Evolution Humaine: Introduction Géographique à l'Histoire*, 1922

[18] Paul Vidal de la Blache, "A travers l'Amérique du Nord", *La Revue de Paris*, 1er avril 1905

[19] Ibid, p.531

[20] Albert Demangeon et Lucien Fèbvre, *Le Rhin. Problèmes d'Histoire et d'Economie*, 1935, p.198

[21] Paul Vidal de la Blache, "La géographie politique d'après les écrits de M. Fr. Ratzel", *Annales de Géographie*, vol.VII, 1898, p.109

[22] David Plowden, *Commonplace*, 1974, p.22

[23] Ibid, p.15

[24] Paul Claval, *Régions, Nations, Grands Espaces: Géographie Générale des Ensembles Territoriaux*, Paris, 1968, p.811

[25] Fernand Braudel, *Civilisation Matérielle, Economie et Capitalisme: XVe-XVIIIe siècle*, vol.1, 1967, p.582

[26] Fernand Braudel, *Afterthoughts on Material Civilization and Capitalism*, 1977

[27] Françoise Fromonot, *La Comédie des Halles*, 2019

[28] Alexandre Woeikof, "De l'influence de l'homme sur la terre", *Annales de Géographie*, vol.X, 15 mars 1901, p.209

[29] Fernand Braudel, *Civilisation Matérielle, Economie et Capitalisme: XVe-XVIIIe siecle*, vol.1, p.549

[30] Paul Vidal de la Blache, *Tableau de la Géographie de la France*, 1903, p.2

[31] Christophe Guilluy, *La France Peripherique. Comment on a Sacrifié les Classes Populaires*, 2014

[32] Eric Charmes, *La Revanche des Villages. Essai sur la France Périurbaine*, 2019

[33] Pierre Deffontaines and Mariel Jean-Brunhes Delamarre, *Atlas Aérien*, 5 vols, 1955-1964

[34] Bruno Latour, *Down to Earth*, 2017

[35] Vidal de la Blache, "La géographie humaine, ses rapports avec la géographie de la vie", *Revue de Synthèse Historique*, October 1903, vol.VII-2, p.223

[36] Marie-Claire Robic, *"L'invention de la "géographie humaine" au tournant des annees 1900: Les Vidaliens et l'écologie,"* in Autour de Vidal de la Blache: La formation de l'école française de géographie, Paul Claval ed., 1993 p.141

**Irénée Scalbert** is an architecture critic and historian based in London. He has taught in many schools of architecture, including the AA School in London, the POLIMI in Milan and the GSD at Harvard where he was a Visiting Professor. He currently teaches at the AA School. His most recent book is a collection of essays, *A Real Living Contact with the Things Themselves* (Park Books, 2018).

# Anthropocene, architecture, and modernity

*In the last decades, the concept of the Anthropocene has become remarkably common in many fields, although sometimes, it is reduced to a catchword. This essay investigates how such concept may require the development of a specific historiography of architecture.*

*The full titles of this essay is 'Prolegomena to a Narrative: Anthropocene, Architecture, and Modernity'.*

text by **Giacomo Pala**

Almost inexorably, any essay concerning the Anthropocene must confront the problem of its definition. This is due to the plethora of descriptions either providing philosophical discussions, referring to scientific studies, or defining specific artistic trends.[1] However, it seems legitimate to start from an assumption shared by more or less everyone: the Anthropocene is the era of human impact on the Earth's ecosystem, including its geology. Or, as we can read in one of the many publications on the topic: "the Anthropocene remains a conceptual work in progress, argued about by human beings who are, in what is also taken to be indicative of the novel age of the Anthropocene, the first species to be self-consciously aware of their power in having transformed the earth".[2]

A "conceptual work in process" that has not spared architecture either.[3] The most common use of the word in our field may be understood as a generic concept adopted to describe a series of tendencies that reject historically determined languages and embrace performative approaches, using computational tools and looking at nature as a source of a more or less literal inspiration. Even though there is no agreement on what the implication of the "Anthropocene" in architecture may actually be (not least because the field is known to be particularly susceptible to ever-faster fashion changes in both aesthetics and conceptual terms), it is possible to pinpoint a certain number of emerging topics: the simulation of natural processes in architectural design, a renewed interest in materials and their provenance, as well as new urban theories. If there is any single shared aim between these topics, it is the interest in finding common points between nature and the built environment; or even the desire of looking at architecture as if it were a natural object.

Moreover, as architects are always subject to influence from other disciplines, and particularly philosophy, another use of the term Anthropocene has become quite popular over recent years: one that attempts to link architecture to a generalised interest in metaphysics and new philosophical tendencies, frequently associated with "Speculative realism".[4] Simplifying to the extreme, the goal, in this case, can be summarized with Tom Wiscombe's words, who defined a "Flat Ontology for Architecture" as "a way of seeing the world as a collection of lively, complete entities that cannot be reduced to universal elements or systems".[5]

It should be immediately apparent that, in architecture, the adoption of the term Anthropocene is a way to open-up its discourses, in an attempt to generate new forms, concepts, practices, and new aesthetics. It doesn't really matter whether the Anthropocene is a new geologic era or not, as debated in the sciences. The term Anthropocene, rather, is used as a conceptual reference just as notions such as "postmodernism", or "digital" already have . In a way, it is a demonstration of what Bruno Latour already clearly stated: "What makes the Anthropocene a clearly detectable golden spike way beyond the boundary of stratigraphy is that it is the most decisive philosophical, religious, anthropological and [...] political concept yet produced as an alternative to the very notions of 'Modern' and 'modernity'".[6]

Whether one agrees or not with Latour's certainties, his words highlight something quite interesting for architecture's history and theory: as the notion of modernity enabled the invention of "modern" architecture, so the Anthropocene could be understood as a way of reading and interpreting architecture. In this sense, one may wonder: what might be a possible impact of the "Anthropocene" in architecture history and theory? Or, even better: as the notion of modernity has produced a sprout of historiographies and theories of what modern architecture's historical determinations may be, would it be possible to use the concept of the Anthropocene to open up the historiography of architecture?

These are the questions this essay will try to answer. Nonetheless, before proceeding – and since the field of investigation granted by a single text is inevitably limited – it is appropriate to clarify from the very beginning this essay's objectives and its main hypothesis. First of all, the Anthropocene is looked at as a concept: a conceptual point of view from which it could be possible to read certain moments, events and facts of architecture's history. The second preliminary remark is related to the previous one: even though the Anthropocene could be defined as a geologic era, it cannot be understood as new socio-cultural epoch. That is to say: the concept of the Anthropocene is here first and foremost used as an excuse to critically look at some of modernity's theoretical chores, and first of all modernity's attempt at granting a central role in the ecosystem to humanity. Then, the notion of the Anthropocene is used as a tool to look at modernity itself, if not as one of modernity's by-products: the name we give to the human influence on the natural world as a whole. In this sense, then, to discuss about the Anthropocene in relation to architecture should not be a matter of defining a new architecture, as if the problems this word signals were not already at work before its invention. Rather, the "Anthropocene" will be used as a concept enabling specific problematizations of architecture's culture. Finally, a remark: this text does not want to represent a well-developed research field. Its aim, rather, is to suggest some theoretical issues, hopefully providing fertile ground for future research.

## Anthropocene and History

In its wider meaning, the Anthropocene signals the need of putting an end to the ontological divide between Nature and Culture, at least in western culture. This problem, as discussed by many, is an incredibly interesting topic of research for historical studies.[7] First of all, it

provides the possibility of inaugurating a new interdisciplinary understanding of architecture. It calls for a cross-breeding between the understanding of cultural history and natural history, as it happens in Marrika Trotter's fascinating studies on the Scottish Enlightenment, where we learn the influence of geology in the work of architects such as Joseph Gandy, or John Soane.[8] Secondly, the Anthropocene creates the possibility of a different understand-

**Andreas Körner**
*Procedural Sinters, 2020*

ing of history. Human history, in-fact, is classically thought of as something separate from the planet's history.[9] This is so true that, sometimes, history itself has been theorized as the outcome of an opposition between nature and the human:

> "Along with the world there began a war that will end together with the world and not before: that of man against nature, of spirit against matter, liberty against fatality. History is nothing else than the account of this interminable struggle."[10]

On the other hand, we see a generalized understanding of natural and geological history as something detached from human history:

"no one of the fixed and constant laws of the animate or inanimate world was subverted by human agency".[11]

These short quotations, respectively from Jules Michelet's "lectures on history" (1831) and Charles Lyell's "Principles of Geology" (1830) are, as proven by Cristophe Bonneuil and Jean-Baptiste Fressoz, two symptoms of the same problem: a binary understanding of the relation between humans and the rest of nature; if not even the illusory opposition between nature and technology;[12] precisely the kinds of understandings the Anthropocene could help us overcome, or at least to question. Needless to say, this is not a completely new topic. For their part, Darwinism, evolution theory and genetics have already contributed to expanding the time of human history, enlightening the existence of points of conjunction between mankind and the so-called animal kingdom.[13] However, the history of nature and that of the social world are generally considered to be two different, and sometimes dichotomous narratives. On the one hand, therefore, the inhuman nature; on the other, the unnatural social sciences. The former studies the environment where humans live, its laws and its other inhabitants; the latter studies the history of human becoming, describing a progressive emancipation from the natural world.

*Nature lives in the social world, and its histories, defining the environmental conditions allowing any culture, with its own type of lifestyle, to exist.*

If it is true, however, that the Anthropocene is the name we give to the understanding of a complex relationship between nature, economy and culture – as well as the understanding of a deep and almost unthinkable (if not sublime) relationship between nature and technology – then things may be more complex. The Anthropocene, by pinpointing the irruption of nature's temporality and its complex dynamics into what we are used to defining as society and history, forces us to think beyond the limits of a cultural and political economy, and a society unbounded from natural constraints. Or, in Bonneuil's and Fressoz's words: "In the Anthropocene, it is impossible to hide the fact that 'social' relations are full of biophysical processes, and that the various flows of matter and energy that run through the Earth system at different levels are polarized by socially structured human activities".[14]

The objective is then the one of thinking of nature and society as a hylomorphism, not as a duality. To do so, it is at first necessary to understand the relationship between nature and society as a non-linear condition. Nature is not only altered and modified by the social through the extensive exploitation of land and through the adoption of technologies, but nature itself defines the same societies that modify it. Nature lives in the social world, and its histories, defining the environmental conditions allowing any culture, and its own type of lifestyle, to exist.

From this point of view, it is necessary to think of a sort of mutual history of Nature and human societies. For example, it is a common assumption to think of any historical period as an epoch composed of a variegated set of world-views that simultaneously express and generate specific sociotechnical arrangements. It is not very common, yet, to study the relationship between any world-view with the metabolism of Earth's ecosystem. Something that would seem to be of interest, if only for one reason: any world-view expresses specific ideological and political agencies informing specific ways of looking at nature, while exploiting it. To give an example, a work by the historian Kyle Harper, can be mentioned; a study that surely resonates with everyone's sensibility, today.[15] The Roman Empire began its fall not only because of the so-called barbarian invasions and various political issues, but also because of environmental problems for which the Romans were ultimately co-responsible. One of the main actors was the Kep's Gerbil (*Gerbilliscus kempi*): a gerbil, originally from northern Africa, which was responsible for the spillover from animal to man of the so-called "plague antonine." This plague was particularly serious precisely because of the overlap between society and nature: the Ro-

momento fui per laire deportata & demissa. Et quiui dicio cum il baten=
te core, oltra il credere ispauentata di tanto repétino caso & tanto ísperato,
Incominciai di sentire quello che ancora io uoleua, guai guai fortissima=
mente exclamare, cum feminei ullulati, & uoce flebile, & pauurosi lamen
ti, quáto piu ualeuano. Quale sentite & uide il Nobile rauennate.

Oue senza inducia uidi disordinariamente uenire due doléte & siagu=
rate fanciulle, indi & quindi, & spesso cespitante, súma, puocatione di pie=
tate, ad uno ignitato uehiculo angariate, & cum cathene candente di for=
te Calybeal iugo illaqueate. Lequale duramente stringiente le tenere &
biáchissime & plumee carne perustulauano. Et decapillate nude, cum le
brace al dorso reuincte, miserabilmente piangeuano, le mandibule stridé
te, & sopra le infocate cathene le liquante lachryme frissauano. Incessante
mente stimolate da uno ísiammabondo & senza ístima furibondo, & im=
placabile fanciullo. Ilquale alligero di sopra lardente ueha sedeua, **Cum**
laspecto suo formidabile, Piu indignato & horribile non fue la terribile
Gorgonea testa ad Phineo, & alli cópagni, Cum beluina rabie & furore,
Et cum uno neruico & ícendioso flagello, feramente percoteua, senza pie
tate stimulante le inuinculate puelle. Et cum magiore uindicta di Zeto
& Amphyone, contra Dirce nouerca.

man Empire of that time was in-fact an immense and, to use a contemporary notion, "globalized" world. In such context, "the merchants hugging the African shore and sailing the monsoon winds were also the agents of an invisible exchange. Where goods and gods go, so do germs".[16] Here we see a real overlap between society, geography, and biological rhythms, all of them contributing to the evolution of a common history.

This is just one example among the many possible that have tried to combine readings of natural history with cultural histories.[17] Nonetheless, it should be enough to make a point: the Anthropocene should not be understood just as a natural condition. It is also intertwined with cultural beliefs, ideological systems and their institutionalizations. To understand the relationship between the elements of such a complex system is one of the first things to do for anyone studying and discussing the "Anthropocene", whether in the context of architecture, or not.

## Architecture and Modernity – through the Anthropocene

as again discussed by Bonneuil and Fressoz, the starting date of the Anthropocene is uncertain. The most common consideration is that it began in the second half of the twentieth century, with what John Robert McNeill and Peter Engelke have called "Great Accelaration":[18] the never-decreasing consumption of energy and the start of an exponential growth of the population. A similar starting date is provided by the "Anthropocene Working Group", who has also verified the existence of clear stratigraphic signals of petrochemical products, as well as traces of radionuclides dating back to the first nuclear test in Nevada in 1945.[19] Others, instead, are convinced that the Anthropocene has more distant origins, going back to the first industrialization processes. According to the Nobel prize winner Paul Crutzen, for instance, the Anthropocene would have begun as early as 1784, precisely when James Watt patented the steam engine.[20] Instead, according to others (Simon Lewis and Mark Maslin), the Anthropocene even began with the colonization of the Americas. This is because, since then, the world would have lived a turmoil of agricultural systems due to the mixing of plants, flowers, seeds and faunae originally belonging to different continents.[21]

Far from wanting to discuss the Anthropocene's date of birth in this context, it is important to notice that these dates more or less coincide with the different understandings of modernity's birthdate. Whether we want it to begin in 1492, and therefore when Christopher Columbus arrived in North America while thinking he was in India; in the 18th century; in the 19th century; or in the 20th, the dates provided by scientists about the beginnings of the Anthropocene are peculiarly similar to the ones commonly used to theorize about the beginning of modernity. This fact shouldn't surprise anyone. After all, modernity is partly defined by technological improvements and by the generalised sense of crisis ("the signature of the modern era")[22] these contribute to produce. And this is also why every historical period – including ours – experiences itself as a moment of crisis, allowing a re-reading and re-writing of the past starting from the diagnosis of the present time: a constant reflection on the present situation (the "modus" of modernity) allowing a specific knowledge of its own past and an opinion on its future.

The intersection between the concept of Modernity with the "Anthropocene", then, is an interesting concept not because – as some might be tempted to think – it would undermine the discussions on the Anthropocene. But, quite the opposite: the notion of the Anthropocene may allow a re-writing of modernity or, at the very least, the identification of a new topic to add to the already complex set of themes defining what "modernity" is, or may be. A second reason, albeit not secondary, for looking with interest at this conceptual intersection is due to the fact that it gives us the possibil-

**Francesco Colonna**

*Hypnerotomachia Poliphili, 1499*

**J.G. Levasseu**

*The angel of death striking a door during the plague of Rome,* 1789

ity of opening-up the common narrative of architecture's history. In other words, the theme of Anthropocene seems to provide the opportunity to open new fields of research in the history of architecture, studying its relationship with the natural world both in conceptual and material terms.

Before continuing, however, it seems appropriate to outline – albeit in an extremely short space – what can be understood as "architecture of modernity", throughout architecture's historiography. Most commonly, histories of modern architecture share some common assumptions.

**I.** One of the most significant events allowing historians to talk about "modern" architecture is the technical development that has taken place since the eighteenth century, onward.

**II.** Modern architecture finds some of its roots in the ideal of reason, if not rationalism, classically assumed to be a notion developing from the Enlightenment, and in the establishment of modern sciences; if not even – as it happens in Manfredo Tafuri's history – in the ideology of the Renaissance.[23]

**III.** Architecture becomes modern once it starts to mirror the social changes

**Hubert Robert**

*Le Pont sur le Torrent,* mid 1780s

of the 18th and 19th centuries (particularly the development of industrial productions). As unforgivably brief as this summary is, it is nonetheless instrumental to note how the histories of modern architecture are as various as the ones of the Anthropocene's history. In other words, architecture's history presents a multitude of genealogies, readings and accounts of historical processes.

Depending on the author, different ideas and concepts (reason, positivism, social revolution) are defined to be inherently modern, and then applied as conceptual categories useful to provide specific readings of the present's historical determinations. To give some examples: Alberto Pérez-Gómez's "Architecture and the Crisis of Modern Science" studies the theories of the 17th and 18th century architecture (mainly French), in the attempt to understand the origins of "the crisis of contemporary architecture".[24] Reyner Banham rewrote the history of early 20th century architecture by looking at experiences such as "Futurism", in order to provide a different interpretation of modernism (a modernism that was beyond the *international style*); a history providing an agenda for a certain architecture of his time.[25] Charles Jencks' "Modern Movements in Architecture"[26] shows a hidden plurality in the world of modern architecture that serves as a discourse useful for the kind of postmodernism he would then define as "radical eclecticism".[27] Even Manfredo Tafuri, the one who tried to detach historical studies from the need of the present (what he would define as "operative criticism"),[28] cannot avoid writing a history of modern architecture that serves the present's needs: he manipulates the past as a way to criticise the present.[29] As we can see, to write a history of architecture – of modern architecture – is a way of understanding the present: to define genealogical paths through which facts, objects, people and events are ordered in a narrative providing an explanation of the present.

## Anthropocene, Architecture, and Modernity

So far, then, we have noted three major aspects in the relation between Architecture, the concept of the Anthropocene, and Modernity.

**I.** In Architecture, today, we witness a generalized interest in the Anthropocene, used as a concept to rethink architecture's relationship with nature and the various entities populating the world.

**II.** The Anthropocene, by challenging the ontological divide between the human and the rest of the world asks us to review our conception of history, no longer understood as eminently social and cultural. It becomes a narrative capable of telling the story of the world as a complex structure in which all kinds of actors play a central role.

**III.** History, especially that of modern (and contemporary) architecture, is always a reinterpretation of the past at the service of the present.

If it is so, then one can think of a history of contemporary and modern architecture from the point of view of today's need of reducing the divide between architecture and nature. A history, then, able to reread modernity in the light of the relationship between architecture and nature, in an attempt to find real points of intersection between the two. Or, anyway, a kind of history enabling the understanding of how - and if - architecture has contributed to the definition of the Anthropocene (also culturally, and metaphorically) during the tumultuous development of modernity.

To reach such a goal, at first it is needed to include the notion of "Anthropocene", or what it means, within the notion of modernity. This is only doable by trying to understand how the usually studied relationships between architecture, economy, ideology, and style may be related to nature and the environment.

But how to do so? At first, to engage the notion of the Anthropocene requires the tackling of topics such as architecture's reliance on energy consumption, architecture's relation to non-human species, materiality and materials (including their origins and scale). Or, as put by Esther da Costa Meyer – professor of the "Architectural History/Theory of the Anthropocene"[30] at Yale University: "if global warming affects primarily the poorest nations or the impoverished swaths of rich ones, architectural historians must track the ways in which their discipline conveys, silences or ignores issues of environmental colonialism".[31]

As also demonstrated by more recent works (Space Caviar's "Non-Extractive Architecture",[32] Elisa Iturbe's work on "Carbon Form",[33] or Daniel A. Barber's *Modern Architecture and Climate: Design before Air Conditioning),*[34] it is evident that architecture must now open up its field of investigation, if it is true that history making is always a way of thinking about the present.

What seems to be necessary, and into production through the work of many researchers and historians, is a re-reading of modern architecture's genealogy, tracing a history of possible processes that – within modernity – have produced, or foreshadowed today's condition.

In conclusion, all that is needed to be stressed is the following: in an interconnected and heterogeneous world such as ours, it is important to attempt the elaboration of a history that is able to produce a specific understanding of modernity, from the point of view of today's needs. This does not mean that the historian should elaborate the narrative of yet another alternative modernity, but – rather - that historical studies need to understand how the relationship between architecture and nature has developed through architecture's forms, typologies, policies, styles and ideologies.

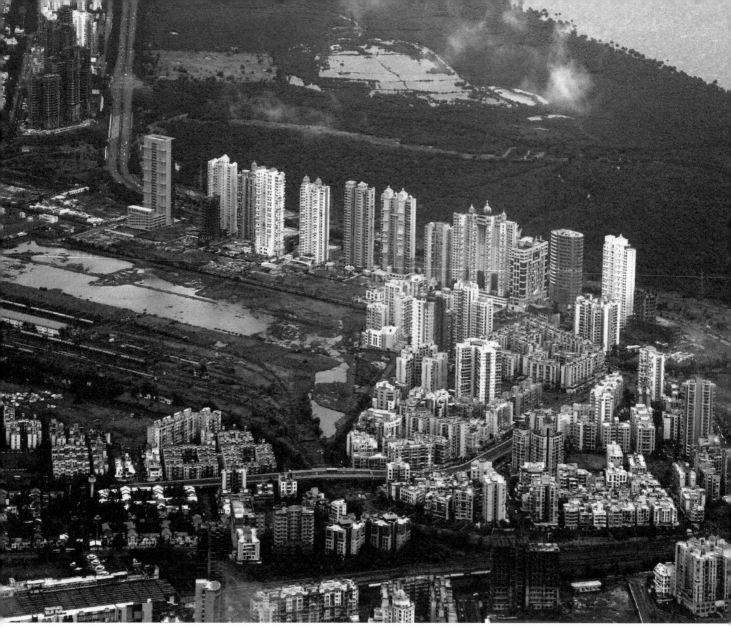

**Anurupa Chowdhury**

*Navi Mumbai Skyline,* 2011

A kind of discourse, therefore, that is as all-encompassing as possible, enabling the connection of natural entities with social ones; humans with in-humans; history with technology. A type of theoretical and design culture for which the concept of Anthropocene, beyond sterile slogans, seems to be useful in order to write a history that - having a proper narrative function – allows for an expansion (not removal) of its canons, and the discovery of new points of view on already known facts and objects.

Ultimately, this history would tell one of the many tales of the non-essentialist and non-deterministic world we have ended up living, designing and building in, helping us to open up a prospect of sense for today's world.

## Endnotes

[1] As examples, see: Jedediah Purdy, *After Nature: A Politics for the Anthropocene*, (Cambridge: Harvard University Press, 2018); Heather Davis, Etienne Turpin (edited), *Art in the Anthropocene: Encounters Among Aesthetics, Politics, Environments and Epistemologies*, (London: Anexact, 2015); Ian Angus, *Facing the Anthropocene: Fossil Capitalism and the Crisis of the Earth System*, (New York: Monthly Review Press, 2016)

[2] Duncan Kelly, *Politics and the Anthropocene*, (Cambridge: Polity Press, 2019), pp.1,2

[3] Etienne Turpin (edited), *Architecture in the Anthropocene: Encounters Among Design, Deep Time, Science and Philosophy*, (London: Anexact, 2013)

[4] Liam Young (edited), *Machine Landscapes: Architectures of the Post Anthropocene*, (London: Wiley, 2019)

[5] On speculative realism, see: Graham Harman, *Speculative Realism: An Introduction*, (New York: Polity, 2018)

[6] The term "Flat Ontology" was coined by Manuel DeLanda in his *Intensive Science and Virtual Philosophy* and – to put it simply - indicates the ontologies of things can only be described with reference to interactions with other entities. In the last years, this term has become quite popular, assuming a slightly different meaning that can be summarized with the following words by Ian Bogost: "all things equally exist, yet they do not exist equally. The funeral pyre is not the same as the aardvark; the porcelatta is not equivalent to the rugby ball. Not only are neither pair reducible to human encounter, but also neither are reducible to one another. In this respect, McLuhan is a better place to look for materialism than is Marx." See: Manuel DeLanda, *Intensive science and virtual philosophy* (London: Bloomsbury Academic, 2002). Bogost is quoted here: Ian Bogost, "Materialisms, the Stuff of Things is Many", 2010 http://bogost.com/writing/blog/materialisms/ (03/07/2020)

[7] As put by Peter Trummer: "with the end of the anthropocentric era, we have also moved into the post-Eupalinos era. Eupalinos, the Greek architect, did not know what to do with the pure white, smooth, hard, delicate, tender, lightweight and glossy thing he found on the beach. It was useless to him, so he threw it back into the ocean. But it might not be useless for other objects; it is just a matter of time before its qualities will meld with the aesthetic properties of other objects" See: Peter Trummer, "Zero Architecture, a Neo-Realist Approach to the Architecture of the City", in Peter Trummer (edited), *Zero Piranesi*, SaC Journal, issue n.5, (Frankfurt: Städelschule Architecture Class, 2020), p.18

[8] Bruno Latour, *Facing Gaia Six lectures on the political theology of nature* (Being the Gifford Lectures on Natural Religion Edinburgh, 18th-28th of February 2013), p.77 https://eportfolios.macaulay.cuny.edu/wakefield15/files/2015/01/LATOUR-GIFFORD-SIX-LECTURES_1.pdf (04/06/2020)

[9] See: David Farrier (edited), *Anthropocene Poetics: Deep Time, Sacrifice Zones, and Extinction*, (Minneapolis: University of Minnesota Press, 2019)

[10] See: Marrikka Trotter, "Temporal sublime: Robert Adam's castle style and geology in the Scottish Enlightenment", in Colin Thom (edited), *Robert Adam and his brothers New light on Britain's leading architectural family*, (London: Historic England, 2018), pp.223-237

[11] On the topic, see: Christophe Bonneuil, Jean-Baptise Fessoz, *The Shock of the Anthropocene: the Earth, History and Us*, (New York: Verso Books, 2016)

[12] Jules Michelet (translated by Flora Kimmich, Lionel Gossman, and Eward K.Kaplan), *On History, Introduction to World History* (1831), (Cambridge: Open Book Publishers, 2013), p.25

[13] Charles Lyell, *Principles of Geology, an Attempt to Explain the Former Changes of the Earh's Surface*, vol.1 (London: John Murray Albemarle-Street, 1830), p.164

[14] See: Christophe Bonneuil, Jean-Baptiste Fessoz, *The Shock of the Anthropocene: the Earth, History and Us*, cit.

[15] An interesting example of a philosophy of history under these terms is Michel Serres'. See: Michel Serres, *Darwin, Bonaparte et le Samaritain - Une philosophie de l'histoire*, (Paris: Le Pommier, 2016)

[16] Christophe Bonneuil, Jean-Baptiste Fessoz, *The Shock of the Anthropocene: the Earth, History and Us*, cit., p.33

[17] Kyle Harper, *The Fate of Rome, Climate, Disease, & the End of an Empire*, (Princeton and Oxford: Princeton University Press, 2017)

[18] Ibid, p.97

[19] See: Clive Hamilton, Christophe Bonneuil and François Gemenne (edited), *The Anthropocene and the Global Environmental Crisis*, (London and New York: Routledge, 2015) and Joy McCorriston and Julie Field (edited), *World Prehistory and the Anthropocene*, (London: Thames & Hudson, 2019)

[20] John Robert McNeill and Peter Engelke, *The Great Acceleration: An Environmental History of the Anthropocene since 1945*, (Harvard: Belknap Press, 2016)

[21] Jan Salasiewicz et.al., "When did the Anthropocene Begin? A mid-Twentieth Century Boudary Level Is Stratigraphically Optimal", (https://www.sciencedirect.com/science/article/pii/S1040618214009136) (12/07/2020)

[22] Paul J. Crutzen, "Geology of Mankind", in *Nature*, 415, 2002 https://www.nature.com/articles/415023a (12/07/2020)

[23] "[…] Brunelleschi razionalizza la tecnica e i modi della produzione edilizia, spezza la continuità dell'organizzazione collettiva del cantiere tradizionale, fa emergere impetuosamente il tema della moderna divisione sociale del lavoro". Manfredo Tafuri, *L'Architettura dell'Umanesimo*, (Bari: Edizioni Laterza, 1969), p.19

[24] Reinhart Koselleck, "Krise", in Otto Brunner, Werner Conze e Reinhart Koselleck (edited), *Geschichtliche Grundbegriffe*, Volume 3, (Stuttgart: Klett-Cotta Verlag, 1982), p.627

[25] "Da ciò che oggi fa problema, [le osservazioni che hanno dato origine al presente volume] si volgono all'indietro, tentando un dialogo con l'età della rappresentazione. […] Confronteremo, infatti, sull'uso del rappresentare agli inizi dell'età convenzionalmente chiamata moderna: uso molteplice e problematico, differenziato a seconda che esso riguardi artisti, programmatori, committenti. Ed è a cause i tale problematicità che il Rinascimento che appare nel titolo non è dato per scontato". Manfredo Tafuri, *Ricerca sul Rinascimento, Principi, Città, Architetti*, (Torino: Giulio Einaudi Editore, 1992), p.XXI

[26] Alberto Pérez-Gómez, *Architecture and the Crisis of Modern Science*, (Cambridge, MIT Press, 1983), p.8

[27] Reyner Banham, *Theory and Design in the First Machine Age*, (Cambridge, MIT Press, 1980)

[28] See: Charles Jencks, *Modern Movements in Architecture*, (London: Penguin Books, 1973)

[29] Charles Jencks, *The Language of Post-Modern Architecture*, (New York: Rizzoli, 1977), p.127

[30] As put by Tafuri: "to re-joint history and theory meant, in fact, making history itself into an instrument of theoretical reasoning elevated to a planning guide". In: Manfredo Tafuri (translated by Giorgio Varecchia), *Theories and History of Architecture* (1968), (New York: Harper & Row, 1979), p.149

[31] For a further reflection on Tafuri's contradictions, see: Mark Wigley, "Post-Operative History", in *ANY: Architecture New York*, No. 25/26, *Being Manfredo Tafuri: Wickedness, Anxiety, Disenchantment*, (New York: Anyone Corporation, 2000), pp. 47-53

[32] Space Caviar, *Non-Extractive Architecture: On Designing Without Depletion*, (Berlin: Sternberg Press, 2021)

[33] see: Elisa Iturbe (edited by), *Overcoming Crbon Form*, LOG 47, (New York: Anycorp, 2019)

[34] Daniel A. Barber, *Modern Architecture and Climate: Design Before Air Conditioning*, (New York: Princeton University Press, 2020)

**Giacomo Pala** is an architect and researcher based in Innsbruck. His work moves between the boundaries of architectural theory, history and architectural design. He is currently a PhD candidate supervised by Peter Trummer at University of Innsbruck and research assistant at the department of architectural theory. Previously, he has worked as a teaching assistant at the University of Genoa and as an architect and external collaborator for various offices, including Coop Himmelb(l)au in Vienna and Space Caviar in Genoa. Since 2013, he has been a member of Burrasca: a platform devoted to the exploration of architectural design and theory in the form of publications.

# Flora of the Colosseum of Rome

*In the 1850's Richard Deakin examined Rome's Colosseum and found 420 species of plants spontaneously growing among it's ruins and documented each species in,* Flora of the Colosseum of Rome, or, Illustrations and Descriptions of Four Hundred and Twenty Plants Growing Spontaneously upon the Ruins of the Colosseum of Rome, *1855. As well as plants common to Italy there were rare plants found nowhere else in Italy and 56 varieties of grass. The stone substrate, niches and unsealed ground formed a microclimate for biodiversity: dry and warm on its south side, cool and damp in the north. Today, photographer, Simone Bossi finds these complex surfaces stripped of vegetal life.*

introduction by **Louise Wright and Linda Tegg**

Contemporary visitors to the Colosseum might find difficulty in reconciling their admiration for the enduring architectural structure with the stories of its original purpose. Historical analysis reporting the inaugural one hundred days suggests that a sophisticated interplay between myth and reality were active in the murderous spectacles that took place there. And that interplay has continued as the monument has been encoded and re-encoded again in service of power.[1] What the conjoined physical and social organisation of the Colosseum make explicit, is how systems of perception produce ways of being in the world. In orienting his attentions towards the vegetal life within the Colosseum in the 1850's, Richard Deakin reconfigures the idea of the Colosseum from an arena of death to a structure that enables life.

The flora of the Colosseum has been studied scientifically five times in different works (1643, 1815, Deakin in1855, 1874, 1951).[2] And again more recently a survey of the current flora of the Colosseum was carried out by the Università La Sapienza of Rome between 1990 and 2000, taking advantage of the scaffolding placed for restoration works so as to reach otherwise inaccessible spots. The flora was surveyed at all the levels of the amphitheatre, from the fresh and damp *hypogea* up to the upper floor, dry and sunny. On this occasion were counted 243 species, of which 169 in the *hypogea* – the area that once would have been underground exposed by the collapsed floor. Also, very rare species were found, like the *Asphodelus fistulosus* and *Sedum dasyphyllum.*[3]

The survey carried out in the 1850's and documented by Deakin reported almost double this number. He noticed that over the years of survey, that sweeping and tidying of the ruins reduced plant species. This has been the case in the reduced numbers recorded more recently when the Colosseum was once again restored. We might say that biodiversity in urban environments suffers under notions of order and restoration. Photographer, Simone Bossi's recent exploration of the Colosseum, now denuded of vegetal life, testifies to the effectiveness of maintenance regimes.

Deakin insightfully described the 'ground' that a building can make beyond the one it occupies, and observes it amounts to much more than the

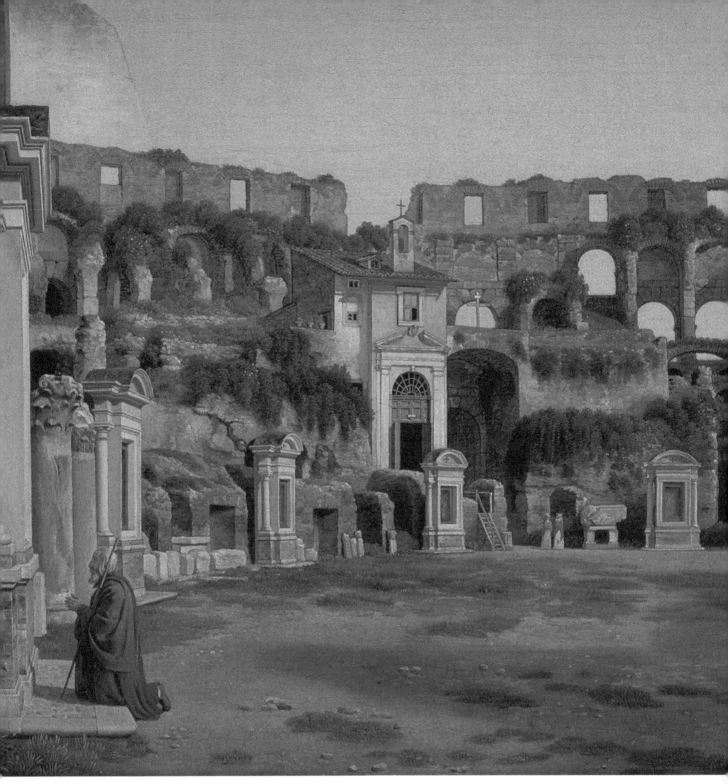

**Christoffer Wilhelm Eckersberg**
*View of the interior of the Colosseum,* oil on canvas, 1816, Statens Museum for Kunst

site's six acres, where plants also grew *on* the Colosseum:

> ...it must be remembered that, though the ground occupied by the building is about six acres, the surface of the walls and lodgment on the ruins upon which they grow is much more extensive, and the variety of soil is much greater, than would be supposed without examination; for, on the lower north side, it is damp, and favourable

# FLORA

## OF THE

# COLOSSEUM OF ROME;

### OR,

ILLUSTRATIONS AND DESCRIPTIONS OF FOUR HUNDRED
AND TWENTY PLANTS GROWING SPONTANEOUSLY
UPON THE RUINS OF THE COLOSSEUM OF ROME.

### BY

## RICHARD DEAKIN, M.D.

AUTHOR OF THE

FLORIGRAPHIA BRITANNICI," "BRITISH FERNS AND THEIR ALLIES,'
"METEOROLOGICAL CHART OF ROME," ETC. ETC.

———◆———

## LONDON:

## GROOMBRIDGE AND SONS,

—

1855.

# PREFACE.

THE COLOSSEUM is the most remarkable, the grandest, and most imposing of all the vast ruins of Ancient Rome. It was built, according to Suetonius (Nero 31), on the spot which was previously occupied by the lake or large pond attached to Nero's palace, and is situated near to the remains of the Baths of Titus, which appear to be built on a part of the foundations of the palace of Nero, on the Esquiline Hill; opposite to it on the north-west side was the temple of Venus and Rome, and it communicated with the Palace of the Cæsars, on the Palatine Hill, by a subterranean passage.

Formerly the Colosseum was known by the name of the Flavian Amphitheatre, in memory of Flavius Vespasian, who commenced it A.D. 72. It is said to have been only four years in building, and to have been completed by his son Titus. They erected it as a triumphal commemoration of their successes in the Jewish wars, as well as the Triumphal Arch of Titus, which stands across the Via Sacra, near to the Colosseum, and is, perhaps, the most interesting of all the triumphal arches in Rome, as its bas-reliefs not only

represent on one side Titus in his car, in the triumphal procession, but on the opposite side are represented the spoils of the Temple of Jerusalem, the sacred ark and the seven-branched candlestick, which are so accurately represented as to entirely agree with the description given in the Mosaic account of them. At the dedication of the Colosseum, Eutropius (lib. vii. c. 21) states that 5000 wild beasts were killed, and that there was an exhibition of games for nearly 100 days; and Josephus (de Belli Jud. lib. vii. c. 5) says, that Titus brought 700 Jews to Rome to grace his triumph; and it is probable that many of them formed combatants etc., in the exhibitions. The Colosseum, it is calculated, covers altogether about six acres of ground; its whole length is 619 feet, and the whole width 513, and the circumference 1741. The length of the arena is 300 feet; its width 190. The outer walls on the perfect side were stated to be 179 feet high; and, from all the accounts and calculations, it seems probable that it was capable of accommodating the extraordinary number of 100,000 persons to witness the exhibitions.

But such is now the state of the ruin, that there is not remaining a single seat of stone of all those which rose in regular succession from the arena to the third story, nor any portion of the upper gallery in the fourth story. To enter, however, into any lengthened description of its present state, or to speculate upon what this or that portion of the building has been, and the uses to which they were applied, would be out of place here, and only to repeat what is found in the guide books and the many dissertations which have been written upon it.

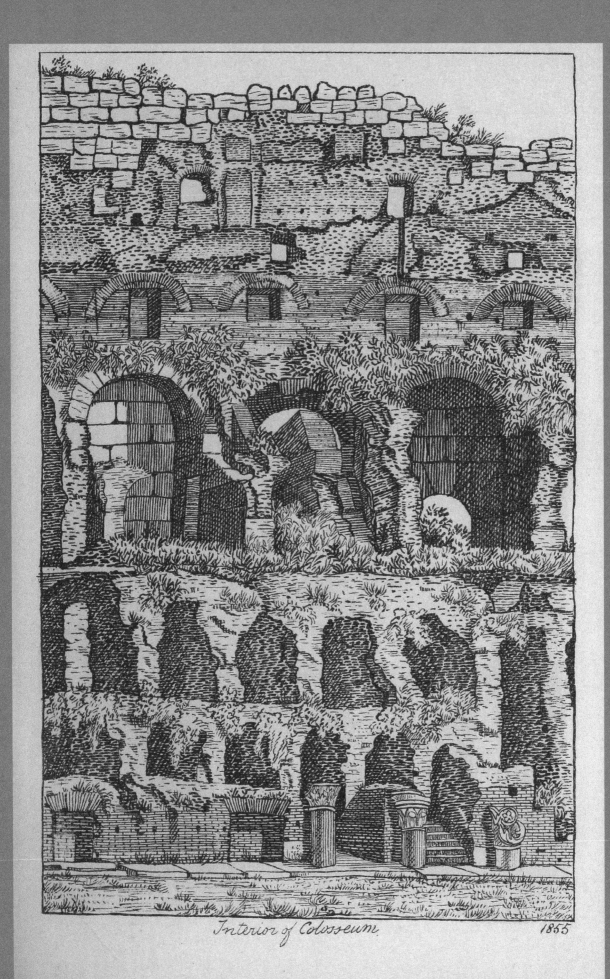

*Interior of Colosseum.* 1855

The enterprising managers of the Sydenham Palace, near London, have, at considerable expense, made the public better acquainted with this most noble of the Ancient Roman structures, as it was in its perfect state, by the best possible means, in having a large model of it made in the exact relative proportions; thus showing, in detail, what it is almost impossible to describe by words or drawings.

No one, however, can stand in the middle of the arena, as it now is, without endeavouring to picture to himself what the scene was when its seats around were filled with 100,000 occupants, to witness the many barbarous scenes which there took place. Not only were the noble and graceful animals from the wilds of Africa brought there in great numbers, and let loose in their wild and famished fury, to tear each other to pieces, but numberless human beings were made to engage them in mortal combat, and cast amongst them to be instantly torn to pieces, and sacrificed in various cruel ways for the amusement of the people, or as a punishment for crimes which they had committed. Amongst these were captive slaves from various conquered states, and not a few were martyred for their disbelief in the divinity of the dumb Pagan idols, and being followers of Christ, the ever-living God, and thus bore testimony to their belief in the doctrines which he had taught. Amongst the foremost and most distinguished of these noble men was St. Ignatius, who was brought from Antioch in the reign of Trajan, on purpose to be exhibited to the assembled multitude in the Colosseum, and was there exposed to the fury of the enraged animals, and in a few minutes

torn to pieces and consumed. But these scenes, the gladiatorial combats, and various games, and vast and numerous exhibitions, are subjects of history which will recur to the mind when pondering over and examining the place in which they occurred, and need not be repeated here.

The object of the present little volume is to call the attention of the lover of the works of creation to those floral productions which flourish, in triumph, upon the ruins of a single building. Flowers are perhaps the most graceful and most lovely objects of the creation but are not, at any time, more delightful than when associated with what recalls to the memory time and place, and especially that of generations long passed away. They form a link in the memory, and teach us hopeful and soothing lessons, amid the sadness of by-gone ages: and cold indeed must be the heart that does not respond to their silent appeal; for, though without speech, they tell of that regenerating power which reanimates the dust of mouldering greatness, and clothes their sad and fallen grandeur with graceful forms and curiously constructed leaves and flowers, resplendent with their gay and various colours, and perfume the air with their exquisite odours.

The plants which we have found growing upon the Colosseum, and have here described, amount to no less a number than 420 species; in this number there are examples of 253 Genera, and illustrations of 66 of the Natural Orders of plants, a number which seems almost incredible. There are 56 species of Grasses—47 of the order *Compositæ* or Syngenesious plants—and 41 of the Leguminous or Pea tribe: but it must be

remembered that, though the ground occupied by the building is about six acres, the surface of the walls and lodgment on the ruins upon which they grow is much more extensive, and the variety of soil is much greater, than would be supposed without examination; for, on the lower north side, it is damp, and favourable to the production of many plants, while the upper walls and accumulated mould are warmer and dryer, and, consequently, better suited for the development of others: and, on the south side, it is hot and dry, and suited only for the growth of differently constructed tribes.

The collection of the plants and the species noted has been made some years; but, since that time, many of the plants have been destroyed, from the alterations and restorations that have been made in the ruins; a circumstance that cannot but be lamented. To preserve a further falling of any portion is most desirable; but to carry the restorations, and the brushing and cleaning, to the extent to which it has been subjected, instead of leaving it in its wild and solemn grandeur, is to destroy the impression and solitary lesson which so magnificent a ruin is calculated to make upon the mind.

In the year 1815, a catalogue of the plants then growing upon the Colosseum was published by Antonio Sebastiano, a Roman botanist, amountiug to 261 species. Some of the species there enumerated are not now to be found; but it will be seen that the numbers are now much increased, or that the list was not then a perfect one.

In the arrangement of the plants I have thought it best to place them under the natural orders, for the

purpose of more fully exhibiting their variety of character, and have so constructed the synopsis that the student may study them, and trace out the Genera and Species, according to the Natural System, or that of the Sexual or Linnean System.

64, VIA SISTINA, ROME,
    *May*, 1855.

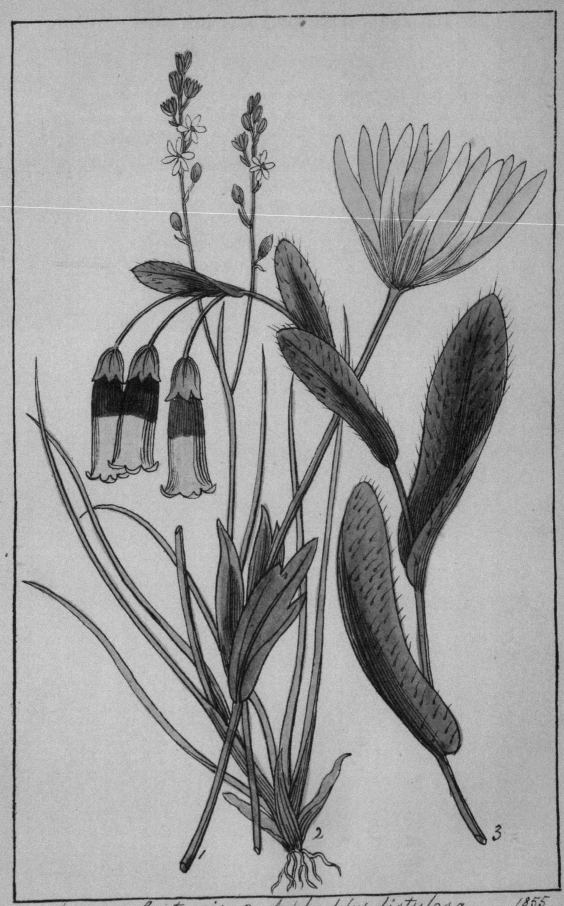

1 *Anemone hortensis.* 2. *Asphodelus fistulosa*
3 *Cerinthe aspera.*

1855

mose spike of numerous flowers, white within, green at the back; capsules, enveloped in the perianth, 3-angled, 3-furrowed, 3-celled.

Perennial, flowering in April and May.

### ASPHODELUS, Linn.   *Asphodel.*   *Asfodelo,* Ital.

*A. fistulosus,* Linn.   *Onion-leaved Asphodel.*   Scape, naked, branched at the end; leaves, upright, striated, subulate, subfistulate.

*Flora Romana,* p. 129.

Scape, about 2 feet high; leaves, nearly cylindrical, striated; perianth, of white segments, having a yellowish line at the back; bractea, yellowish.

Perennial, flowering in April.

This pretty little plant grows on the upper part of the ruins of the Colosseum, which is the only place that it is known to grow in about Rome.   It is a very much smaller plant than the *A. ramosus,* which is very abundant on banks, waste places, etc., in all parts of the Campagna, and its fleshy, fasiculated roots afford an abundant supply of food for foxes, which are very numerous.

### ASPARAGUS, Linn.   *Asparagus.*   *Sparagio,* Ital.

*A. acutefolius,* Linn.   *Acute-leaved Asparagus.*   Stem, shrubby, angular, unarmed, the branches downy; leaves, evergreen, rigid, linear, roundish, with a bristle point; tube of the perianth as long as the segments.

*Flora Romana,* p. 130.

Stem and branches long, slender, widely·spreading; leaves, numerous, short, rigid; flowers, small, yellowish fragment.

Perennial, flowering in September.

The young, quick-grown, tender stems of the *A. officinalis* are well known as a culinary vegetable.   But the young and tender shoots of all the wild species growing in the hedges and bushy places in most parts of Italy, are indiscriminately cut and sold in the markets for the use of the table.   In the wild state the shoots are much smaller, harder, and of a

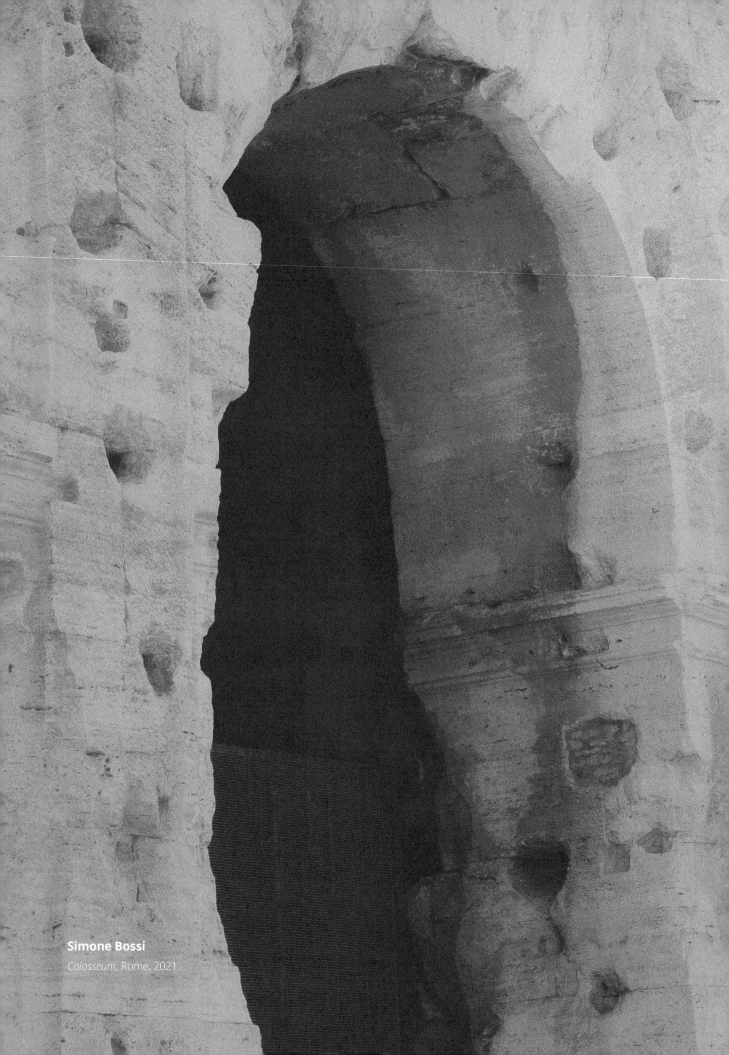

**Simone Bossi**
*Colosseum, Rome, 2021*

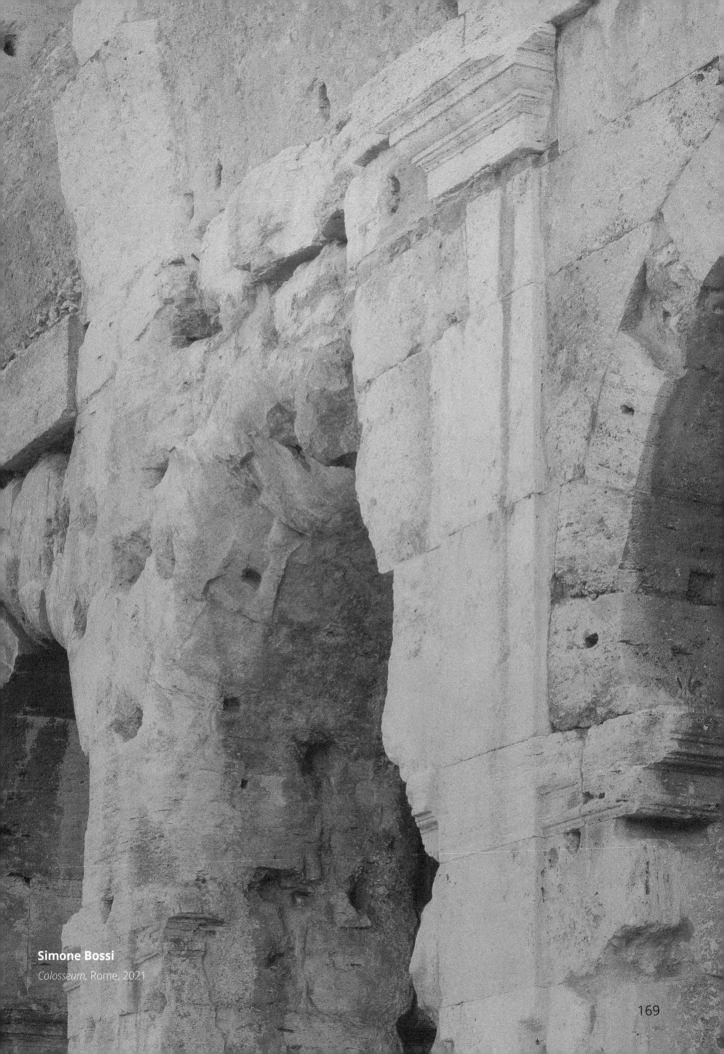

Simone Bossi
*Colosseum, Rome, 2021*

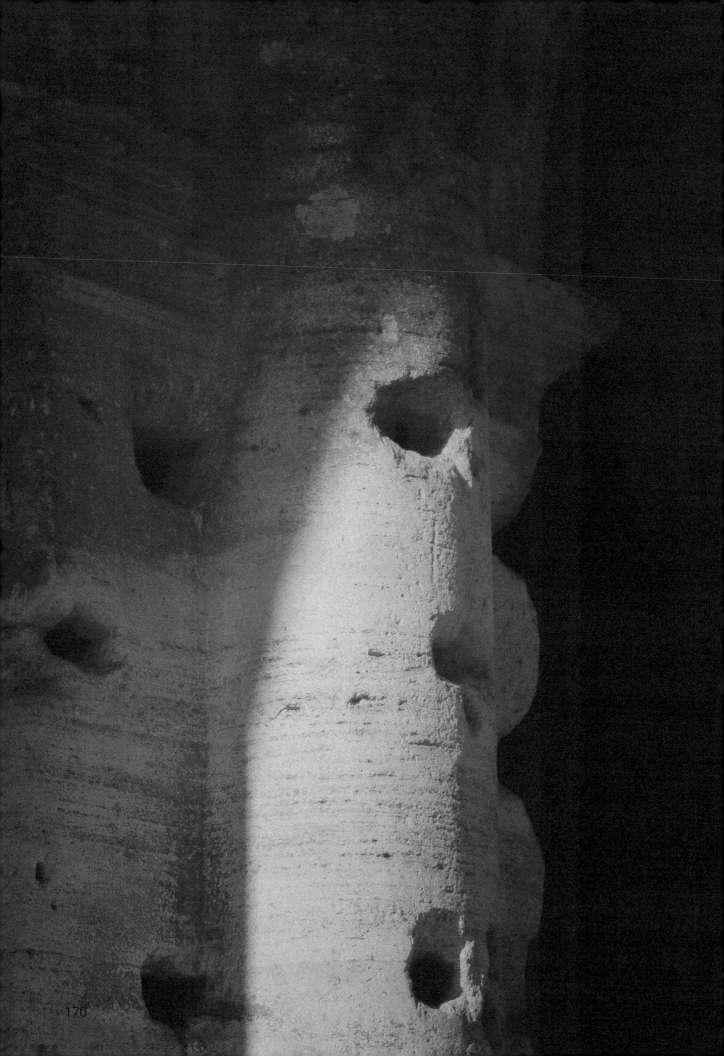

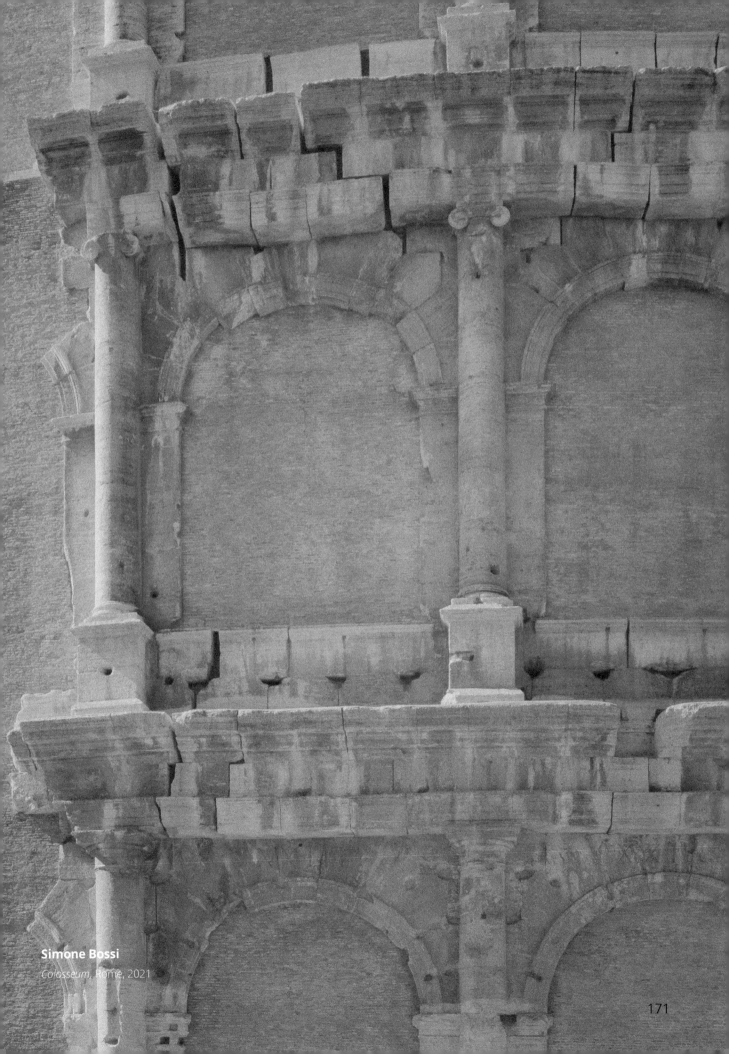

**Simone Bossi**
*Colosseum, Rome, 2021*

to the production of many plants, while the upper walls and accumulated mould are warmer and dryer, and, consequently, bettered suited for the development of others; and, on the south side, it is hot and dry, and suited only for the growth of differently constructed tribes.' [4]

This reading of the building's surface exposes a complex porosity. Varied microclimates supported the colonizing 'spontaneous' plants who, unlike the public of Rome, or today's tourists lining up at the entrance, assemble on their own terms. The impressive biodiversity is in part a product of the quieter agrarian uses that took place during the monument's abandonment. [5] Their occupation of the architecture destabilises the program of the Colosseum in both symbolic and material registers. The memory of this life, slowly acting on the masonry, offers an alternative perspective as a place of flourishing potentials. It also inspires an architecture with the capacity to create a variety of habitats, embrace dampness and shade, dirt, sun, and warmth and to make space for the unexpected.

### *Endnotes*

[1]Keith Hopkins, and Mary Beard. *The Colosseum* ( Harvard University Press, Cambridge, Massachusetts, 2005). Accessed August 23, 2021. doi:10.2307/j.ctvkjb57x.
[2] http://www.the-colosseum.net/history/romantic.htm, accessed 20.09.02
[3] Ibid
[4] Richard Deakin, *Flora of the Colosseum of Rome, or, Illustrations and Descriptions of Four Hundred and Twenty Plants Growing Spontaneously upon the Ruins of the Colosseum of Rome*, London, Groombridge, 1855, p. vi – vii.
[5] G. Canevaa, A. Pacinia, L. Celesti Grapowb, S. Ceschina "The Colosseum's use and state of abandonment as analysed through its flora" *International Biodeterioration & Biodegradation* 51 (2003) 211–219

**Linda Tegg** is a Melbourne-based Artist who makes work out of inhabiting and reconfiguring the conditions of spectatorship. Within her immersive installations; images, plants, animals, and the built environment are brought into unlikely proximities to generate new points of orientation and relation. This speculative work engages with the construction of images of nature, and the frameworks through which we find meaning in the world.

Interdisciplinary collaboration characterises much of Tegg's work. In 2018 she collaborated with Baracco+Wright Architects as the Creative Directors of *Repair,* Australia's representative exhibition at the 16th International Architecture Biennale Venice, and was the inaugural artist in residence at the School of Geography at The University of Melbourne. In 2014 she grew *Grasslands* a site responsive public artwork at the State Library of Victoria with Horticulturalist John Delpratt.

Tegg's artwork engages with cultural institutions as well as public space and has been widely exhibited in Australia, The United States, and Europe. She was the Samstag Scholar of 2014, and the Georges Mora Foundation Fellow of 2012. Tegg has degrees from The School of the Art Institute of Chicago, The University of Melbourne, and RMIT University.

**Simone Bossi** is an Italian photographer with an architectural background. He studied architecture at Etsa Universidad de Sevilla and graduated at Milan Polytechnic in 2011. Simone worked as an architect in Italy, Netherlands and Switzerland from 2008 to 2010 when he decided to start his career as a self-taught photographer.

# Small plants in the concrete jungle

*From the point of view of moss, the urban environment provides niches, like pavement crevices, that offer just enough shelter and resources to survive. These small plants, often overlooked, were amongst the first to colonise land around 400 million years ago. While tough, observation and experimentation show they are more likely to grow in certain conditions relating to microtopography and microclimate. Moss can filter water, capture pollutants and reduce soil erosion but few initiatives have explored its full potential. Collaborations between biologists, architects, designers and landscapers could pave the way for a greener, more sustainable cityscape using these ancient pioneers.*

text by **Alison Haynes**

From the point of view of moss, the urban environment provides niches, like pavement crevices, that offer just enough shelter and resources to survive. These often overlooked, small were amongst the first to colonise land around 400 million years ago. While tough, observation and experimentation show they are more likely to grow in certain conditions relating to microtopography and microclimate. Moss can filter water, capture pollutants, and reduce soil erosion but few initiatives have explored its full potential. Collaborations between biologists, architects, designers, and landscapers could pave the way for a greener, more sustainable cityscape using these ancient pioneers.

To observe moss in the urban environment is to witness a wild process. Towns and cities offer small niches – such as a weathered crevice on an aging wall, or a shaded path next to a leaking pipe – that provide just enough shelter to protect a germinating spore blown in by the wind or nurture a fragment of green plant that has broken off a nearby moss cushion. Moss can survive a range of habitats - from the frozen deserts of Antarctica to humid rainforests of Australia. It grows, depending on the species, on a variety of substrates: rock, earth, the trunks and leaves of trees, even whale bones, each with its own chemistry and physical characteristics. Concrete, that ubiquitous material of our built environments, has a natural counterpart in limestone; the bricks we make walls and paths with share similarities with clay soils ... so perhaps it's not so surprising that moss can find places to thrive in our towns and cities.[1]

These small plants were among the first to colonise land around 400 million years ago, using the same traits that allow them to survive city life today. They can manufacture sunscreens to protect themselves from harsh light[2] and many have a remarkable ability to shut down metabolism and 'dry without dying', otherwise known as desiccation tolerance.[3] Their leaves are just one cell thick but the size of these plants (generally up to 1.5cm tall) means the water they absorb through these leaves is enough to support photosynthesis and metabolism. That is why mosses do not need roots to draw water into the plant; but use only very fine rhizoids, thread-like structures underneath cushions and mats to attach to the substrate.

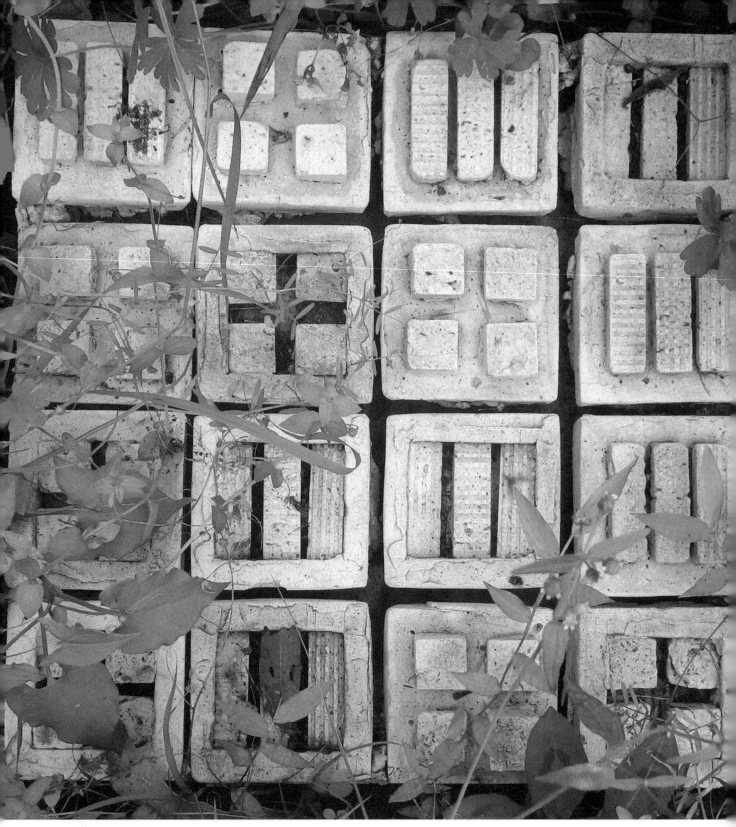

**Alison Haynes**

*Experimental panel*, 2019 © Alison Haynes

Coledale, NSW, Australia. This panel is one of 16 placed out in private gardens as part of an experiment by Alison Haynes to test moss establishment on an urban gradient. Each is made up of 12 concrete tiles of four designs, differing in texture and relief.

Hence their ability to exploit tiny spaces devoid of soil. Pavement cracks, when deep enough to trap sediment, not only provide an area for growth but can also protect from trampling and wind while trapping water and allowing a plant to stay moist for longer.[4]

Most efforts to understand how moss interacts with building surfaces have come from the desire to remove it - whether from roofs, garden paths, or gravestones.[5] But a research discipline referred to as bioreceptivity takes a more proactive approach, investigating the characteristics of colonisation and surface qualities that enable and encourage biological growth. It studies this for its own sake, moving beyond the terms 'biodeterioration' and 'biodegradation'.[6]

In the current climate of urban greening, deliberate planting is accepted practice for larger plants (trees and shrubs) and projects (notably roofs and walls),[7] but much less has been attempted using smaller plants like moss, or other organisms such as lichen (which is a generally a fungus and algae). However, these organisms also have uses in the built environment and are appealing because they require little substrate, low water, and nutrient input, and are potentially low cost.[8]

Building material characteristics that influence colonisation include pH, chemistry (for instance being calcareous or siliceous) porosity, and micro-topography, which could also be described as texture.[9-11] In a set of experiments, moss grew best on capillary matting, then cement plaster, followed by lime plaster, terracotta brick, slate, and quartztite.[12] As different moss species show differing affinities for substrate, however, this could depend on the species involved.

Environmental conditions such as air quality, temperature, and humidity also count, particularly at the micro-scale at which moss experiences them. Scientific observations in the wild have laid the foundations of understanding. The small-scale 'lay of the land known as microtopography, is paramount to moss growth. This has been observed on new lava sheets after volcanic eruptions - where 'safe sites' (dimples) provide an opportunity for growth because they

**Alison Haynes**

*Brick beginnings*, 2020 © Alison Haynes North Wollongong, NSW, Australia. Moss has two life history stages: a green, mat or cushion-like gametophyte, and a stalky sporophyte that produces spores and grows out of the gametophyte. The former has one set of DNA and the latter has two.

*Shaggy moss rug*, 2017 © Alison Haynes Shenzhen, China. The tiniest of cracks between city tiles on a wall have acted as a launch pad for a healthy ragged rug of moss in this modern city.

*Liverwort jewels in the car park*, 2020 © Alison Haynes. Thirroul, NSW, Australia. Tuning in to the micro-diversity in the local area reveals a surprising variety. This assemblage of liverworts and moss is surviving in a small drainage channel in a car park.

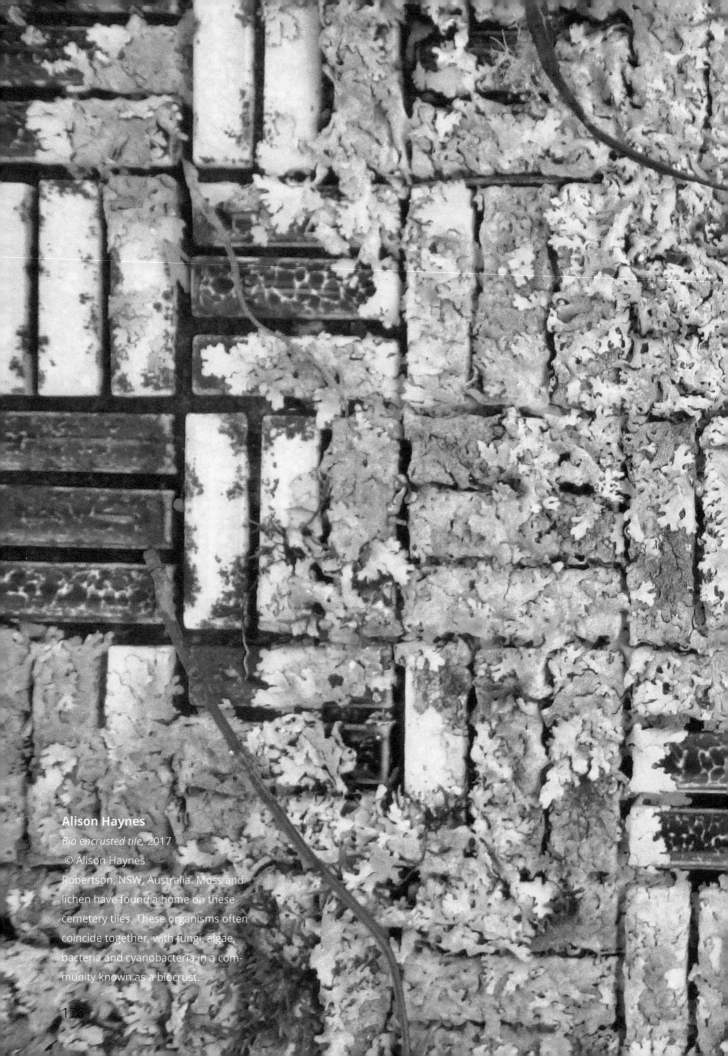

**Alison Haynes**
*Bio encrusted tile,* 2017
© Alison Haynes
Robertson, NSW, Australia. Moss and
lichen have found a home on these
cemetery tiles. These organisms often
coincide together, with fungi, algae,
bacteria and cyanobacteria in a com-
munity known as a biocrust.

176

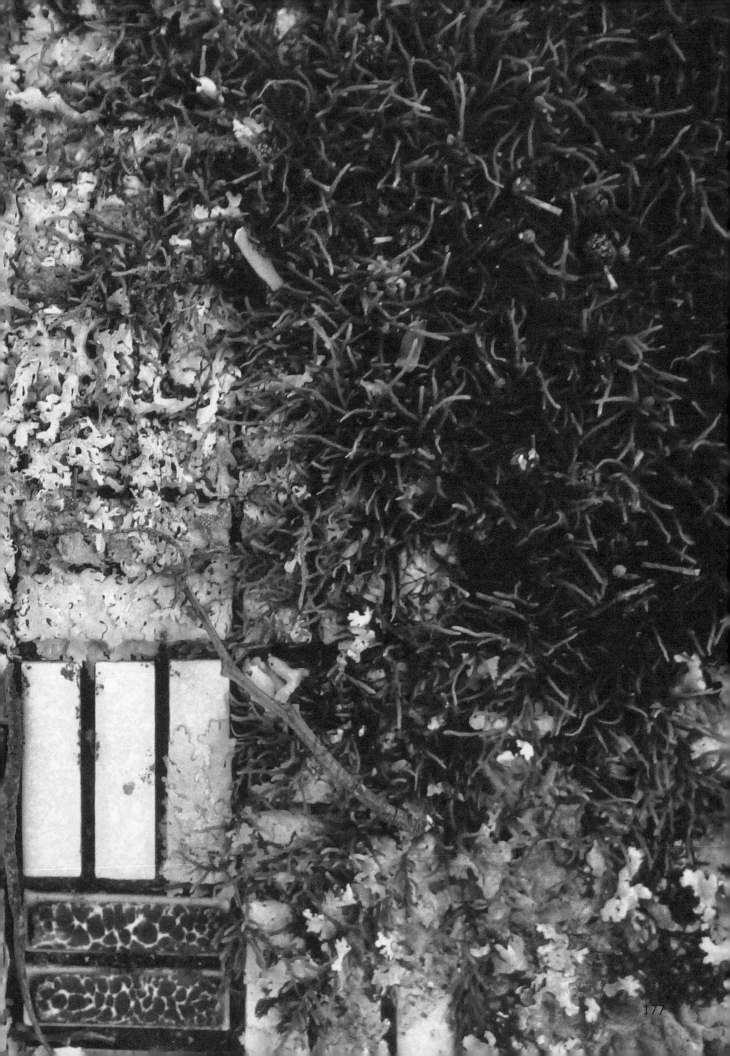

supply shade, shelter, and a collection point for moisture.[13]

Preliminary results from my own experiments with microtopography and microclimate suggest shade is the strongest driver in moss establishment. This is because it ameliorates harsh sunlight - that damages cells and invokes defence responses[14] - and also because shade reduces evaporation of available water.

'Thinking small' could have many benefits in built environments. Perhaps the visual quality of alleyways could be improved with additions of small plants like moss, filling in the gaps in much the same way as occurs naturally in forests? Cruz and Beckett suggest the idea of a building 'bark' as opposed to 'skin' - which might host a variety of organisms including cryptogams (organisms that reproduce by spore, such as ferns, and bryophytes like moss and liverworts).[15] Already experiments are underway to test the power of moss to assist with stormwater management,[16] for cooling,[17] to test for particulate matter capture,[18] and to enhance the survival of larger plants on green roofs.[19]

To date, few design initiatives have explored the potential of moss – particularly in low-tech set-ups – but biologists, architects, designers and landscapers could collaborate to create a more complex, greener and more sustainable cityscape. Many questions remain: will moss survive plantings? Will new moss colonise surfaces? Will architectural features become harbours for unwanted weeds rather than the target taxa? How are they best maintained? what design specifications are optimal in terms of depth of indents and crevices? how can designers incorporate ideas of climate and microclimate to maximise plant survival, visual aesthetics, comfort, and benefits such as cooling? I believe the best approach is to take up the challenge with an open mind, with creativity on the one hand, and solid scientific experimental set-up on the other - so we can learn together and create new possibilities with this ancient pioneering plant.

**Alison Haynes**

*Mossy drain*, 2016 © Alison Haynes Wellington, New Zealand. An old weathered drain grate provides substrate for a water-loving moss.

*Wild green wall*, 2020 © Alison Haynes Punta Arenas, Chile. A wild green wall of moss has sprung up between bricks and pipes, probably helped over the years by leaks and poor drainage.

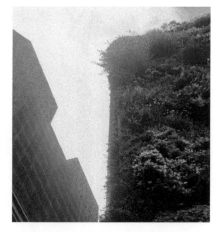

*Living wall, Spain*, 2019 © Alison Haynes Madrid, Spain. Moss sits alongside vascular plants on this spectacular green wall - the Caxia Forum Vertical Garden, aided by the hydroponic living wall system that includes irrigation and recovery of water.

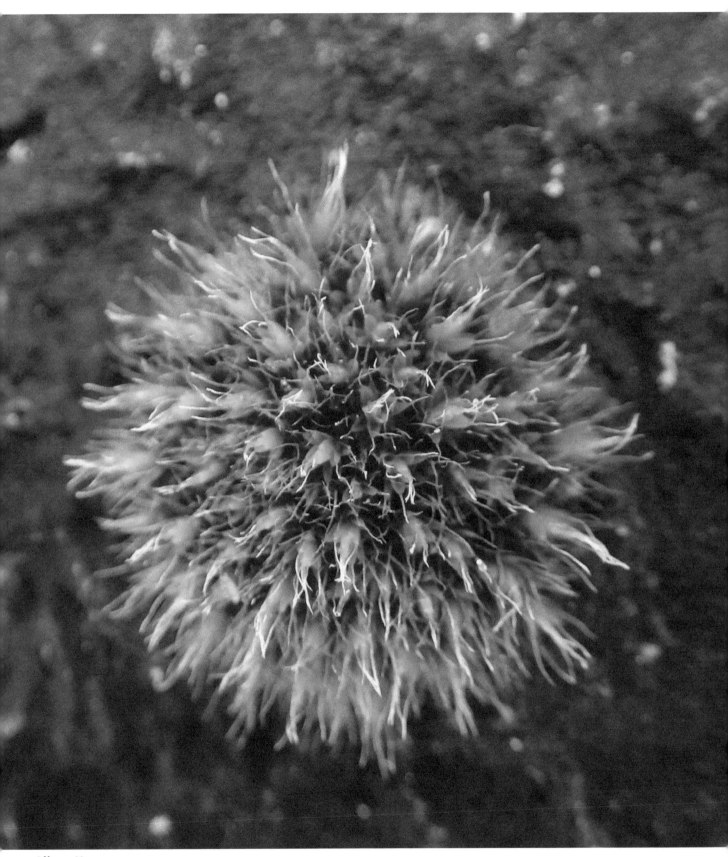

**Alison Haynes**

*Moss ball,* 2018 © Alison Haynes

Pere Lachaise Cemetery, Paris, France. The ball-like growth form of this moss cushion helps it conserve water, as do the tiny hairs on the ends of its leaves.

## Endnotes

[1] Bates, Jeffrey, "Mineral nutrition and substratum ecology" in *Bryophyte Biology* ed. Goffinet and Shaw, 2009, Cambridge, Cambridge University Press)

[2] Waterman, Melinda; Bramley-Alves, Jessica; Miller, Rebecca E.; Keller, Paul A.; and Robinson, Sharon A. "Photoprotection enhanced by red cell wall pigments in three East Antarctic mosses", *Biological Research,* 2018, 51: 49

[3] Proctor, Michael; Oliver, Melvin; Wood, Andrew; Alpert, Peter; Stark, Lloyd; Cleavitt, Natalie; and Mishler, Brent, "Desiccation-tolerance in bryophytes: a review", *The Bryologist,* 2007, 110(4):595-621.

[4] Floyed, Aaron and Gibson, Maria, "Bryophytes of urban industrial streetscapes in Victoria, Australia", *The Victorian Naturalist ,* 2012, 129 (6): 2-3-214

[5] Guillitte, Olivier , "Bioreceptivity: a new concept for building ecology studies", *The Science of the Total Environment,* 1995, 167, 215-220

[6] Ibid

[7] Lundholm, Jeremy, "Green Roofs and Facades: A Habitat Template Approach", *Urban Habitats,* 2006, 4(1): 1541-7115.

[8] Perini, Katia; Castellari, Paola; Giachetta, Andrea; Turcato, Claudia; Roccotiello, Enrica, "Experiencing innovative biomaterials for buildings: Potentialities of mosses", *Building and Environment,* 2020, 172, 106708

[9] Bates, J

[10] Proctor, M, Oliver, M, Wood, A, Alpert, P, Stark, L, Cleavitt, N, and Mishler, B, "Desiccation-tolerance in bryophytes: a review", *The Bryologist,* 2007, 110(4):595-621.

[11] Cruz, Marcos and Beckett, Richard, "Bioreceptive design: a novel approach to biodigital materiality" *arq,* 2016, 20.1, 51–64

[12] Perini,K, Castellari,P, Giachetta, A, Turcato, C, Roccotiello, E

[13] Cutler, Nick ; Belyea, Lisa; Dugmore, Andy ; "Spatial patterns of microsite colonisation on two young lava flows on Mount Hekla", Iceland. *Journal of Vegetation Science,* 2008, 19: 277-286

[14] Kultz, Dietmar 2005, Molecular and evolutionary basis of the cellular stress response, *Annual Review of Physiology,* 67: 225 - 257.

[15] Cruz, M and Beckett, R

[16] Anderson, Malcolm ; Lambrinos, John and Schroll, Erin "The potential value of mosses for stormwater management in urban environments", *Urban Ecosystems,* 2010, 13:319–332

[17] Ondimu, S.N., Murase, H. " Combining Galerkin Methods and Neural Network Analysis to Inversely determine Thermal Conductivity of Living Green Roof Materials", *Biosystems Engineering,* 2007, 96 (4), 541–550

[18] Haynes, Alison; Popek, Robert; Boles, Mitchell; Paton-Wals, Clare and Robinson, Sharon A., "Roadside Moss Turfs in South East Australia Capture More Particulate Matter Along an Urban Gradient, *Atmosphere,* 2019, 10, 224; doi:10.3390/atmos10040224

[19] Paço, Teresa A.; Cameira, Maria R.; Branquinho, Cristina; Cruz de Carvalho, Ricardo; Luís, Leena; Espírito-Santo, Dalila; Valente, Fernanda ; Brandão, Carolina; Soares, Ana L. ; Anico, Adriana; Abreu, Francisco; S. Pereira, Luís , "Innovative green roofs for southern Europe: biocrusts and native species with low water use" , 40th IAHS World Congress on Housing, December 16-19 2014, Funchal – Portugal

**Alison Haynes** is a biologist and writer based in Australia, pursuing a PhD on the ecology and physiology of urban moss at the University of Wollongong. Originally from England, she studied law in London and Paris then worked in magazine and book publishing as a writer and editor. Later she studied conservation biology, with honours in conservation genetics. She has field experience in Australian deserts, farmland and forests, and recently camped in Antarctica to sample moss. Her research encompasses urban ecology and stress physiology but she also teaches evolution, biodiversity, biochemistry and biogeography. She's keen to collaborate in science-art-industry projects.

# Spaces for plants in void metabolism

*Tokyo as a gathering of residential houses with small gardens can be characterized with its fragmentary green spaces that escape the mesh of statistics. Plants appear in voids that keep transforming with ever metabolizing masses, although not actively counted in design and planning consideration. To bridge the gap between formal (typological) and ecological imaginations, this essay explores mass-void typologies in relation with caring of plants, focusing on the possibility of urban "minor subsistence" as motivating human behaviours that can open access to cycles of more-than-human beings and overlap different rhythms of humans, plants, buildings and the city by design.*

text by **Yoshiharu Tsukamoto, Masamichi Tamura, and Fumiya Nonaka**

## Tokyo, April 2020

On 10 April 2020, a spring day with trees like plum, bayberry and cherry blossom gradually blooming here and there, Toykoites witnessed the Tokyo metropolitan government ask them to stay at home in response to a national declaration of a state of emergency to contain Covid-19 pandemic. Notably it was only a call for "voluntary" cooperation because the postwar Japanese constitution was drafted by the GHQ (General Headquarter) to decentralize the war-time regime, so that the state power cannot take authoritarian measures like dictating a lockdown even today. Despite that, due to cultural tendency to respect social norms, people mostly volunteered to refrain from outing to distant places, which barely helped the nation avoid unfavorable consequences like overwhelming hospitals.

Since the call for voluntary confinement expected citizens to keep away from situations so-called 3Cs (Closed spaces, Crowded places, and Close contact setting), people in Tokyo would stroll around the neighbourhood. The season was just changing from winter to spring. Firmly independent of the mess in human society, behaviours of plants like budding and blooming just as every year might encourage people who had often confined themselves at home. It reminds me that unfolding buds of cherry blossom trees cheered people after the Great East Japan Earthquake on 11 March 2011. Although cherry blossom viewing this year didn't allow people to gather under the flowers, it must have helped them discover plants in more personal encounters.

We too took walks. Not only enjoying green in nearby parks, we found ourselves attracted more carefully to the life of plants in house gardens on streets and interstices between them. Tokyo is not rich in green in terms of statistics, as it ranks at 50th place among other global cities in an environment ranking.[1] Its per capita green park space remains just 5.73 square meters,[2] marking a vivid contrast with, for example, 31.23 square meters in Copenhagen[3] as "the world's greenest city".[4] However, once strolling in Tokyo, one will discover that the entire city is finely covered in plants that grow in

gap spaces between houses. Outside official statistics, these discrete green fragments in the hands of individual house owners collectively represent the unique way of greening in Tokyo as a gathering of detached houses. Let's see how this fragmentary green has been formed in the city.

## Tokyo and Void Metabolism

In the two decades following World War II the population of Tokyo increased from 3.49 million to 10.87 million, and the capital today concentrates 13.5 million, approximately 11 percent of the total population, in a space of 2,191 square kilometers – that means 0.6 percent of the nation's land.[5] Despite this overpopulation, the city center is still occupied with dense rows of low-rise individual houses due to its historical development that distributed land titles to individual owners ever since the Meiji Restoration. In the 1920s, Tokyo witnessed the development of suburban residential areas, with detached houses as the typological form for middle-class families. Around that time, in 1923, the Great Kanto Earthquake hit the city, and the city experienced reconstruction every time after such devastations as extensive air raids on Tokyo between 1942 to 1945. Especially in the aftermath of World War II, the last case in those destructive events, the government faced financial difficulties to lead reconstruction plans. Therefore the city had to be rebuilt piecemeal by individuals on a Do-it-if-you-can basis. In this situation people relied on familiar carpenters to build wooden houses, resulting in the reconstruction of Tokyo as a gathering of wooden detached houses again even after the wartime air raid once burnt them down to the ground-zero. The development was facilitated economically by home loans available at low interest rates and the country's life-time employment custom, driving urban sprawl to suburbs along with high economic growth, while normalizing long commutes and gender divides in the nuclear family as staples in the domain of urban planning. Furthermore, during the bubble economy following the Plaza Accord in 1985, land speculation prevailed and escalated land prices, which prompted further fragmentation of land tenures because landowners had to pay escalating inheritance tax by dividing the land and selling some portion. As a concrete result, the average distribution of a residential site in the 1920, approximately 250 square meters, shrunk into 75 square meters in this period. Consequently, the number of individual owners of private land in Tokyo, which adds up to more than half of the total area, increased from almost 1.1 million in 1975 to 2.2 million in 2018 through the decades that witnessed the collapse of the bubble economy in 1992.[6]

In other words, the huge metropolitan area that even embraces 30 million can be seen as an unparalleled urban-morphological practice where buildings under individual initiatives occupy numerous land fragments. Its morphology is characterized by detached houses and their gap spaces, as well as by the intrinsic rhythm of 30 years as the general average lifespan of [wooden] houses. In Japan, there is no party wall because every building is surrounded by a certain amount of void as a legal requirement called "Kenpeiritsu [building-land ratio]".[7] Tokyo as the sum of buildings and gap spaces, or masses and voids has been metabolized with each mass updating in an average interval of 30 years while thus altering the nature of neighboring voids. Capturing this ephemeral nature of buildings in Tokyo positively with a biological metaphor, Metabolists in the 1960s conceived the megalomaniac idea of city=architecture by translating the vision into an urban form that consists of semi-permanent "Cores" with built-in lifelines and infrastructures and surrounding "Capsules" as replaceable living units for individuals. In contrast to this vision of "Core Metabolism," so to say, Tokyo in reality turned out to be what can be called "Void Metabolism," a process in which [the solid aspect of] the city keeps transforming while sustaining voids

*With this vitality latent in the ground in consideration, the earlier-mentioned contrast between masses and voids can be defined as oppression and emancipation of the ecological energy in soil.*

permanently.[8] In this void metabolism, detached houses with an intrinsic update interval of 30 years can be seen as having experienced at least three generation changes through the 1920 to the present day, meaning that buildings newly produced today constitute the fourth generation. As the generations proceed, each building site shrinks while altering the role of unoccupied void from a garden to interstices of at most dozens of centimeters. Still, plants conquer such small residues. That is, a garden is given as a gift in Japan.

With this vitality latent in the ground in consideration, the earlier-mentioned contrast between masses and voids can be defined as oppression and emancipation of the ecological energy in soil. Masses become micro-topographies, which in turn form micro-climates that influence the behavioral capacity of plants. Assuming this connectivity, designers can find opportunities to participate in urban ecologies not only by planning urban parks but by designing individual houses. If ecological imagination about plant behaviors overlaps with formal imagination about building shapes and spatial arrangements, one can design accessibility to ecological potentials in soil to live as an engaged member who cares and helps urban green as a commons beyond individual sites.

### Gardens as Gifts

Many residential sites in Tokyo were forests and arable lands until the early 20th century. Thanks to the volcanic island's soft soil and rich precipitation, plants easily sprout as far as bare ground receives sunshine and rainfall, and people can make it look like a garden just by selecting the given spontaneous vegetation. One can enjoy the makeshift garden as it is or even apply imaginary layers to make it into other things like a "conceptual garden". Unlike dry areas like Dubai and Los Angeles, where greening a house requires expensive irrigation systems, one can maintain a garden in Japan without such considerable costs, which can be thought as helping the nation-wide proliferation of the typical detached house with a garden.

### Plant Care and Urban Minor Subsistence

The behavioral capacity of plants in a given urban void is further influenced by human behaviors such as selective planting and daily maintenance. For example, greenery in public facilities and commercial sites prefer slow growing plants to reduce maintenance costs. In contrast to such economic rationality to limit the capacity of plants, private gardens can accept time consuming maintenance as a playful experience. Through the pleasurable engagement, gardeners learn the given ecological conditions like the amount of sunshine in the site, understand behaviors of plants, and improve skills to balance his or her own intention with plants' spontaneity. As such, commonning an exquisite garden with passers-by offers the gardener one of the most rewarding moments of life as a citizen.

The way private gardens are maintained indicates urban possibilities of the concept of minor subsistence, which Takeshi Matsui, a Japanese researcher of environmental ethics, originally found in secondary activities in farming villages, such as gathering and hunting.[9] Called also "asobi shigoto [ludic work]", this type of activity has only little economic significance so that industrialization or mechanization did not happen, thereby requiring skills and knowhow with room for bringing up masters in the community, which has endowed life in farming and fishing villages with joy and delight.

Matsui emphasizes the bodily pleasure of internalizing seasonal cycles through the acquisition of skills as follows: "Given that certain animals and flowers appear in the same season as in the other years, it is obvious that minor subsistence itself is necessarily entangled in such conse-

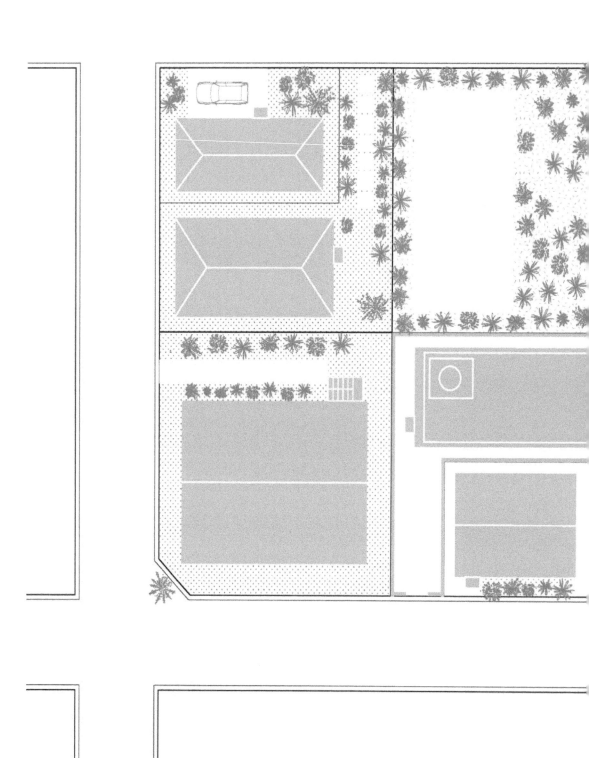

Typologies of greenery in voids in Tokyo (clockwise from top left) : Second Generation Roadside Margin / Flagpole Site Approach, Empty Lot (oppressed) / Empty Lot (covered in weeds), Third generation mini development, First generation South Garden (adjacent to the road on the north [and the east]), First generation South Garden (adjacent to the road on the south [and the east]), First generation South Garden (adjacent to the road on the sorth [constituting continuous hedges]), Roadside Garden, and North Corridor.[11]

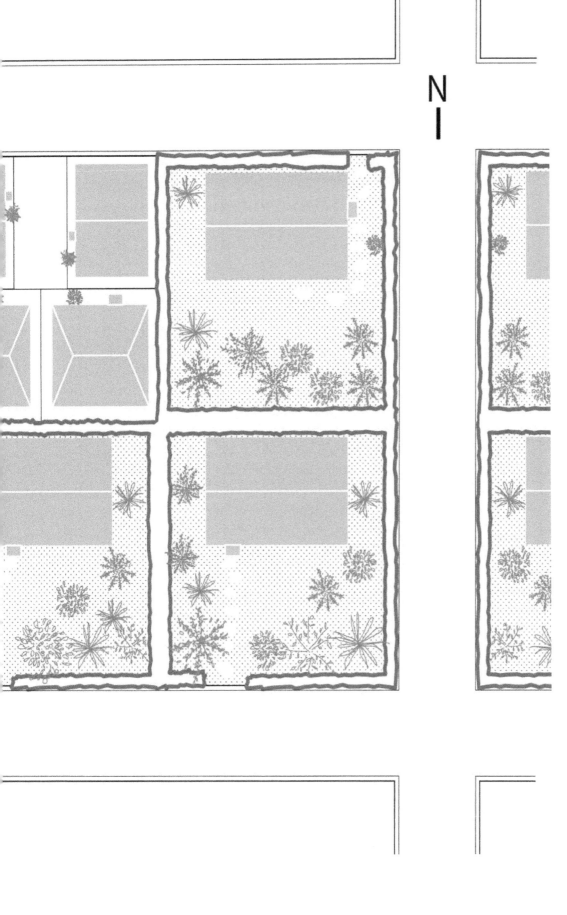

N

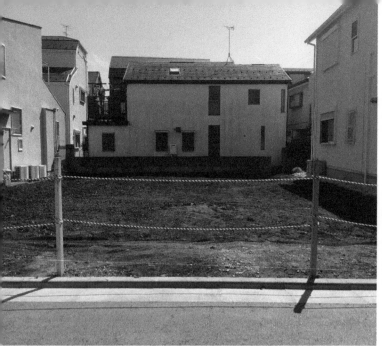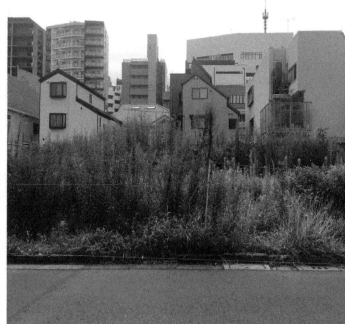

**Tsukamoto Laboratory**

Transition of a site typical of the first-generation house, from being emptied, covered in weeds, oppressed by weed barriers, to completed "mini development" houses in the third generation

quences of rhythms in biological-nature".[10] It can be argued that, beyond its original context in traditional farming villages, this kind of fulfillment can motivate behaviors outside economic cycles in urban voids. In encounters with tiny gardens between buildings, through quiet charms of flowers and freshness of new green leaves, we do appreciate the joy and delight of people who submit themselves to rhythms of plants.

## Typologies and Urban Vegetation

The life of plants in micro-climates produced by buildings in Tokyo indicates its connection to typological patterns and thereby design possibilities.

As discussed earlier, Tokyo metabolizes with an intrinsic 30-year cycle based on the average lifespan of houses. Differences in the construction and the timing of updates differentiate modes of housing industry, family models and life styles, which together constitute a genealogy of residential buildings. If we set 1920 as the starting point of the first generation, around which detached houses were established as a type, it follows that the second starts from 1950, the third from 1980, and the fourth from 2010 to this day. Typologically, the first-gen house can be characterized by a single-storied house with a garden on the south in a site of approximately 250 square meters, the second-gen by a two-storied house with a smaller garden and a parking space in 140 square meters, and the third-gen by a two- or three-storied house with a parking space occupying two thirds of the ground plan in 75 square meters. The fourth-gen basically repeats the third-gen typology, though with some critical exceptions. Overall, the most part of Tokyo is found in the mosaic of these generations.

Each generation displays a certain pattern in the void too. In the first generation, with enough room in the building site, and before motorization, the void is preferably positioned on the south as a garden drenched with sunshine; in the second generation the unoccupied area after making a parking lot adjacent to the road becomes a garden; and in the third generation the void becomes a setback next to the entrance to meet the legal requirement after ensuring 500mm from the property line [as another legal requirement]. The first-gen south garden has further patterns in visibility from the street depending on which side of the site connects to the road; hiding the house

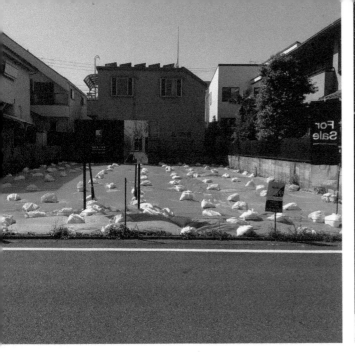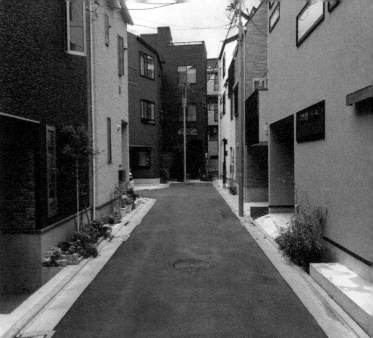

when adjacent on the south, hidden by the house when adjacent on the north, and alternating a house and a garden when adjacent either on the east and the west [in a row]. In addition to these quantitative aspects, trends in tree choice also mark generational differences of plant species.

Distribution of land estates through selling in lots was made possible as the effect of new zoning plans, and all the first generation houses were seen as part of the entire townscape as its reiteration could produce continuous green hedges. During this period, various plant species were grown in gardens like a variety pack. However, since the second generation, differences in lifespans and construction years of individual houses have randomized subdivision and mass-void arrangement patterns, making formal analysis no longer sufficient to estimate how green appears in residential areas. Furthermore, since the third generation, so-called mini-development has produced houses without even a single tree. The scenery marks a drastic contrast to vacant lots that are immediately covered in weeds while awaiting subdivision for this mini development.

Over the course of time, plants in Tokyo have come to inhabit in voids with more specific and minor conditions, such as legally required 500mm setbacks from property lines, so-called flagpole sites generated by the combination of subdivision and legal requirement on connectivity to the road, and corridors of terraced houses that usually come on the north to give the south for windows. In order to emancipate ecological potentials in the soil of those voids, human behaviors to look after plants in response to unique conditions in each site can be produced in the margins for urban minor subsistence. Carefully considering and coordinating behaviors of both humans and plants will help update designs of the fourth generation houses.

Although not designed by architects, cases below exemplify unique coordinations of behaviors by both plants and humans.

### Case 1. First-generation South Garden

The first-gen house typically places a garden on the south, which is exposed to the public when the site connects to the street on the south side. Consequently, green hedges were formalized as buffer zones and explicit property lines. In general, hedges use slow growing plants like buxus micro

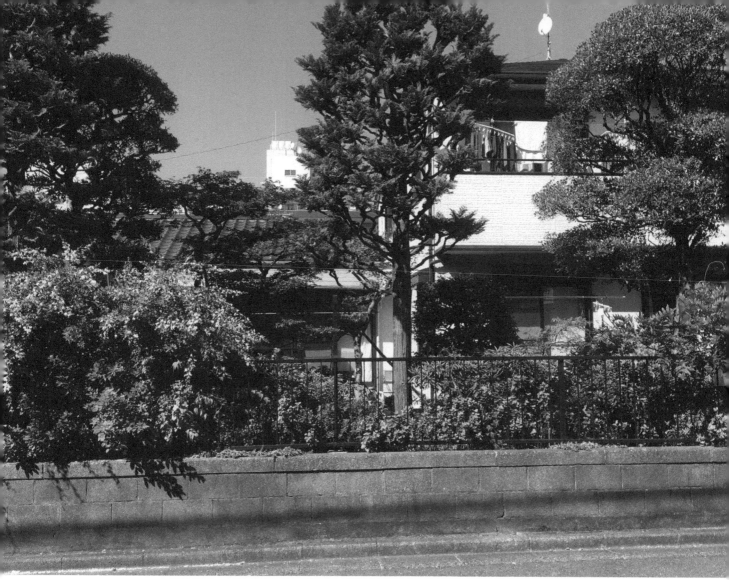

**Tsukamoto Laboratory**

Continuous green hedges that produce a unified townscape based on voluntarily maintained private gardens

phylla, yew plum pine, sasanqua, and the continuation of those limited plant species create green edges that endow a sense of unity within the townscape. Behind each hedge would be a variety of plants grown in the garden, but usually it is not visible to passers-by.

In this south garden, however, the south side uses a fence instead of a hedge, inviting both gaze and sunshine to the garden and allowing the public to enjoy various plants that are not used for hedges. With well-pruned medium height Japanese cypress and beech trees, and shrubs like azalea on the edge between the road and the house, this garden represents a typical garden of suburban houses, where residents can enjoy various seasonal signs such as flowers, autumn leaves and nuts and fruits. The coexistence of daisy and azalea flowers hints at the presence of a person who well understands different plant behaviors as the former can survive on little water while the latter not.

The joy of showing this kind of south garden to the neighborhood will be greater when it faces the street on the south than on the other sides. Although serene townscapes with continuous green hedges have largely disappeared with the changing generations of houses, fragmentary green spaces scattered in voids all around Tokyo have created fine-grained mosaics. Neighboring with other newer generation voids, abundant green in still-surviving south gardens adjacent to the street on the south accentuates rhythms of greenery that change in every single street.

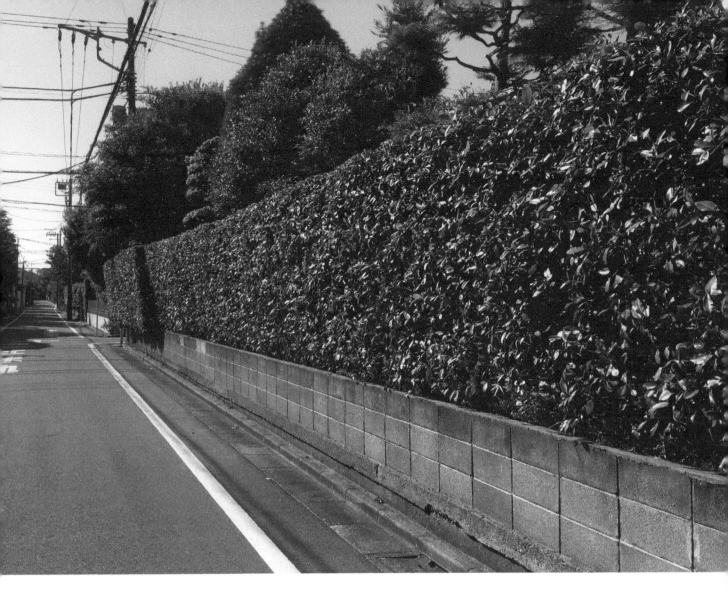

### Case 2. Second-generation Roadside Margins

Voids in the second generation houses are all drawn to the road to ensure a parking space adjacent to the road, then its residue is allotted as a garden for humans and plants. This type of void thus comes to the fore, and when not partitioned by walls or fences, the way plants behave there expresses the personality and preference of the resident to the public.

Facing the street on the east side, this garden represents a typical form of the second generation house that gives plants the rest of the void for a parking lot and a pathway for humans. In a closer look, however, the type is overridden by a specific set of ecological conditions in this site. On the south side of the void (left in the photo), reminiscent of the previous first generation house, a tall beech tree enjoys sunshine above a building on the adjacent site, beneath which is shaded with low-light plants growing, whereas plants that prefer light, like Japanese maple and bottle gourd, lush on the north side. Different micro-climates are inhabited by different plant communities, together sharing green gifts with the public.

Prioritized for the building and parking space, the void left always next to the property line poses an open question about how it should relate to the road as the public realm. When it opens itself as a garden for human and plant behaviors, without barriers like walls, it informs a possibility to go beyond its own frame and alter the nature of the road as another void that inevitably comes side by side.

189

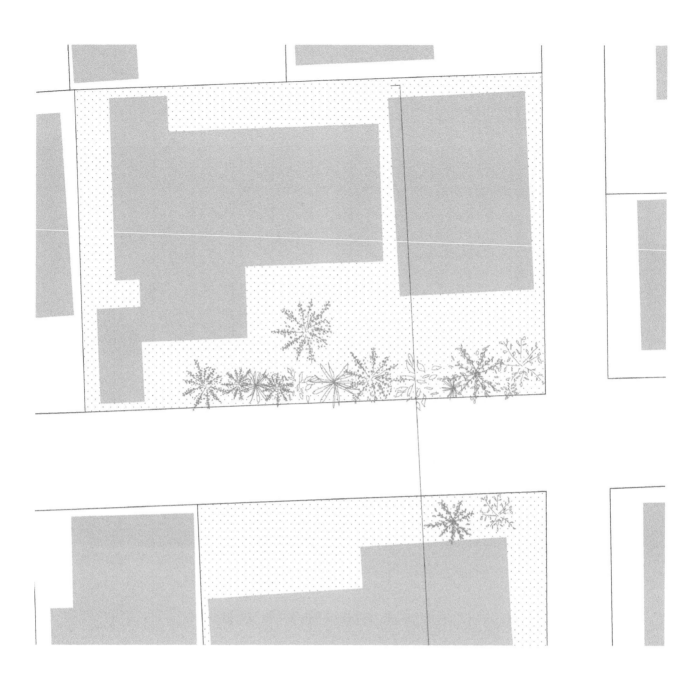

Shrub lespedexa, Japanese rose, Creeping phlox, Lambsquarters, Rhododendron, pseudochrysantheum, Purpole toadflax, Cypress vine, Chinese wisteria, Japanese maple, Hiryu azalea, Indian chrysantheum, Common zinnia, Four o'clock flower

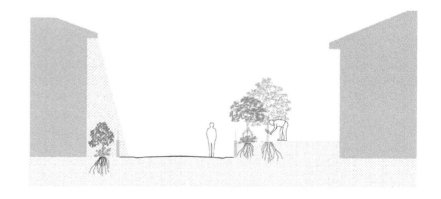

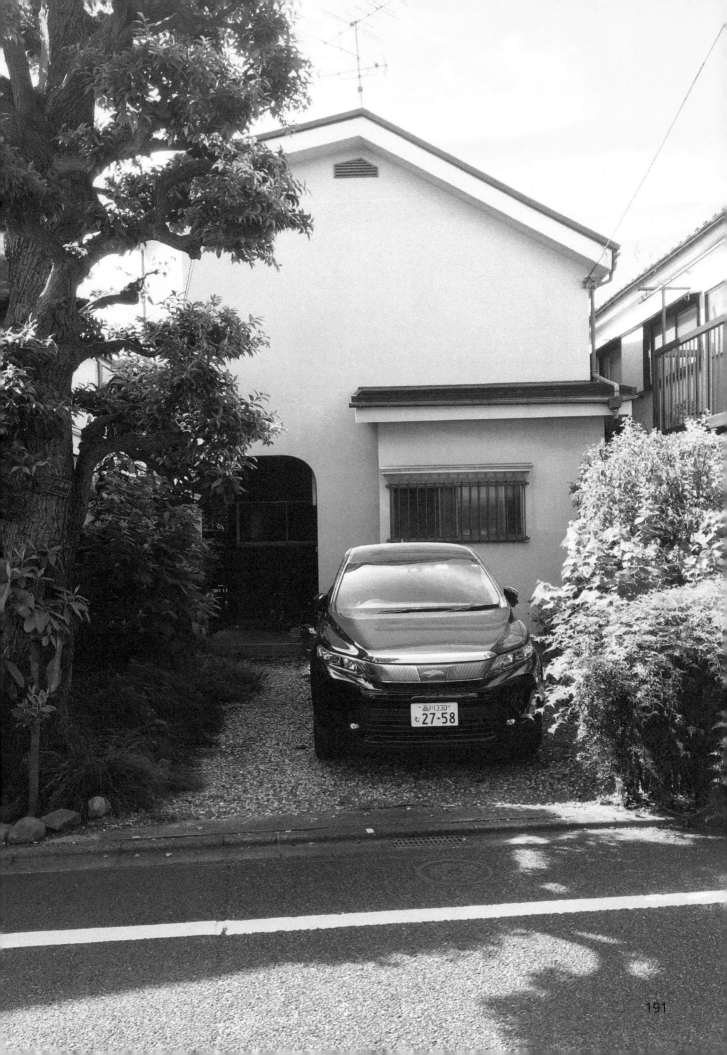

## Case 3. Roadside Gardens

In subdivided tiny building sites after the third generation, the void to meet the legally required building-to-land ratio is often consumed by [also legal] setbacks from property line and a parking space. When soil in the setback on the street side is left open without walls or fences, it becomes a roadside garden that is accessible from the road to take care of plants.

In this roadside garden in an eastside void drenched with morning sunshine, the tiny area is occupied with various plants, including a low height fragrant olive as well as dozens of flowering plants like hydrangea, mugwort and verbena bonariensis, and even shade-tolerant plants like ivy in the shade of other plants. Within a less-than-1-meter shallow setback, the anonymous gardener applies skills to exploiting both sunny and shaded places under soft sunshine from the east, and in the delightfulness of plants, passers-by can feel the gardener's daily care to keep all those plants growing well despite their different behavious.

In this type of roadside garden, the person taking care of plants and people looking at them stand on the same side. Although they would rarely see each other as plant care would take place in early morning to avoid busy traffic, limited access from the house results in a reversal of standpoint for the gardener, and the overlapping of caring and seeing experiences in the same view will cultivate a communal empathy. If this specific character of roadside gardens develops beyond each individual site, it will facilitate a type of communal behavior to look after plants in neighboring roadside gardens that share the same street as common access.

*Submitting green with subtle signs of human life to the street, this type of approach garden adds another dimension of depth to the appreciation of human behaviors through plant behaviors.*

## Case 4. Flagpole Site Approaches

Each consisting of a residential lot (flag) and its long approach (pole), so-called flagpole sites result from the combination of subdivision and a legal requirement to keep building sites always connected to the road. The frontage of the pole part is required to be wider than 2 meters, which sometimes serves as a parking space, and the both sides of a pathway for humans are given to plants as strip-shaped gardens. Heavily influenced by surrounding masses, complex ecological conditions and skills to manage them in this type of garden are embodied in diversity in the way plants grow.

For example, in this approach garden (center) from the road on the north to the south, the graduation of moss translates the transition of light between two micro climates, the shade of buildings on both sides and the sunny area lit by sunshine from the roadside. Subtle but selective weeding by the resident can be found in the orderly field of moss and ground cover, without other types of plants that would have otherwise grown there and interrupted the view. On the left side ground cover grows thicker in the shade of the block wall of a house next door, while the right side is connected to a setback of the other house next door whose resident grows vegetables in planters by sharing the same approach. Plant behaviors can also tell us human relations.

This type of narrow approach garden is often found with well-treated plants thanks to daily usage, but passers-by cannot freely enter to see them closely, which indicates a transition between public and private realms. Such green branches from the main street increase the amount of vegetation in the folded form although each frontage is narrower than other types of void vegetation like south gardens and roadside gardens. Submitting green with subtle signs of human life to the street, this type of approach garden adds another dimension of depth to the appreciation of human behaviors through plant behaviors.

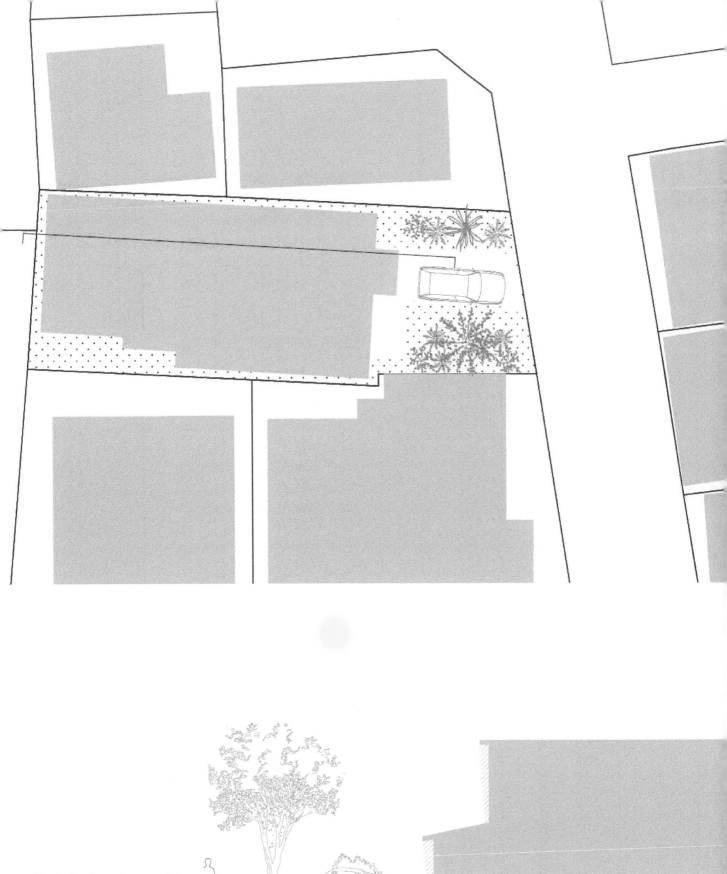

Beech, dwarf mondo grass, winter daphne, fern (shaded area) / bottle gourd, Japanese maple, azalea (lit area)

## Case 5. North Corridors

Terraced houses generally prefer to have windows on the south wall, therefore doors and corridors come on the north side as the result. Also due to the traditional preoccupation with making gardens on the south, this type of void repeated on the north has long been neglected as a place for plants.

However, in this narrow shady corridor, running toward the northwest with its frontage being almost 2 meters, shade-and drought-tolerant English ivy grows thick on exposed soil under the eaves while the gap space that receives reflected light and rainfall is occupied with various plants in a row on soil and some in planters. Setts also help collect rainwater to plants while refraining moisture from evaporating quickly. The narrow garden is made upon a skillful reading of conditions in the shade of buildings with the influence of setts and eaves counted, where appropriate plant communities grow in further articulated micro climates.

North corridors as a type replicate similar formal conditions (north, strip-shaped) in strong correlation with ecological ones (shaded, humid), which can be even seen as a typology complementary to that of south gardens. This type of north corridor, long neglected as a place for human and plant behavious, has a possibility to become what can be called north garden with a variety of shade-tolerant plants, just as opposite to the south garden with various plants that prefer light. This small north garden by an anonymous citizen provides a clue to emancipate enormous ecological potentialities now under oppression on the north side across the entire city. When it is established as a common human-plant behavioral type, north and south gardens complement each other and together cover both directions across the city respectively with different appropriate plant communities.

*Sweet Osmanthus, Cape jasmine, Obedient Plant, Smooth hydrangea, Common daisy, Common mugwort, Blue anise sage, Purpletop vervain, Edging lobelia, Bugleweed, English Ivy*

## Concluding Remarks

As so far exemplified through the cases, discrete green fragments in Tokyo as a gathering of residential houses are maintained through human behaviors that try to increase the behavioral capacity of plants in typologically repeated voids. In each of these unique conditions, various skills and daily caring are fully employed, ranging from selection of plants suitable for sunny and shady conditions, pruning and weeding to ensure light and air current, to watering and evaporation control to solve the trade off between light and water to name a few, whose accumulation crystalizes in a delightful garden. When a townscape is full of such well-treated vegetation, it indicates the presence of a communal foundation that operates without language. This sensitivity to plants as our closest and ubiquitous companion species in the city, especially becoming more evident in with-corona society, can further extend to other species such as insects and birds for inviting multi-species communities in potentially vibrant urban voids.

On the other hand, architecture design has yet to play an active role between the oppressed ecological potentialities in urban voids and human behaviors that emancipate the latent vitality in soil. It is in this context that void metabolism as the constant alteration of an urban-scale void through changing masses indicates three key directions for designing urban environments in Tokyo. Firstly, the city's uncountable greenery diffusing across fragmented voids can be linked to cancel human-made borders between building sites through a shared ecological continuity. Secondly, the relation between voids and masses can be rearranged anew to emancipate the oppressed vitality of soil into spontaneous gardens gifted by the country's geoclimatic conditions. Lastly, more inviting voids can be reserved for individual and communal initiatives to enable urban minor-subsistence activities as an intimate encounter with rhythms of other-than-human species in the city.

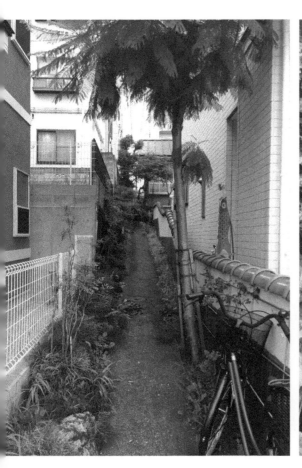  

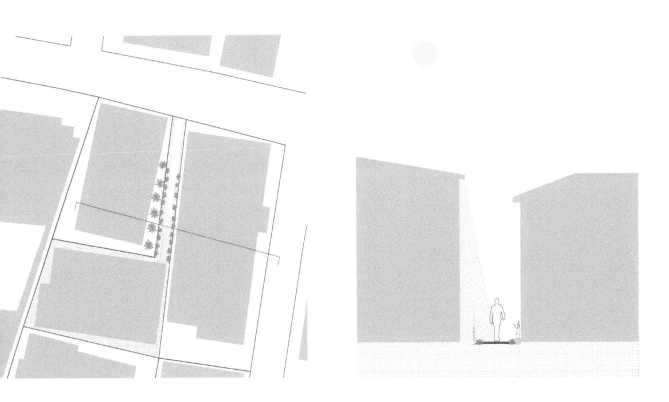

Racomitrium japonicum, Common periwinkle, Brachymenium exile, Marchantia polymorpha, Stonecrop

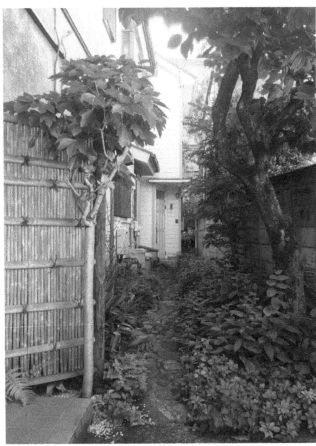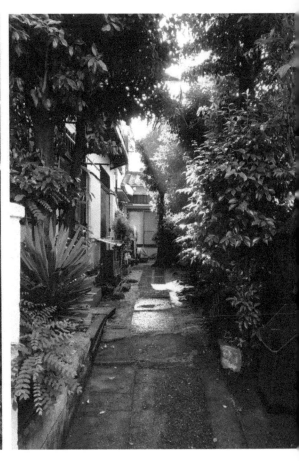

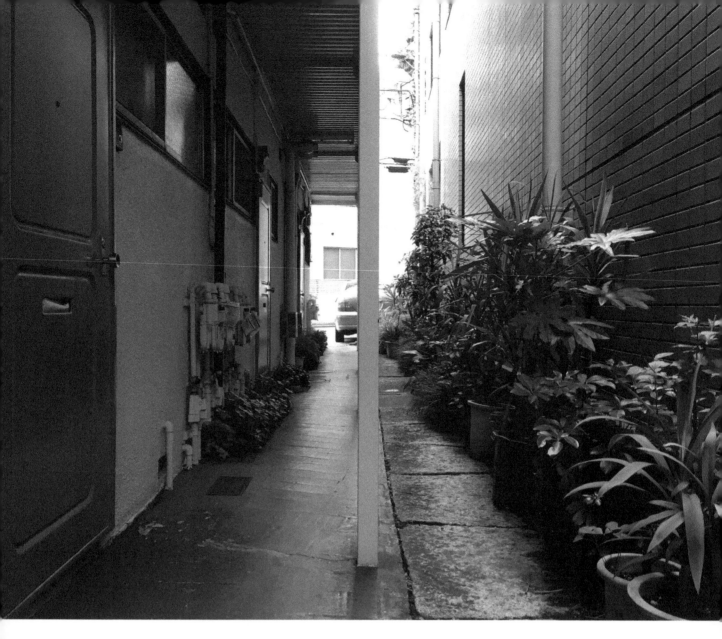

**Tsukamoto Laboratory**

Continuous green hedges that produce a unified townscape

Void metabolism reframes numerous voids across the city from the by-product of each mass in separate grids toward broader urban fabrics to provide devices to help people care for plants more easily. Enhanced connectivity among green fragments will also expand wildlife corridors and enmesh isolated ecological niches into larger overarching ecosystems, where void-metabolic urban design will play a new role to promote interspecies democracy. The further potential of fragmented green spaces in Tokyo, whose totality would exceed the amount of greenery in parks, will be realized by overlapping the behaviors of buildings, humans, plants, and eventually animals. Through linking typologies and ecologies in void metabolism, urban minor subsistence will help entangle various actors in the city into new networks to orchestrate their so-far unsynchronized rhythms.

## Endnotes

[1] Arcadis Sustainable Cities Index 2016 - Planet sub index https://www.arcadis.com/media/0/6/6/{06687980-3179-47AD-89FD-F6AFA76EBB73}Sustainable Cities Index 2016 Global Web.pdf

[2] https://www.kensetsu.metro.tokyo.lg.jp/content/000049137.pdf The number insluces urban parks, other types of public parks and other green spaces (the number decreases to 4.7m² when focusing only on the special wards in the center)

[3] Excludes natural reserves https://www.statista.com/statistics/858892/green-areas-per-inhabitant-in-copenhagen-denmark. All green areas amount to 42.4m² https://ec.europa.eu/environment/europeangreencapital/wp-content/uploads/2012/07/Section-3-green-urban-areas_Copenhagen.pdf

[4] https://www.telegraph.co.uk/travel/discovering-hygge-in-copenhagen/worlds-greenest-city

[5] Includes the entire metropolitan area https://www.metro.tokyo.lg.jp/ENGLISH/ABOUT/HISTORY/history03.htm

[6] "Tokyo No Tochi [Land in Tokyo]" as of 2018 https://www.toshiseibi.metro.tokyo.lg.jp/seisaku/tochi/index.html

[7] In 1919, "Shigaichikenchikubutuhou" established the concept of building-to-land-ratio at 60% for residentaial houses, which is inherited to the present day "Kenchiku Kijunho [The Building Standard Act]"

[8] Tsukamoto, Yoshiharu "Boido metaborizumu shiron" [A tentative theory on void metabolism], in : *Space Design*, 519 (2007), pp. 70-72

[9] Matui (1998) takes the concept of Asobi Shigoto from an earlier argument by Kitoh (1996) to develop the concept of minor subsistence. Following their arguments, Mitsuhashi (2015) attempts to connect this "subsistence" concept to the same name concept by Illich (1980) as the autonomous and vernacular way of life.

[10] Matsui (1998) pp.266

[11] Identification of plant spacies utilizes "Picture This" application by Glority Global Group Ltd.

**Yoshiharu Tsukamoto** founded architecture firm Atelier Bow-Wow in 1992 with his partner Momoyo Kajima. The Tokyo-based practice is renowned for their domestic, commercial and cultural architecture and theories, especially their work surrounding the concept "Behaviorology". The firm has also championed the experimental project "Micro-Public-Space", which has been exhibited across the globe. The pair has published 11 books, including *Made in Tokyo, Behaviorology, Commonalities – Production of Behaviors, Windowscape series, and Graphic Anatomy Atelier Bow Wow*. Tsukamoto is professor in the Graduate School of Architecture and Building Engineering at Tokyo Institute of Technology and has lectured at Harvard GSD, UCLA, Columbia University, Rice University, and Cornell University.

**Masamichi Tamura** is a doctoral student at Tsukamoto laboratory at Tokyo Institute of Technology and a member of the Older Adults and Parks Committee of World Urban Parks.

**Fumiya Nonaka** is a graduate of Tokyo Institute of Technology and an ex-member of Tsukamoto laboratory.

# Species in correlation: Superstudio and ground/planet continuity

*Reflecting on current environmental crises as related extensions of the production-consumption system, this paper refers to architectural works from the Sixties and Seventies (Superstudio's visions and a late project by Le Corbusier), suggesting analogies between their critique of the status quo and current positions that call for enhanced integration between human and non-human ecologies. Referring to philosophical positions including the thinking of Martin Heidegger and Timothy Morton among others, the paper also investigates the problematics of social inequality as related to the production-consumption system and invites to embrace spatial continuity and species intercorrelation as conditions for moving forward.*

text by **Mauro Baracco**

**Superstudio**

*L'Architettura riflessa [Reflected architecture]*, 1970-1971.
*Lo specchio dell'agricoltura [The mirroring of agriculture].*
Courtesy Archivio Toraldo di Francia, Filottrano
@ Superstudio

The title of this issue of *Antennae* says it clearly: how to rethink urban *spaces* for the cohabitation of different *species*, beyond the human-centered dominant inclination to envisage environments that relate mainly to us. This topic has become increasingly critical, not only for the recalibration of cultural positions that have progressively prioritised the lives of humans over those of other species, but also in addressing global warming and climate change as problematic conditions arguably prompted by human activities that have exponentially intensified from the industrial revolution onwards. The reflections of this paper revolve around the ongoing discourse on the relevance of effective levels of coexistence between human and non-human related systems as a proactive strategy to contribute to urban resilience through the mitigation of climate change's effects. Triggered by current discussions on 'new radical' design approaches towards climate change and global warming, these reflections underline some analogies with the thinking of historical 'radical' positions, in particular, the work of Italian group Superstudio from mid-sixties to the late seventies, well before the present discourse on the environmental crisis. Symptomatically in similarly addressing social and cultural (if not environmental yet) complexities of their time, the historical works discussed in this paper did arise as a critique to the production-consumption system that strongly stemmed from the crumbling of the ideals of modernism, and then unrolled even more solidly through post-modernism and the economic liberalism of the eighties, nineties and over into the new millennium. In parallel, and indeed ignited by ideas of social 'progress' based on production-consumption-capitalization systems, inequalities have been progressively emerging in the form of both social disparity between humans and accentuated imbalance between human and non-human species. In response to these problematic dynamics, current engagement with environmental and social repair invites to regain awareness and implementation of simple, essential life modes echoing a sort of revised 'proactive existentialism' that also implies interconnected co-participation in/with the planet through rediscovered dimensions of 'body-ness', in the legacy of Superstudio's appeals for a world to be experienced through primary life actions, "without architecture". Ac-

**Superstudio**

*Il Monumento Continuo [The Continuous Monument],* 1969-1970. *Nel deserto del Sahara [In the Sahara desert],* 1969.
Courtesy Archivio Toraldo di Francia, Filottrano @ Superstudio

cording to Adolfo Natalini, one of Superstudio group members:

> ...if design is merely an inducement to consume, then we must reject design; if architecture is merely the codifying of the bourgeois models of ownership and society, then we must reject architecture; if architecture and town planning is merely the formalization of present unjust social divisions, then we must reject town planning and its cities...until all design activities are aimed towards meeting primary needs. Until then, design must disappear. We can live without architecture...[1]

Among various definitions of new radical approach in design practice today, a more effective engagement with non-human species and the notion of 're-wilding' – also including calls for reusing and adapting the existing instead of producing new volume, i.e.: stopping saturating the world with unnecessary stuff – are indicative of an encouragement towards more reduced and less impactful degrees of human occupation.[2] These calls seem to go hand in hand with an idea of reversion to basic, essential ways to live in and experience the world, through the relinquishing of our dominating character, embracing effective levels of coexistence with 'otherness' and integrating our being and related activities with the 'otherness' of non-human natural species. A definitive awareness that we/humans are nature too, interconnected entities of our planet and the extended universe, has more recently strongly

emerged through the wider discussion on the notion of the Anthropocene, to-gether with the realization that our contribution to the developing conditions of the planet is also unavoidably harmful to the planet itself.  As natural be-ings originally stemmed from the hominin lineage, and intrinsically related, by means of 'correlationism', to Earth's geology and other interdependent/inter-connected conditions of its natural systems, we have 'naturally' and increas-ingly affected the modification of our planet's conditions, arguably through a decisive acceleration from the end of WW2.[3]

The current calls for rewilding – a notion that also relates to visions of a planet freed from things, where buildings are reused and adapted if not removed and in a state of progressive ruination (see how magic has become Chernobyl to-day, for instance) – is a response to the harmful actions over a planet dilapidated by our dominant species, yet is also tragically confronted by the awareness that this very same dilapidation of the planet may ineluctably proceed in parallel with the presence of our species within it as interconnected with everything else – Timothy Morton suggests that, "...deep down I know I come from others and am related to others... (in) an ecological age in which we know full well that there is no 'away' – waste goes *somewhere*, not ontologically 'away'. Nor is there Nature as opposed to the human world".[4] A grim reality, frustrating and discouraging, is that most of the products for sustainable green technologies heavily depend on the mining of rare earth minerals.[5] Even more dreary and bleak, because of unthink-able solutions for it, is the idea that Anthropocene and the unpleasant effects of our existence on the earth have inescapably been triggered by the emergence, since agriculture appeared in its early manifestations around 12.000 years ago, of a form of nature as inextricably associated with our life and the necessity to sup-port it.[6] However, the notion of rewilding can also be approached, and embraced, in more positive terms, especially if conceived in relation to possible forms of rewilding to be associated to ourselves – our bodies and intuitions – rather than merely the spaces we inhabit. The TV series Black Mirror intriguingly hints at pos-sible mutations of our species' states as interconnected with otherness, depict-ing a "high tech near-future where humanity's greatest innovations and darkest instincts collide".[7] A decade after the launch of this series (2011-2014), its envi-sioned dystopian futures do not seem so far after all. Some are already with us: think of COVID-19 and associated shifts in social, communication, technology-related and psychological behaviours among others. Our 'darkest instincts', as intrinsic elements of our original and inexplicable state of "being-thrown-into-the-world"[8] have certainly strong affinities with the intuitive and merely physical sphere of the body as the essential, primary means of our existence within – and correlated with other species of – the planet. Through the desperate awareness of being the culprit of major ecological disturbances as outcomes of our attempt to rationally and constructively 'make sense' of the world in solving and defining – always and irrefutably to us-humans only – its unsolvable and undefinable as-pects, perhaps retreating to the elementality of the dimension of the body can be a way to recalibrate our presence in the planet. By learning to 'unlearn' – thus by also learning to rely on our physical and mental intuitions more than the rational and logical processes to which we have been steadily and constantly educated – we may find ourselves in tune with living modes that are lighter, less dominant, more effectively 'ecologically interconnected',[9] weaker (as less domineering) and yet stronger (as more powerful in repairing, and harmlessly coexisting with, eco-logical systems). Through an extended history of thinkers and philosophers runs a constant debate with regards to the problematics in the equation that relates, on the one hand, an instinctive inclination of human beings towards forms of socialization, and yet, on the other, negative outcomes associated to social in-equalities as the  direct result  of  an idea of 'progress' based on production-

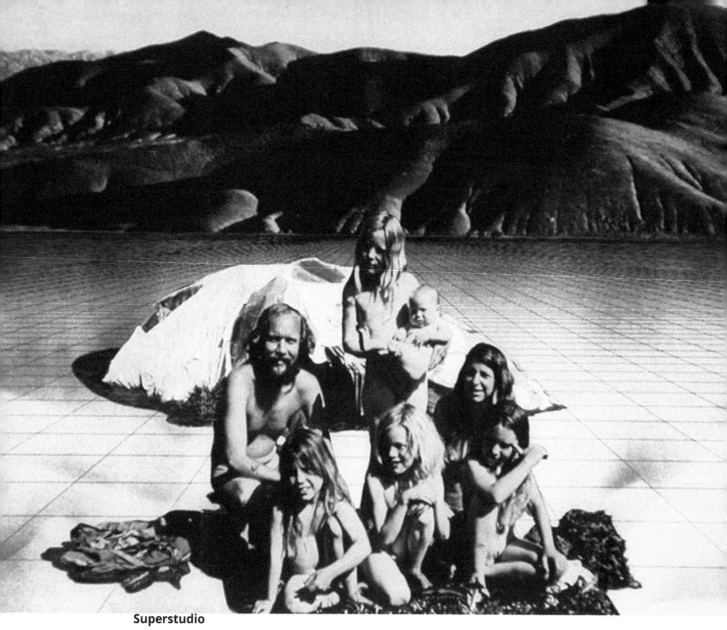

**Superstudio**

*Gli Atti Fondamentali, Vita (Supersuperficie) [The Fundamental Acts, Life (Supersurface)],* 1971-1972.

*L'accampamento [The camp],* 1971. Courtesy Archivio Toraldo di Francia, Filottrano @ Superstudio

consumption-capitalization systems. From Rousseau to Leopardi, Thoreau, Arendt, Heidegger and Lorenz,[10] just to name a few, comes an invitation to reflect on the exponential diminution of our ability to experience our places, our planet, in more instinctive ways. These invitations call for a recalibration: from mind and ratio to body and intuition. They promote critical reflections on increasingly amplifying degrees of inequalities between humans, and by extension, between humans and the other species of the planet to which humans are however interdependently correlated.

In response to the title of this issue of Antennae – 'spaces and species' – and the considerations shared so far, how can we envision 'radical' ways, critical readjustments, for the repair of the ecological systems that we have been inhabiting since 'being-thrown-into-the-world' as correlated to/with all other species of this planet? How can we, architects, designers, thinkers, artists, human beings all, reimage spaces to allow for harmless coexistence with otherness? Is this possible? Is this too late, as some think? Is this perhaps even impossible, due to the inherent levels of disturbance that, as some others argue, are embedded in us – and our 'natural' way of 'being nature' – since ever? Even if we accepted the latter consideration, would it be worthwhile to

at least attempt to repair the planet in/with which we interrelatedly coexist? Could we live in the awareness of the disappearance of our species, and yet through our disappearing compassionately try to minimize our dominating presence as part of the interdependent whole of species that make the planet? The current calls for environments in closer integration between human beings and other species, as well as for buildings and spaces where to "live together"[11] point clearly to the issue of inequality that in different ways affect the world today:

- inequality as exaggerated dominance of human beings over other species. Even accepting that the dominating character is inherent with us, thus not eliminable with regards to the correlated whole of planet's species, the excessive overpower that we have been exercising is however well manifest and demonstrable,
- inequality through different social worlds and their associated welfare and health conditions.

As it is so eloquently and explicitly stated in the Shadow Places Network manifesto as a wakeup call through current crises associated with environmental impoverishing and the cracks of economic systems based on production/consumption modes, "we are not, as we have been told, on a path to progress. Instead, much is being undone. Much is being lost and displaced. Ecologies are in crisis. Connections are being severed. Inequities stratify our social worlds".[12]

The reflections conveyed to this point, as well as the various bibliographic references that have been included so far in order to support this paper's argument, do suggest the retreat into 'body-ness' and intuitive thinking as a possible revised approach to life. To pull back into our 'body-ness' as a means for simple – and simply necessary – actions and functions may help us in participating into/with the planet as lightly and less intrusively as possible. Could this be a valid, effective approach for decelerating our overwhelming effects on all other correlated species? Together and directly associated to this thinking, would stopping constructing new buildings, instead reusing and readapting what we have got, be the way to go? And so, by extension, could we stop filling the planet with stuff, and instead start acting as deeply concerned – thus deeply in touch – with our own ground – the grounds of our own places – and yet aware that we are part of a whole of correlated species at a planetarian scale? Bruno Latour uses the term "terrestrial": "For the Terrestrial is bound to the earth and to land, but it is also *a way of worlding*, in that it aligns with no borders, transcends all identities".[13]

Superstudio's visions are informed by this compelling notion: they are deeply 'terrestrial' in proposing worlds with humans grounded to their place, in some images through the pure simplicity of their bodies, in some others accompanying elemental moments of life with the simplicity of everyday things from everyday routines, yet at the same time always participating and interconnected to the world through global infrastructural systems that in their anonymity and sense of spatial infinity deny in fact any idea of architecture. Monumentality as the expression of individual and formal/formalist objects is also provocatively criticised by being assimilated and then translated into an infinite, thus undeterminable and unmeasurable form of revised monumentality: *The Continuous Monument*.[14] The negation of architecture, a symptom of Superstudio's critique of the then emerging global market's dynamics, is carried out by paradoxically accepting and going beyond the idea of a world wholly interconnected as a "wired planet", where the total interconnection between humans – and by extension also humans and non-humans – becomes an uninterrupted, unseparated 'background architecture'; a continuous 'im-partial'[15] setting, everywhere equally 'not present' to "give back creativity to its users".[16] Superstudio's depictions embrace

**Superstudio**

*Overleaf: L'Architettura Interplanetaria [Interplanetary Architecture],* 1969-1971

*Autostrada Terra-Luna [Earth-Moon highway],* 1970-1971.

Courtesy Archivio Toraldo di Francia, Filottrano

© Superstudio

205

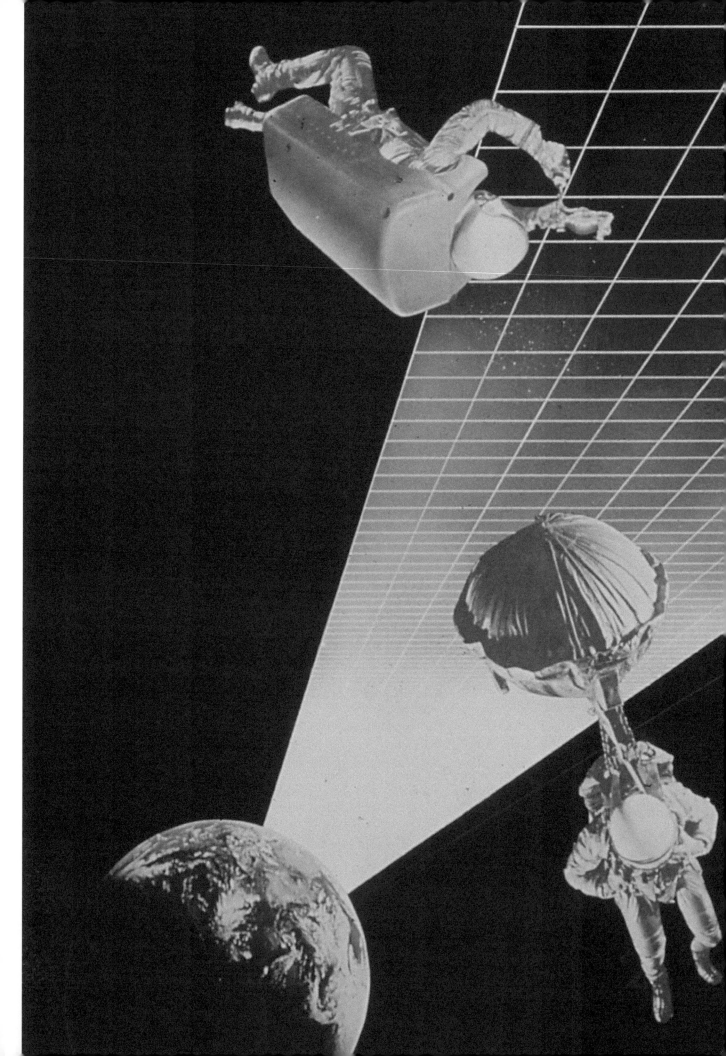

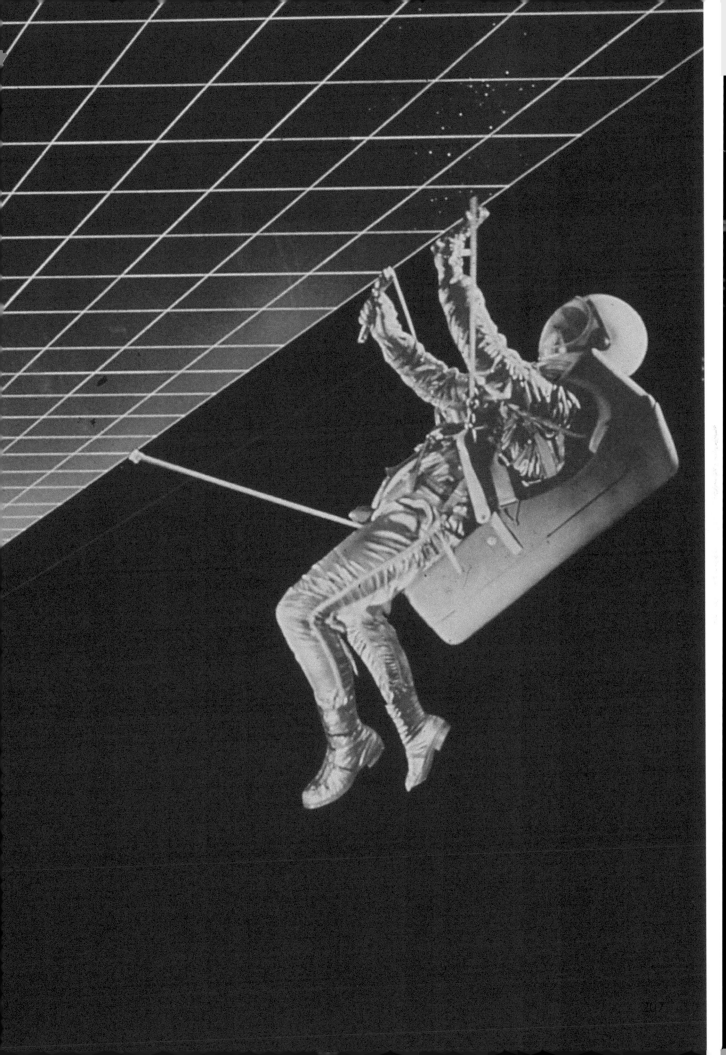

a planetarian dimension and yet encourage deep engagement with specificity of place from where to regain both environmental and self-awareness at once. Their proposed environments, both urban and natural, express the inextricable interconnection of human and non-human entities as all parts of an undivided system, *the wired planet*, that only by conventional modes, by means of reassurance,[17] is stereotypically conceived as constituted by individual things. In their drawing *Earth-Moon highway for Interplanetary Architecture* (1970-71) the level of interconnectedness is pushed even further, to suggest states of interdependence between species and ecological systems at literally an 'interplanetarian', universal level.

Precursory to the current extended environmentalist related disquiet, Superstudio's critique of the production-consumption system carries out the seeds of today concerns for human accentuated domination and the various associated aspects of inequality and abuse, fed by that rhetoric of economic and social progress that is explicitly criticized by Shadow Places Network. Not surprisingly Superstudio's work and theoretical positions have been consistently and extensively re-evaluated through discussions that are these days more specifically focussed on climate change and related forms of urban resilience. In the various visions of their *Reflected Architecture* series (1970) the totalitarian character and scale of the built volumes 'disappear' through their blankness in order to reveal, to *reflect* indeed, their surrounding environments. Architecture realizes that its only ethical dimension is that of allowing the world to be, acknowledging the context – the surrounding space comprised of all other species, built and unbuilt entities – that is by default defined by, yet also already existing before, its own presence. Architecture must mute itself in order to silently, more lightly, 'weakly' co-participate into/with the planet. These positions progressively intensify through the *Fundamental Acts* (1971-1973), a series of five films of which only two produced, in which human life is brought back to simple, essential activities, freed from work, thus from the constraints of the production-consumption system.[18] In the second film, *Ceremony*, architecture is reduced to nothing: people start their day by exiting from some underground space – through a hole in a concrete slab on the ground which we assume must be the roof of some buried indoor environment – and spend their day and night in the open, among trees and other non-human beings in a vegetated landscape with no buildings, except for a makeshift shelter made up of fabric in the (non)form of a basic tent-like structure element.[19]

The trust in unconfined outdoor space dimensions to recalibrate the balance between human and non-human species by embracing otherness through slower, restful, more meditative life actions, had already been clearly expressed in the images produced to promote the *Quaderna* furniture series in 1970,[20] when through some considerations on Italian design Superstudio stated: "our aspiration to calm and serenity through greater balance is also our hope".[21] Quaderna's furniture components are displayed in open vegetated spaces, grounded – and as such interdependently co-participating – to their specific places, laid among the endemic grass species of their places, inhabited by humans (children) and cows of the distinctive cattle breed from those specific landscapes. They allow undetermined individual arrangements through primary forms and laconic aesthetics that in their abstraction, thus negation of individual object-ness, tend to a planetarian dimension – to an idea of inexplicable "oneness".[22] The ultimate, both chronologically, as one of Superstudio's last works, and theoretically, the apex of their pursuit of a world freed up from built objects, is a work exhibited at the 1978 Venice Biennale. *The Wife of Lot* was an installation of five architectural models made up of salt, that under the corroding effects of water slowly dripping from above through a sliding mechanism – itself part

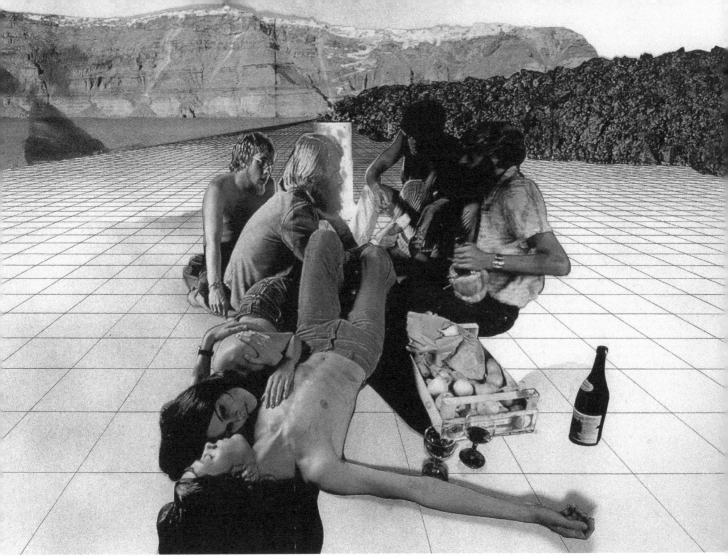

**Superstudio**

*Gli Atti Fondamentali, Vita (Supersuperficie) [The Fundamental Acts, Life (Supersurface)]*, 1971-1972

*Frutta e vino [Fruit and wine]*, 1971. Courtesy Archivio Toraldo di Francia, Filottrano

© Superstudio

of the installation – progressively disappeared through the duration of the exhibition. Melting and indeed dissipating to become inextricably identified with life, architecture leaves ground to a blank gridded 'infrastructural mute presence' – the *Continuous Monument* progressively translated through the years into *Supersurface* – that matching with the dimension of the planet, allows essential existential – "anthropological and philosophical" – activities[23] from each specific place of the global network.

One of the five dissolving architecture models was Le Corbusier's Pavilion for l'Esprit Nouveau (1925). Not surprisingly Superstudio must have selected an early work of this iconic modernist architect as a target of their critique to architecture aligned with 'progressive' goals. The late Le Corbusier, more definitely from the end of WW2, abandons all together his ideas of architecture as "a machine for living it" – a pure pristine 'modern' object instrumental to produce architectural – and social – amelioration. Parallel to his early obsessions for functionalist and technologically-driven architecture were marching strongly also ideas of measuring systems ("the modulor", for instance) and 'regulating lines' to corroborate his dreams for re-beautified cities as the result of predetermined, quantifiable spatial framing between (urban) objects.[24] The late Le Corbusier, to whom Superstudio must have

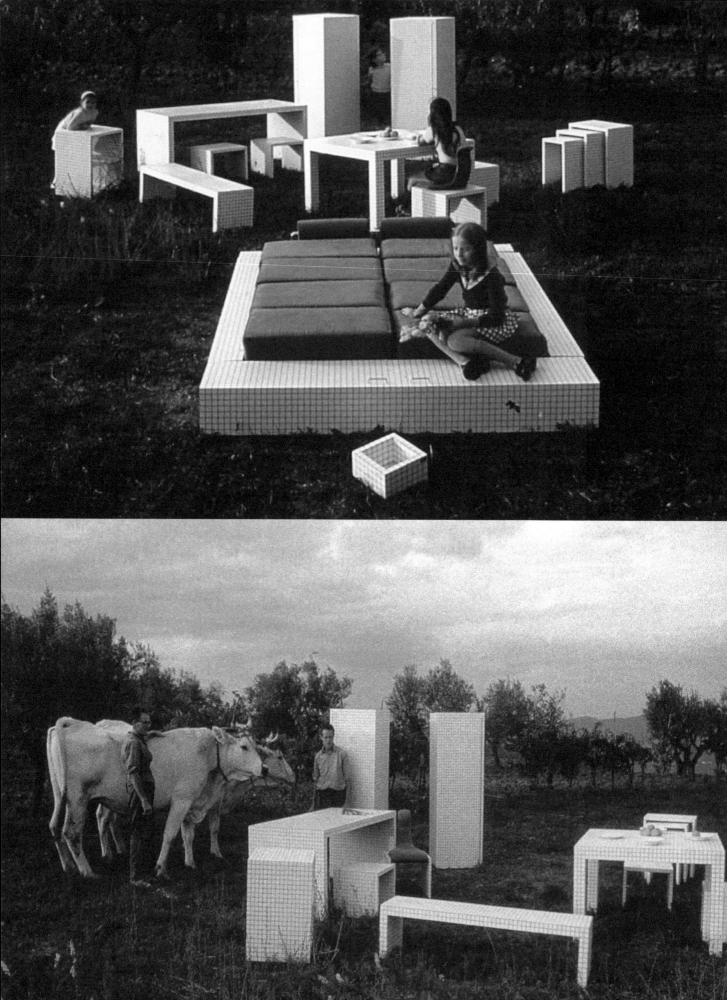

felt in empathy with, throws away all salvific ideals supposedly embedded in architecture; he comes to the realization that space is unmeasurably continuous, a whole dimension in/through/with which buildings, landscapes, humans, non-humans, beauty, ugliness, everything else and more coexist. His notion of ineffable space – *l'espace indicible*, often mentioned and discussed over both his design works and writings from 1945 onwards – guides him through projects – La Tourette, Ronchamp, Chandigarh among others – where architecture no longer frames selected built or unbuilt landscapes, with notions such as "here", "there", "near", "far" and similar becoming irrelevant. One of his smallest projects, the Cabanon on the Mediterranean coast in Roquebrune-Cap Martin, south of France, where Le Corbusier used to spend summer holidays, is no more than a shack, demure in form and size, coexisting with/in its own natural surroundings, interdependent with/to its own ecology. Its reduced footprint instigates outdoor life, in the air, with the trees, animals, water, ecologies of the place. Some archive images symptomatically depict Le Corbusier naked while walking in, out, around, along the adjacent beach, taking a swim, spending time in painting and other activities. Through the spatial 'con-fusion' of his little shack with the whole ecological system of that place, Le Corbusier was there releasing himself to the planet by co-participating to/with its own place through his naked body as the simplest, purest, essential form conceded to him as a human.

I don't think Le Corbusier was aware of the address that Martin Heidegger shared with an audience at the opening of a sculpture exhibition in St Gallen, Switzerland, in 1964, conveying observations on the "indeterminateness" of space. This address was held in German and published, in both German and French versions combined, in 1969, four years after Le Corbusier's death – due to a heart attack while having a swim at the Cabanon. The text, later published in English and other languages, is intriguingly attuned to Le Corbusier's idea of ineffable space, and the notion of ecological correlationism discussed above. Some passages from Heidegger's remarks, critical of the "physical-technological" dimension of space that is conventionally defined as an objective entity through logical/rational thinking, are here pertinent to the argument of this essay:

> The way that space reigns throughout the work of art hangs, meantime, in indeterminateness. The space, within which the sculptured structure can be met as an object present-at-hand; the space, which encloses the volume of the figure; the space, which subsists as the emptiness between volumes – are not these three spaces in the unity of their interplay always merely derivative of one physical-technological space, even if calculative measurement cannot be applied to artistic figures?...Place always opens a region in which it gathers the things in their belonging together...We would have to learn to recognize that things themselves are places and do not merely belong to a place.[25]

Still the notion of space – "third space" – is the focus of recent observations by artist and writer Jenny Odell, who proposes to 'do nothing' as a practice for slowing down, being reflective, withdrawing actively in taking a critical distance, sabotaging, denouncing the many faults of a status quo based on ideas of productivity that are mainly driven by capitalist narratives of efficiency and value.[26] Once more, Odell's calls to decelerate and focus in looking *at* reality rather than quickly, superficially *through* it, and in so doing also reimagine effective forms of correlation between humans and non-humans, are unambiguously in continuity with Heidegger's invitations to meditative thinking – not only on metaphysical notions of space, being, time, but also more prosaically on everyday aspects and things of our life[27] – as well as Su

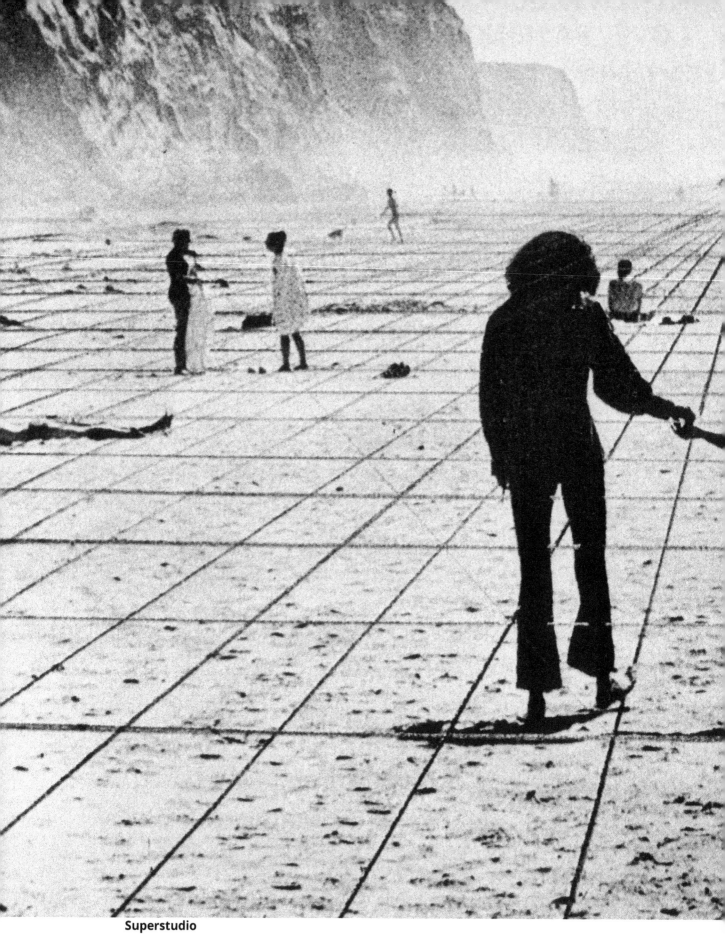

**Superstudio**

*Gli Atti Fondamentali, Vita (Supersuperficie) [The Fundamental Acts, Life, (Supersurface)]*, 1971-1972. *Viaggio da A a B (Travel from A to B)*, 1971. Courtesy Archivio Toraldo di Francia, Filottrano © Superstudio

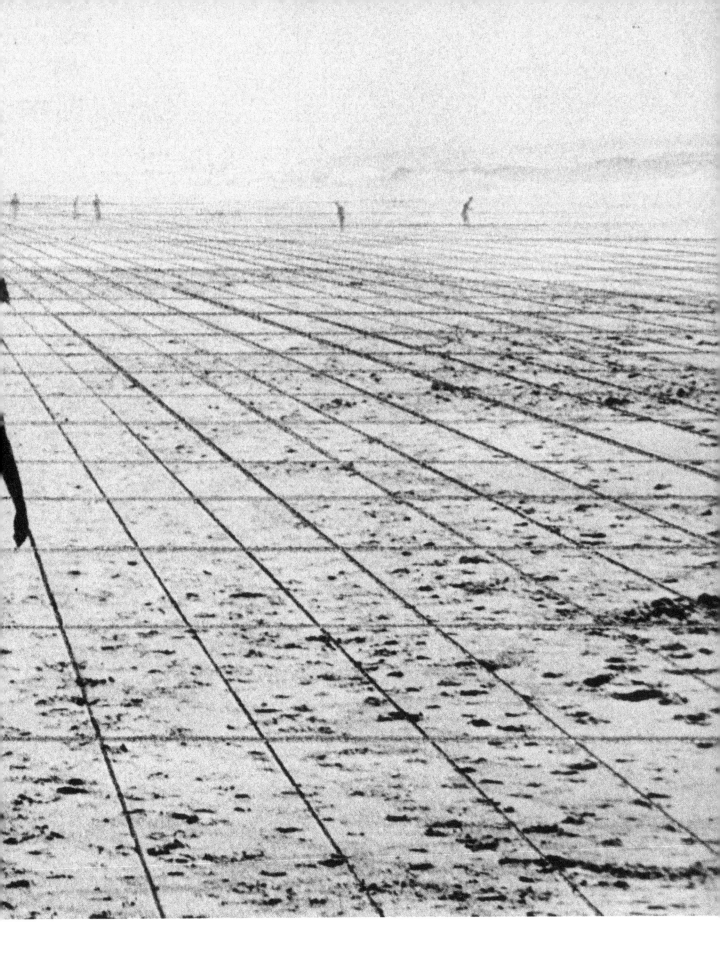

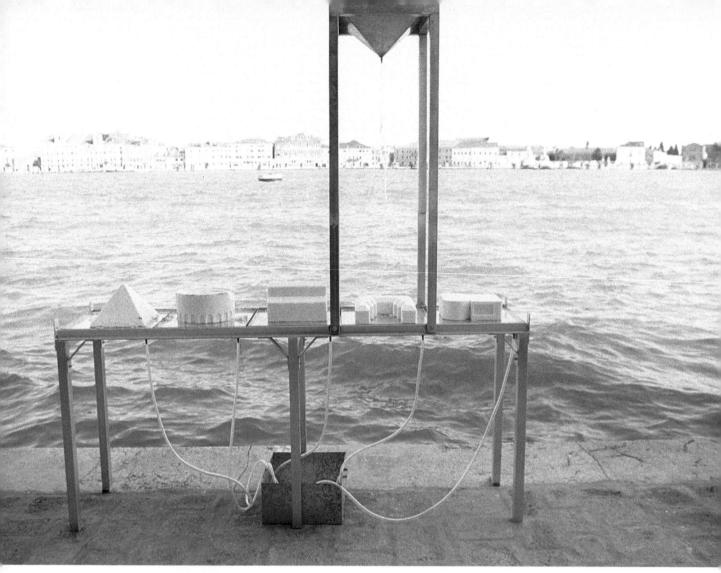

**Superstudio**

*La Moglie di Lot [The Wife of Lot],* 1978. Magazzini del Sale, Venice Biennale. Courtesy Archivio Toraldo di Francia, Filottrano. Photo: Cristiano Toraldo di Francia © Superstudio

perstudio's existentialist positions, Le Corbusier's late critique to techno-scientific objectivity, the post-structuralist auras of Georges Perec's writings – not coincidentally an inspiring source for the title of this Antennae issue – and many more. Doing actively nothing, either with naked bodies, or walking hand-in-hand, or surrounded by simple things, or painting, or just standing still, feeling the breeze, breathing the air, "dwelling on what lies close and meditating on what is closest",[28] or in any other form, is after all an effective approach, as suggested by the architectural positions discussed in this essay, for slowing down, and because of this, paying attention and becoming further acquainted to our inexplicable and undeterminable, yet utterly innate dimension of correlation to the ground of our places and to the planet – to us and everything else beyond and with us, to the oneness that since ever we are by being *with-in* it.

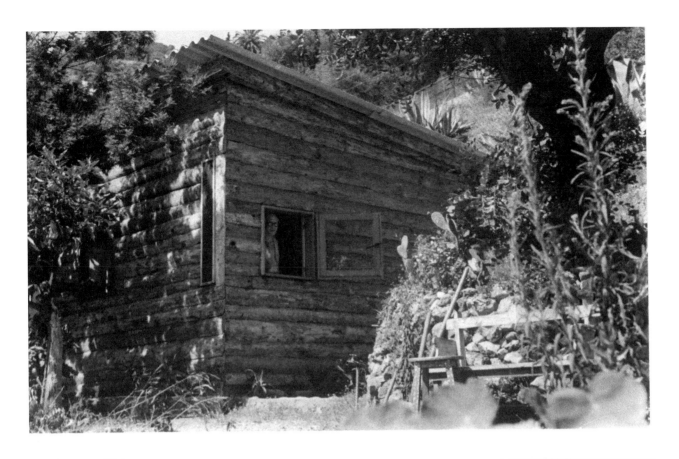

**Le Corbusier**

*Cabanon, Roquebrune Cap Martin,* 1951. *The building and surrounding landscape with Le Corbusier at the window* and *Surrounding landscape viewed from inside the building* © Fondation Le Corbusier. Unidentified photographer

## Endnotes

[1] Natalini, Adolfo. 3rd March 1971. *Superstudio*. Public lecture at Architectural Association School of Architecture, London.

[2] On 'new radical architecture' and 'non-human addressed design' see among others: Galilee, Beatrice. 2021. *Radical Architecture of the Future*. London and New York: Phaidon. Antonelli, Paola. *Broken Nature: Design Takes on Human Survival*. 2019. New York: Rizzoli Electa. Brillembourg, Alfredo, Klumpner, Hubert, and Kalagas, Alexis. 2016. "Free Radicals." In Betsky Aaron, Brillembourg Alfredo, Klumpner Hubert, Heng Liu, Doreen. *Re-Living the City: UABB 2015 Catalogue*, in which Aaron Betsky states: "We do not need to make or build anymore. What we need to do is to reuse, rethink, and reimagine what we already have". Betsky, Aaron. 2016. "A Manifesto". 24. In ibid.

[3] Extending a philosophical lineage that includes Hume, Kant, Marx, Heidegger, and Foucault among others, Timothy Morton argues that "there are no accessible things in themselves...(but) only things insofar as they correlate to some version of the (human) subject, which is why this thinking is called correlationist." Morton also critiques the idea of separation between humans and nature: "...the Anthropocene names two levels we usually think are distinct: geology and humanity. Since the late eighteenth century, humans have been depositing layers of carbon in Earth's crust. In 1945 there occurred the Great Acceleration of the Anthropocene, marked by a huge data spike in the graph of human involvement in Earth systems. The Anthropocene binds together human history and geological time in a strange loop, weirdly weird...I am responsible as a member of this species for the Anthropocene...I'm also part of an entity that is now *a geophysical force on a planetary scale*." Morton, Timothy. 2016. *Dark Ecology: For a Logic of Future Coexistence*. New York: Columbia University Press.

[4] Ibid.

[5] "Rare earth minerals are a set of seventeen chemical elements that are currently exclusive commodities, especially during the transition from the extraction of fossil fuels to the development of sustainable or 'green' technologies. They are used extensively in consumer electronics and within the military. Solar panels, wind farms, laptops, cell phones, electric vehicles, fluorescent lighting, and most green technologies depend on the use of these metals." Turan, Neyran. 2019. *Architecture as Measure*. 36. New York and Barcelona: Actar Publishers.

[6] "...we see global warming [a term that Morton prefers to use instead of 'climate change'] as a *wicked problem*...A wicked problem is one you can rationally diagnose but to which there is no feasible rational solution..." Still, Morton proposes that: "Nature (is) something that happened to human-built space, demarcating human systems from Earth systems. Nature as such is a twelve-thousand-year-old human product, geological as well discursive...*The Anthropocene is Nature* in its toxic nightmare form. Nature is the latent form of the Anthropocene waiting to emerge as catastrophe", Morton, Timothy. Op. cit. 75, 76, 113, 114.

[7] See *Black Mirror*'s tv series description in: https://www.netflix.com/au/title/70264888

[8] The ontological condition of "being-thrown-into-the-world" and related notion of *Dasein* are at the core of Martin Heidegger's philosophical thinking, since *Being and Time*, 1953.

[9] The term "ecology" (from Greek *oikos*: "household," "home," or "place to live; and *logos*: "word", "thought", "principle" or "speech") is informed by the notion of *interconnection* as: "the relationship of living things to their environment and to each other".

[10] Among other texts on social inequalities and re-evaluation of 'animal-like' and 'body-driven' ways of relating to the world, see: Jean-Jacques Rousseau, *A Discourse on Inequality* (orig. 1755). Henry David Thoreau, *Walden; or, Life in the Woods*, (orig. 1854), and *Civil Disobedience*, (orig. 1849). Giacomo Leopardi, *Zibaldone di pensieri* (orig. 1898). Hannah Arendt, *The Human Condition* (orig. 1958). Konrad Lorenz, *Civilized Man's Eight Deadly Sins* (orig. 1974).

[11] "How will we live together?" is the title of the 17th International Architecture Exhibition, Venice Biennale, 2021, put forward by general curator Hashim Sarkis.

[12] See Shadow Places Network manifesto: https://www.shadowplaces.net/

[13] Latour, Bruno. 2018. *Down to Earth. Politics in the New Climatic Regime*. 54. Cambridge UK and Medford, MA, USA: Polity Press; "a way of worlding" is acknowledged by Latour as a "neologism...by Donna Haraway to distinguish the world from the globe of globalization".

[14] *The Continuous Monument*, extensively documented in publications and exhibitions, is described by Superstudio as "an architectural model for total urbanization...a closed, immobile object that leads nowhere but to itself and to the use of reason." Superstudio. 1969. "The Continuous Monument: an Architectural Model for Total Urbanization". In Lang, Peter, and Menking William. 2003. *Superstudio: Life Without Objects*. 123. Milano: Skira.

[15] Not in parts, from "im" as "not", and "part".

[16] Superstudio founding member Cristiano Toraldo di Francia observes: "(With *The Continuous Monument*, 1969)...there was a desire to produce objects with no form, or with a minimal form, without colours or messages. We believed that...the only way to give back creativity to the users...was to carry out a sort of formal *harakiri*; leave on the field some neutral elements and see what everyone could do with them; it was a bit like the square paper notebook into which we can scribble, colour in, write and do whatever we want...in *Supersurface*, 1972, there is a bigger shift: there is no longer any form. In *Supersurface*...forms are now all intellectual, brought back to their original place. Architecture is the earth: the wired planet is the architecture." Superstudio. 2015. *La vita segreta del Monumento Continuo: Conversazioni con Gabriele*

*Mastrigli*. 115 and 125. Macerata: Quodlibet. Translation from Italian by Mauro Baracco.

[17] In "The Age of the World Picture", Heidegger discusses the modern inclination "to picture" the world as 'objectively' determined in accordance to human beings as 'subjects' and 'relational centres' of everything – this 'reassures' us in mitigating the "angst" originally associated to the inexplicability of our "being-thrown-into-the-world". Heidegger, Martin. 1977. "The Age of the World Picture" (orig. paper, 1938). In *The Question Concerning Technology and Other Essays*. New York: Harper and Row.

[18] "In the *Fundamental Acts*, Superstudio imagines a nomadic humanity moving between different points of the *Supersuperficie* (*Supersurface*) carrying only 'a few objects dear to it' – a drawing, a grass flag, an ugly book, animals as friends...In this 'state of nature' freed from work, where basic needs are met, the whole of life is dedicated to physical and cerebral activities". Chiappone-Piriou, Emmanuelle. 2020. "Catalogues, inventories, myths: Superstudio's objects of affection". In *Superstudio – Migrazioni*, edited by Emmanuelle Chiappone-Piriou, Vol. 1. 62. Köln: CIVA and Verlag der Buchhandlung Walther und Franz König.

[19] Superstudio. 1973. *Ceremony*, film. See: https://www.youtube.com/watch?v=_r0CUJLssOk

[20] *Quaderna* furniture series, produced by Zanotta, originally created as part of *Misura* series, 1969-1972.

[21] Superstudio. 13 June 1970. "A Difficult Childhood for the Italian Design", Milano: *Corriere della Sera* newspaper.

[22] "Oneness" is a key term introduced by Heidegger to suggest a dimension of indivisible spatiality – a complex, rationally ungraspable idea of space – "the simpleness of the simple onefold of worlding" – informed by a sense of 'mirror-playfulness' and 'co-belongingness together'. See Heidegger, Martin. 1971. "The Thing" (orig. 1951). In *Poetry, Language, Thought*. New York: Harper and Row.

[23] In Superstudio's words: "Architecture never touches the great themes, the fundamental themes of our lives. Architecture remains at the edge of our life, and intervenes only at a certain point in the process, usually when behaviour has already been codified, furnishing answers to rigidly stated problems. Even if its answers are aberrant or evasive, the logic of their production and consumption avoids any real upheaval...In accepting his role, the architect becomes accomplice to the machinations of the system...It then becomes an act of coherence, or at least try at salvation, to concentrate on the re-definition of the primary acts, and to examine, in the first instance, the relationships between architecture and these acts...This tentative anthropological and philosophical refoundation of architecture becomes the centre of our reductive processes". Superstudio. "Fundamental Acts: Introduction" (orig. 1973). In Lang, Peter, and Menking William. Op. cit. 177.

[24] Le Corbusier's early work is informed by functionalist ideals fuelled by a modernist rhetoric based on the equivalence between social progression and technological advancement; for instance, in *Towards a New Architecture* (orig. *Vers une Architecture*, 1923) industrial buildings and products are highly celebrated, and the house is described as a "machine for living in" ("une maison est une machine-à-habiter"). Two of the book's several chapters are called: "Architecture or Revolution" and "Regulating Lines" – terms that symptomatically grant architecture the power equivalent to a "revolutionary" force, and suggest notions of a measurable and quantifiable, objective type of spatiality.

[25] Heidegger, Martin. 1997. "Art and Space" (public address, 1964; orig. ed. 1969). In *Rethinking Architecture: A Reader in Cultural Theory*, edited by Neil Leach, 121-124. London: Routledge.

[26] Odell, Jenny. 2019. *How to Do Nothing: Resisting the Attention Economy*. New York: Melville House.

[27] "...anyone can follow the path of meditative thinking in his own manner and within his own limits. Why? Because man is a *thinking*, that is, a *meditating* being. Thus meditative thinking need by no means be 'high-flown'. It is enough if we dwell on what lies close and meditate on what is closest; upon that which concerns us, each one of us, here and now...". Heidegger, Martin. 1966. "Memorial Address" (public address, 1955). In *Discourse on Thinking* (orig. *Gelassenheit*, 1959). 47. New York: Harper and Row.

[28] Ibid.

**Mauro Baracco**, PhD, is an Architect, Director of Baracco+Wright Architects or B+W (est. 2004) and from 1995-2020 was an Associate Professor at the School of Architecture and Urban Design, RMIT University. His teaching and research have manifested an interest in the local that has developed from historical and cultural to include ecological relationships of the built and unbuilt environment. This activity encompasses design, teaching and philosophy. Together with Linda Tegg and Louise Wright he was a Creative Director of the Australian Pavilion Venice Biennale 2018 with the title *Repair*.